Praise for *The Coach's G*

"I needed to transform how I approac̱̱̱̱̱̱̱̱̱ ̱̱̱̱my research. Rena was instrumental in ensuring I was incredibly productive. From goal setting to structuring my time effectively, to creating metaphors that facilitated my ability to push through challenges, she has helped to make me a happier and more efficient academic. Her positive energy is infectious and her ability to help her clients see the big picture is unparalleled. I don't know what I'd do without her!"
—**Modupe Akinola**, assistant professor, Columbia University

"*The Coach's Guide for Women Professors* will be an amazing asset for female academics. It is packed full of practical and empowering strategies that will pay immediate dividends, as well as being a resource that you will want to return to for clear solutions to challenges that arise. It is an invaluable resource for women (and men) who care about advancing their own careers as well as the careers of women in the academy."—**Linda C. Babcock**, James M. Walton Professor of Economics, author of *Women Don't Ask: Negotiation and the Gender Divide,* Carnegie Mellon University

"*The Coach's Guide* is a true gem, realistic and empowering. It touches on a wide range of challenges from time management to departmental politics to the nuances of identity, and the universal truth that no one gets anywhere alone! Achieving a successful career and a well-balanced life is a continuous task, not a one and done event, and this guide will stand the test of time."
—**Nancy Cantor**, chancellor, Rutgers University-Newark

"This book distills the key lessons from Rena's vast experience coaching academics. Her coaching has helped me enormously professionally, but I also appreciate the greater peace of mind; thanks to our discussions, I don't take work frustrations home with me. Although Rena's book is tailored to women professors, most of these lessons and strategies apply to everyone; I've ordered copies for myself and my advisees."—**John Cawley**, professor of policy analysis and management, professor of economics, and codirector of the Institute on Health Economics, Health Behaviors and Disparities, Cornell University

"I would not have gotten tenure without Rena Seltzer's skillful coaching. I am positive of that. If you can find a way to work with her as a coach, do it! But if you can't, read her book at least twice. It has all the life and career hacks every academic (male and female!) needs. Rena knows academia, in all

its glories and pitfalls, and it is exhilarating to see one's world so accurately portrayed through on-point advice. I am a happier, healthier, higher-impact, and more productive academic, thanks to Rena's coaching and book."
—**Dolly Chugh**, associate professor, New York University

"Rena Seltzer's workshops are perennial favorites with Yale faculty. Workshop alumni get more writing done, have more control over their schedules, and feel increased confidence in their leadership skills. Rena has also served as a coach for a number of Yale faculty leaders. Here as well, her work has been transformative. I am delighted to recommend *The Coach's Guide* to anyone aspiring to learn from this wise and inspiring academic coach."
—**Tamar Szabó Gendler**, dean of the faculty of arts and science, Vincent J. Scully professor of philosophy, and professor of psychology and cognitive science, Yale University

"A thoughtful, immensely practical resource for women to achieve excellence and well-being in academic careers."—**Adam Grant**, professor, and *New York Times* bestselling author of *Give and Take,* Wharton

"*The Coach's Guide* provides a toolbox of ideas relevant to faculty across life and career stages. Each chapter contains concrete, pragmatic, and targeted strategies designed to help faculty identify and overcome obstacles to professional success and to re-discover joy and balance in their work and personal lives."—**Deandra Little**, associate professor, director for the Center for the Advancement of Teaching & Learning, Elon University

"Every administrator, faculty member and graduate student can benefit from implementing the concrete recommendations in *The Coach's Guide*. It's akin to having a professional development coach at one's beck and call."
—**Yolanda Flores Niemann**, professor of psychology, coeditor of *Presumed Incompetent: The Intersections of Race and Class for Women in Academia,* University of North Texas

"This book has something for ALL women in academia. Traditionally, the academy has been governed by unwritten rules that determine academic career success. Through the lived experiences of women faculty, *The Coach's Guide* sheds light on those unwritten rules in order to help women navigate successfully around them. This book offers just the right tools."
—**Gloria D. Thomas**, director, Center for the Education of Women, University of Michigan

"The advice in *The Coach's Guide* corresponded to conclusions that I have drawn from my research on women faculty. I also related to the book on a personal level – as a professor, a parent and spouse, and a newly appointed associate dean. I loved the checklist at the beginning of the book and I found myself laughing at how many of the items related to my own experiences. I highly recommend this book to anyone who is engaged in or contemplating an academic career." — **Lisa Wolf-Wendel**, associate dean for research and graduate studies, University of Kansas

THE COACH'S GUIDE FOR WOMEN PROFESSORS

THE COACH'S GUIDE FOR WOMEN PROFESSORS

Who Want a Successful Career and a Well-Balanced Life

Rena Seltzer

Foreword by
Frances Rosenbluth

STERLING, VIRGINIA

Published by Stylus Publishing, LLC
22883 Quicksilver Drive
Sterling, Virginia 20166-2102

Library of Congress Cataloging-in-Publication Data

Seltzer, Rena, 1964-
The coach's guide for women professors : who want a successful
career and a well-balanced life / Rena Seltzer.
 pages cm
Includes bibliographical references and index.
ISBN 978-1-57922-896-5 (pbk. : alk. paper)
ISBN 978-1-57922-895-8 (cloth : alk. paper)
ISBN 978-1-57922-897-2 (library networkable e-edition)
ISBN 978-1-57922-898-9 (consumer e-edition)
1. Women college teachers. 2. College teaching–Vocational
guidance. 3. Feminism and education. I. Title.
LB2332.3.S45 2015
378.1'2082–dc23
 2015006908

13-digit ISBN: 978-1-57922-895-8 (cloth)
13-digit ISBN: 978-1-57922-896-5 (paperback)
13-digit ISBN: 978-1-57922-897-2 (library networkable e-edition)
13-digit ISBN: 978-1-57922-898-9 (consumer e-edition)

Printed in the United States of America

All first editions printed on acid-free paper
that meets the American National Standards Institute
Z39-48 Standard.

Bulk Purchases

Quantity discounts are available for use in workshops and for
staff development.
Call 1-800-232-0223

First Edition, 2015

For my clients

CONTENTS

FOREWORD

This book is not for everyone. Any woman professor satisfied with a successful career should not bother; nor should anyone satisfied with a well-balanced life. This book is a guide for those who aspire to the very difficult combination of the two.

To paraphrase Thoreau's (1854) *Walden*, go confidently in the direction of your dreams. Live the life you've imagined. As you simplify your life, the laws of the universe will appear less complex.

It sounds like wonderful advice, but I have never figured out exactly what it means. Being a professor is the life of my dreams, but, as far as I can see, it is anything but simple. We have scholarship to launch, students to teach, colleagues to engage, and administrators to satisfy, not to mention our families and private lives to manage—all against the backdrop of subtle and not-so-subtle forms of gender bias. Nevertheless, it *is* a wonderful life when things go smoothly.

Even Thoreau eventually tired of Walden Pond and reimmersed himself in the stimulation of human society. The question that Rena Seltzer addresses in this book is not how to retreat into spiritual contemplation, but how to keep a very complicated and demanding life on track. We all know the feeling of muddling through, making a hash of things, and picking up the pieces to keep going. We all could have used expert advice from someone who has encountered similar situations. We all probably could have made better decisions with input from a life coach.

Seltzer's book is the next best thing to a personal life coach. The book is partly a how-to manual with advice on just about every aspect of the academic career: what to do about time management, how to motivate and assess students, strategies for getting work published, and so on. Seltzer (although you may find yourself referring to her by her first name, because this book will feel like a comforting friend) distills usable techniques from the enormous bodies of literature on writing and teaching effectiveness. I already have plans to hand out "exit tickets" in my next class (see chapter 3).

As we all know, however, a successful career is not just a matter of mastering writing skills and communication techniques. The greatest wisdom of this book is in the recognition of the deep psychological and sociological

issues that lie at the base of our challenges. With insight and empathy, Rena Seltzer picks through the detritus of embarrassing episodes and horrendous faux pas to distill lessons for the next round. Using examples from real people she has helped through a variety of struggles, she has constructed labels through the labyrinth.

Seltzer recognizes the fragile psychology of a stressed-out person: writer's block, addiction to web surfing, venting to family and friends, inability to let go of unpublished work—the list goes on. She not only proposes strategies to stay on task at the office—what she calls "work strategies"—but also suggests ways to restore health, revitalize emotions, and nourish friendships using "keystone habits." I was not surprised to learn that she has a black belt in karate because under her gentle exterior is a tough person who celebrates the connection between mind and body and who understands the importance of appropriate outlets for frustration and energetic expression.

Beyond individual psychology, the book also provides guidance for how to navigate endemic structures of sexism and racism that we have only begun to recognize and tackle as a society. We ask, "What should I do about sexist and/or racist colleagues or students? How do I manage unfair coauthors or colleagues? How can my partner and I manage our dual-career household? How can I get my work done when I have so little time with my family as it is? How do I break into male-dominated networks?" But this is not a book about society's problems; it is a helpful guide for how to cope in constructive, life-affirming ways. Speaking with authority requires recognizing society's double standards that make it hard for a woman to be liked and respected at the same time. Seltzer provides an array of suggestions for how women can be more powerful without alienating their biased audiences.

Seltzer has written a gem of a book. I have watched her present parts of it at faculty development sessions at Yale University, where I was deputy provost for faculty and development. The women professors who attended these workshops could not get enough of Seltzer because she provides wisdom for what matters most: career success on terms that make us happier people. I am delighted she has written this book, and you will be a richer person for having read it.

Frances Rosenbluth
Damon Wells Professor of Political Science
Yale University
New Haven, CT
March 2015

ACKNOWLEDGMENTS

This book was truly a team effort, and I am grateful to the many people who contributed. My publisher John von Knorring was enthusiastic about the concept for this book from our first conversation. He provided wise counsel on the form and breadth of the manuscript and supported my goal to speak to the diversity of experiences of women professors. I am grateful for his support.

The spark for this project came from Christina Ahmadjian, who suggested that I write these ideas down in a book. My writing group of Cheri Alexander, Sandra Finkel, Shari Fox, and Melissa Britt Rosenblum provided encouragement on early writing that gave me confidence to move the project forward. Sam Beasley, Katy Mattingly, and Sally Palaian provided me with inspiration by completing their books just as I was embarking on this work, as well as being steadfast friends and supporters. I am indebted to Frances Rosenbluth, who shared wisdom on women in leadership from both her research and her personal experience and wrote the eloquent foreword to this volume.

Leslie Keenan shepherded me through writing the proposal, helped to shape the book, read and commented on drafts, and kept me on a tight writing schedule. Leslie's confident guidance and regular assurance that the book was right on track made the process enjoyable.

Aaron Ahuvia, Evan Caminker, Nancy Cantor, Deborah Field, Laura George, Linda Gillum, Deborah Goldberg, Susan Gano-Phillips, Diana Kardia, Katy Mattingly, Anthony Walesby, Liz Wierba, and a number of anonymous academics took time out of their demanding schedules to share their experiences and insights into all levels of university leadership and administration, as well as insights about teaching. I am beholden to their generosity. Countless workshop participants tested out the exercises in this book and shared their own experiences and ideas.

For their careful reading and feedback on chapters, I want to thank Aaron Ahuvia, Deborah Field, Susan Gano-Phillips, Laura George, Laura Helper-Ferris, Alicia Kent, Deandra Little, Ina Lockau-Vogel, Michael McVey, Deborah Dash Moore, Adrianne Neff, Julia Piper, Caroline Richardson, Ching-Yune Sylvester, Greg Saltzman, and Gloria Thomas. McKenzie Baker managed the production schedule with dedication and good humor,

and Nicole Hirschman and Julie Kimmel provided expert copyediting and proofreading.

Thank you to Stylus Publishing for permission to reprint the sample rubric from *Introduction to Rubrics* and to the *New Yorker* Cartoon Bank for permission to reprint the Robert Mankoff cartoon.

I am blessed with a wonderful circle of friends and professional colleagues. A few not previously mentioned who played supportive roles in this project include Hans Anderson, Ben Dean, Lynn Fouchey, Carla Grayson, Cynthia Hudgins, Janet Kahan, Carol Lessure, Kristen Mitchell, Eileen Quintero, David Ruderman Jamie Saville, Fritz Seyferth, Abigail Stewart, Tony Tsai, Jean Waltman, Paula Wishart, and Willie Wolf. I am doubtless forgetting people who deserve mention—I am nonetheless grateful for their support.

Elizabeth Papazian shared an insider's perspective on academic life through a number of conversations at family gatherings, and Joel Seltzer contributed valuable thoughts on teaching. Debra and Tova Seltzer gamely tried out practice exercises and gave constructive comments. Eugene Shore has given me sound business advice over almost two decades, and Roberta Shore came up with the name of my business and has provided wise guidance on everything from raising children to growing flowers.

My mother, Marjory Cort Seltzer, started as my first editor in grade school and continued to provide meticulous copyediting of my writing well into my professional career. She demonstrated how to delegate to one's kids and spouse by insisting that her three children and her husband all rotate cleaning and cooking chores—this at a time when boys and men did not routinely engage in those tasks. She has also lived a well-balanced life including work, creative pursuits, and community involvement. My father, Martin Seltzer, always managed to give 110% at work, to be active in the community, and to still be home for dinner with his family. He is always willing to talk or just listen. I am grateful for my parents' belief in me.

Despite my efforts to follow my own advice on work-life balance, writing this book sometimes pulled me away from time with my family. My sons, Isaac and Elijah, were good-natured about my absence and, when I needed a break, they welcomed me back into family activities. My life partner, Pam Shore, did far more than her share of managing our family life to provide me with time to write and acted as my business consultant, first reader, and closest companion for more than a quarter century. My family served as my first audience for workshop presentations and patiently listened on cross-country car trips whenever I took a break to pontificate on something I had just read as part of my research. They keep things in perspective with their humor and

remind me not to take myself too seriously. Pam, Isaac, and Elijah are my greatest joys.

Finally, I am deeply indebted to my clients, the smart, funny, and dedicated women and men from whom I am constantly learning and who have agreed to share their experiences to help other academics. Working with you is a great privilege.

INTRODUCTION

Morgan's career got off to a strong start, and she made it through the tenure process, but after she gave birth to her son, her productivity plummeted. With teaching, advising, committee work, and a hard deadline to pick up the baby from day care, there just aren't enough hours in the day. Morgan is embarrassed by the dearth of publications on her CV in the past few years, and she worries she will never make it to full professor.

Courtney has written several of the articles she needs to earn tenure, but she is having a hard time getting them placed in good journals. She is also overloaded with service commitments. With a joint appointment, her service load was supposed to be 50% for each department, but, in fact, it is more. Courtney is beginning to wonder if the joint appointment was a mistake.

Marie enjoys teaching and working collaboratively with her colleagues, but she struggles with writing. She does everything else first and puts off the writing for as long as possible. When she gets back a rejection or a revise and resubmit, she is afraid to take it out and read the comments. When she does read the comments, she feels paralyzed by the enormity of what is being asked, and she lacks confidence that she is up to the task. She believes that she has something to say and that her research could make a positive contribution to her field, but the anxiety she feels around writing is overwhelming.

Inez holds an endowed chair at one of the best departments in the country. She is a prolific author who is engaged in a number of collaborations with former students, but she has one major frustration. Her potentially field-changing book keeps being shuffled to the end of the line in favor of projects that are more urgent: A former student needs to get an article out to go in his tenure portfolio; a graduate student is going on the market, and this publication will greatly help his chances in a tight job market. Despite having a clear outline of what she wants to do and even a book contract, she just can't get to the one project that she most cares about.

L anding a tenure track position propels the recipient of that job into a high-stakes game. If she plays it right, she can count on a job for life, but, if she fails, she may be out of the running for a position in a career for which she has spent years preparing. The main criteria for tenure at many institutions, research and publications, have no short-term deadlines and are activities that professors are expected to pursue mostly on their own. Meanwhile, faculty members face a barrage of immediate tasks with short-term deadlines and public sanction, such as poor student evaluations, if they are not done well. In addition, there is no guarantee that once the work is done it will be accepted. Grants that take weeks to prepare may not even be scored, and papers may be rejected or returned with requests for time-consuming rewrites.

Faculty members are also working during a period of rapid change in higher education. States have reduced their funding for public universities, and students and parents are increasingly cautious about taking on high debt loads, creating pressure for public and private universities to contain costs (Government Accountability Office, 2014; Kiley, 2013). Departments rely more heavily on adjunct instructors, so there are fewer tenure track positions and more service obligations for those who do make it onto the tenure track. For-profit universities have joined traditional public and private institutions in the academic marketplace, and technology is spurring disruptive change as institutions shift to new models of knowledge delivery, including online and blended classes (Ehrenberg, 2012; Kezar & Sam, 2010).

During this crucial time, many professors are also juggling the care of family members. Women in academia often put off childbearing and child rearing until after graduate school, but with their biological clocks ticking and awareness that fertility problems increase dramatically as women age, they may not be willing to wait any longer to start families. These women are often preparing for and teaching new courses and spending hours on research projects, while at the same time rising early and staying up late to nurse babies and pump milk for bottles to be given when they are at work. Other women may have responsibilities caring for older children, aging parents, or other family members.

Along with these stresses, professors often are not told exactly what is required to "win." A number of papers in well-regarded peer-reviewed publications may be a criterion, but the professor may be left guessing exactly how many papers are required, which journals "count," and how many first- or solo-authored papers are expected. Service and teaching may be required, but again, how much is enough? What scores are needed on teacher evaluations? How can a professor hold to high standards while having to satisfy her student "customers"? If the field values books over articles, will any publisher

do, or does the book need to be published by a certain caliber of press to be acceptable?

While professors are navigating all of this, there are numerous opportunities for even the best laid plans to be derailed. Coauthors may drag their feet on turning around their parts of a paper, careful analysis of data may yield no interesting results, or you may come across a book that makes exactly the argument that you have spent the past year refining. More mundane problems can be equally serious; for example, a hard drive failure that wipes out hours of work, a repetitive stress injury that takes away the ability to type for more than short sessions, or an ill colleague whose schedule must be covered can all eat away at designated research time.

Women in academia continue to face additional challenges compared to their male colleagues. Full-time working mothers put in about five hours more a week on paid and unpaid work than full-time working fathers (Milkie, Raley, & Bianchi, 2009). Women are less conditioned than men to ask for what they need and face greater social sanctions when they do speak up for themselves (Babcock, Gelfand, Small, & Stayn, 2006; Bowles, Babcock, & Lai, 2007). Although salary differences have diminished over time, women at research institutions still risk starting with lower salaries than their male counterparts, and salary inequities are more pronounced at higher ranks (Porter, Toutkoushian, & Moore, 2008). Students expect female faculty members to be more nurturing than their male professors (Tierney & Bensimon, 1996). In predominantly male fields, some women still face outright hostility. Women of color and those from other historically underrepresented groups must also contend with biases related to race, ethnicity, gender identity, and sexual orientation (Castellanos & Jones, 2003; Gutiérrez y Muhs, Flores Niemann, González, & Harris, 2012; Museus, Maramba, & Teranishi, 2013).

Even when tenure is achieved, the challenges don't end. As women become more senior, their service responsibilities grow. They are given roles serving on executive committees, editing journals, and providing leadership for their professional societies. Although these are honors and markers of achievement, they all take time. For women who are also parents, the intensity of caring for small children gives way to the busy activity and homework schedules of older children. Many women who excelled as students and junior faculty members by accepting every invitation and being open and accessible now feel that their schedules are killing them. They often love their work and are proud of their achievements, but something has to give.

Where are you? Are you a newly minted professor who is picking up this book in hopes of getting a strong start on your career? Are you someone who has always been successful but is struggling now that you have a baby or since

the birth of your second child? Are you confident in your work but facing challenges to your authority from students and/or colleagues? Are you someone who loves to write but can't find the time, or someone who has difficulty settling down to write even when time is available? Are you an associate professor whose service roles are getting in the way of completing the manuscript or articles you need to get to full? Are you a department chair who excels at administration but isn't ready to throw in the towel on your own work?

The good news is that you can make changes that will set you up to succeed while still leading a balanced life. In this book I will take you through the techniques and strategies I have used successfully with scores of clients to support them in reaching their goals.

Morgan, whose productivity suffered after the birth of her son, made huge progress by learning to say "no" to requests, being strategic about crafting assignments that don't give her an overwhelming grading task, and being fiercely protective of her time. She has completed and submitted several more publications, and she has a new research project underway.

Courtney, who was struggling to place her articles in good journals, recently scored hits at two of the best venues in her field. She incorporated strategies including using template articles, communicating with journal editors earlier in the process, and seeking feedback from friendly reviewers prior to submitting. She also sought out mentoring on how to handle the politics around the joint appointment and was able to make changes to reduce her service load without losing the goodwill of her colleagues.

Marie, who hated writing, still finds it challenging but is better at reminding herself that she has managed difficult revisions before and can do it again, at setting herself up to work in locations where there are few distractions, and at asking for help when she needs it. When she feels paralyzed, she uses the technique of getting started by committing to write for just 10 minutes. Marie has cranked out a number of papers and revisions and is within close reach of the number she believes will earn her tenure.

Inez, the endowed chair, has become a clear-eyed realist about time. Where she used to say, "It won't take much time," she now tells herself, "*Everything* takes time." This new attitude means that she is much quicker to turn down talks, trips to Europe, and requests for parent volunteers. Inez still does the talks, travel, and school activities that mean the most to her, but even so, she constantly turns down opportunities. Inez has also become strategic about tasks she can give away. She assisted a former student with her grad school applications but assigned another mentee to help; arranged to have her dry cleaning delivered to her office; and asked her brother to do the program for a family event. Inez is still incredibly busy, but she is making

progress on her book, and she thrives on her full schedule now that she has time for the work that she cares most about.

In addition to successfully finishing the books and articles that are needed to achieve tenure or promotion and gaining a sense of mastery over their time, clients have used coaching to rebuild a vibrant research program after a period of drought, finish and publish solo articles that had been taking a backseat to coauthored projects, find comfortable ways to connect with key people in their discipline, practice and implement more powerful speech patterns in meetings and one-on-one conversations, negotiate for salary and other desirable resources, and much more.

How to Use This Book

Although many of you will want to read this book from front to back, I invite you to customize your reading to meet your needs. If, when it comes time to write, you find yourself doing urgent tasks like washing the bathroom grout with your toothbrush, then turn immediately to chapter 2 for techniques on how to deal with writing avoidance. If your research and writing are going well but you feel isolated in a department where there is hostility toward women faculty members, then go straight to chapter 7 for information on how to strengthen your voice and increase your sense of power. At some point, I encourage you to go back and read the rest of the book. Often, professors think they are doing well at issues such as setting boundaries around their time, but as we probe deeper they realize that there is much more they can do to create the kind of work and home life they long for. This book includes numerous stories and examples on which you can draw and thus benefit from the experience of legions of academic women who have struggled to find workable solutions to the complexities of a well-balanced and satisfying academic life.

My work follows the philosophy of co-active coaching, which posits that the coach is not expected to be more knowledgeable than the client in her area of expertise, but to be skilled at helping the client to identify inner and outer resources to meet her needs. Because I have worked almost exclusively with professors for some years now, I have also acquired a large store of knowledge about the issues that are important for the professors with whom I work. My goal for this book is for the reader to benefit both from specific strategies that have worked for others and from the coaching mind-set that will encourage the reader to identify her own best solutions and put them to work in a way that makes sense for her.

What Is Coaching?

Whether called leadership, executive, life, or performance coaching, most of the public has come to understand that the word *coach* refers not only to a person who works with athletes but also to a professional who helps individuals to achieve their career and personal goals. A common question is, "How does coaching differ from therapy?" The arena of physical development provides a useful analogy: A physical therapist helps someone with an injury return to normal functioning, whereas a sports coach helps someone who is already healthy and operating at a high level to attain an even greater level of performance. Likewise, coaches see their clients as people who are naturally creative, resourceful, and whole and who want something more. As a coach, I support my clients to perform at the top of their game. I hold on to their vision and challenge them to think bigger than they might on their own.

How Do I Find a Coach?

I suggest asking colleagues for recommendations. Chances are that people you know either are already working with a coach or know someone who is. Because coaches who work with academics generally hold meetings by telephone or Skype, you do not need to be bound by geographic proximity. Most coaches offer a free consultation, which gives you a chance to explain your goals and challenges and learn how the coach will help you to achieve your ambitions. The International Coach Federation also provides a coach referral service at this link: www.coachfederation.org

Because readers of this book come from a broad range of disciplines, have varying personal styles, and work in different institutions and departments, it is essential that each reader use discernment in choosing strategies that are appropriate for her situation. Even for one individual, solutions that work in one instance may not make sense at a different point in time. When in doubt about how to proceed, confer with trusted colleagues. Chapter 5, "Networking and Social Support," explains how to cultivate mentors and expand your social network so that you will have access to this type of support.

Historically, besides mentors and sponsors, successful men in academia had the support of a full-time stay-at-home wife, as well as secretaries,

research assistants, graduate students, and others. Throughout the book I will ask you to take steps to build a team of support that might include a variety of paid and unpaid helpers and services at home and at work, as well as advisors, friends, and colleagues.

Although many parts of this book speak to challenges that are common to all professors, I also strive to address some of the unique challenges of professors from historically underrepresented groups and the ways those challenges can be addressed by both the affected individuals and their allies. Academic women are not a monolithic group. In recent years White women have made significant inroads at all levels of academic careers, including administration. Unfortunately, the same is not true for women of color.

In 2011, White women composed 39.6% of the U.S. population. They made up 32.6% of all instructional faculty and 41.3% of all executive, administrative, and managerial positions. African American women fare better in administration than in the professorate as a whole, making up 5.8% of administrative positions but only 3% of all professors, although they are 6.8% of the population at large. At 3.4%, Asian American and Pacific Islander women are slightly better represented in the professorate as compared to representing 2.7% of the general population. However, when it comes to administration, Asian American and Pacific Islander women are underrepresented, at 1.9%. Women of Hispanic origin and American Indian and Native Alaskan women are underrepresented across the board. Hispanic women make up only 2% of the professorate and 3.2% of administrators, despite being 8.1% of all Americans, whereas American Indian and Native Alaskan women are 0.2% of all professors and fill only 0.3% of administrative positions, although they make up 0.6% of the population (Ennis, Ríos-Vargas, & Albert, 2011; Rostogi, Johnson, Hoeffel, & Drewery, 2011; U.S. Census Bureau, 2010; U.S. Department of Education, 2013).

Even issues that seem to affect women of all backgrounds do not manifest in the same way for women from different groups. For example, caring for aging parents is a role that falls to daughters more than to sons, but the amount of time spent on this care is greater in cultures that emphasize strong family ties and respect for seniors and may also be influenced by whether there are language and financial barriers that would make it harder to access outside help. Women of Latina heritage have traditionally taken on a larger share of the day-to-day care for aging parents or in-laws compared to their Anglo-American female counterparts. Similarly, African Americans and Asian Americans are more likely to hold traditional values about caring for older family members (Bookman & Kimbrel, 2011; Dilworth-Anderson et al., 2005; Dilworth-Anderson, Williams, & Gibson, 2002; Torres, 1999; Weiss, González, Kabeto, & Langa, 2005).

Having their competency questioned is another issue that many women face, but it's one that plays out differently for women depending on their ethnic and racial heritage. Although White women contend with more authority challenges than White men, women of color are even more likely to have their competence questioned by both students and colleagues. The upshot is that although female academics share some common experiences related to gender, there is great variation in their experiences, challenges, and opportunities.

There are not only distinctions between groups but also differences *within* groups. For example, Asian Americans are often cited as a "model minority," but a person whose family came to the United States fleeing war and political instability in Cambodia is likely to come from a family with less education and fewer resources than a person whose parents emigrated from India to take advantage of educational or economic opportunities in the United States. Likewise, in her chapter "Lessons From the Experiences of Women of Color Working in Academia," Yolanda Flores Niemann (2012a, p. 493) pointed out that foreign nationals who attend U.S. universities often come from upper-class backgrounds, whereas students from historically underrepresented groups who were born in the United States are more likely to come from families with lower socioeconomic status. These differences will influence the outlook and experiences of those students who go on to academic careers.

Each person has a mix of identities and cultural characteristics. The intersections of a woman's various identities interact in complicated ways and present different challenges based on her unique mix of culture, race, sexuality, gender expression, and other characteristics. An example of this complexity can be seen in the experience of political scientist Constance G. Anthony, who wrote about being a White lesbian academic from a working-class family (Anthony, 2012). When she brought up her working-class background in academic circles, others responded with silence, incomprehension, and even denial of her class background. Anthony wrote that when she told a mentor that she was the first in her family to go to college, "he gamely insisted that 'really you are middle class.'" In contrast, she said of her experiences coming out as a lesbian, "no matter the level of acceptance I have received after such a proclamation, I have never been met with silence or told, 'But you are really straight, right?'" (p. 306).

Institutional context also plays a role in the experience of individual academics, so the same person will fare differently depending on the type of institution and even the location of the college or university where she works. The denial of class that Constance Anthony described would be more likely to occur at flagship state universities and elite private colleges than at the less

selective state universities and community colleges that educate a larger percentage of first-generation students. Another example of the impact of institutional context is seen in the experience of Vietnamese American professor Linda Trinh Võ. Võ had won awards for her teaching when she worked at a campus with a diverse student body, but when she moved to an institution where the vast majority of the students were White and had limited previous contact with people of color, she had to contend with hostility from students (Võ, 2012, p. 102). Furthermore, the experience of transgender, gay, and lesbian academics will be impacted by factors such as whether they are at a secular and/or liberal institution or they are at a conservative religious one. Given the diversity of academic women's experiences, this book addresses not only common experiences but also how issues play out differently for women from various backgrounds and of diverse identities.

It is impossible to discuss women in academia without acknowledging the problems posed by the increasing reliance on instructors who are not on the tenure track, because women are disproportionately represented in these ranks. In their work on non-tenure-track faculty, Adrianna Kezar and Cecile Sam found that in addition to the gender difference, it is also true that "the overall trend leans slightly toward racial and ethnic minorities being overrepresented in non-tenure-track faculty positions" (Kezar & Sam, 2010, pp. 41–43).

Non-tenure-track faculty members are a diverse group, including working professionals who teach a course or two, people who choose to work part-time, instructors who have full-time appointments, and, more problematically, people who would prefer a full-time position but instead are piecing together work on a semester-by-semester basis and are living without benefits or job security. My personal belief is that higher education is best served when all teachers earn a living wage and receive "perks" such as time for planning, meeting with students, and staying abreast of developments in education and in their fields of study. Many of the topics covered in this book will be relevant to both contingent professors and those on the tenure track. However, an effective response to the institutional and social forces that have been changing the academic workforce is beyond the scope of what I will address in these pages.

This raises the larger issue of "how things should be" versus "how things are." Many books on women in academia focus on illuminating the problems and inequalities and calling for changes in the institution. Given my education in women's studies and social work and my personal interest in social justice, I am keenly aware of the broad context in which individuals operate and the importance of institutional change. However, in my day-to-day work, I help women who need to make the best choices for themselves and their families given the current circumstances. Although I am deeply

appreciative that others are engaged in scholarship and actions to make academic institutions more welcoming for people from diverse backgrounds as well as more compatible with personal life and balance, the main focus here is on supporting the individual. Still, I can't resist a few suggestions, so I will occasionally present actions individuals and departments can take to support institutional change. Although this book is geared toward women faculty members, much of the information will be useful to both women and men who are striving to succeed in academia while maintaining a semblance of balance in their lives. Graduate students, postdocs, and anyone contemplating an academic career will also find this to be a useful guide.

I want to say a word about the many stories that are included in *The Coach's Guide for Women Professors*. So much of what I have learned comes from the people with whom I've had the privilege to work, and this book includes many anecdotes that are drawn from the experiences of my clients. I took care to change the names and distinguishing characteristics to keep the people who inspired the stories anonymous. Whenever I use an anecdote in which someone might identify herself or himself, I obtained that person's permission. I owe a huge debt of gratitude for the gracious responses to these requests. Another set of stories in the book comes from interviews I conducted with professors and academic administrators. Finally, I share experiences of my friends. When people are named, it is either because they agreed that their real name could be used or because I am writing about a matter that is part of the public record. Any unattributed quotes in the book are from personal conversations with the author.

Now I'd like to turn to you, the reader, and invite you to take a clear look at the challenges you currently face. Please complete the following assessment by putting a check mark next to any items that apply to you. It will help you to determine where you are at present in a variety of areas related to academic success and life balance.

Where Are You Checklist

1. ☐ I never have enough time.
2. ☐ My email inbox contains over 200 messages.
3. ☐ Grading eats up too much of my time.
4. ☐ I have one or more revise and resubmits that are more than three months overdue.
5. ☐ My reviews are always late.

6. ☐ I work on both Saturday and Sunday.
7. ☐ I have trouble falling asleep or I wake up in the middle of the night because I'm worried about everything I need to do.
8. ☐ I don't get enough time with my family.
9. ☐ I wish my spouse handled more of the home and/or child care duties.
10. ☐ I do more of the home and child care duties because I don't trust my spouse to do them well.
11. ☐ As a single parent, I frequently feel like I am shortchanging my work, my child, or both.
12. ☐ The caretaking I do for a family member who is older or ill is interfering with my career goals.
13. ☐ I do everything else first and then write in the time left over.
14. ☐ I regularly interrupt my writing to make time for my students.
15. ☐ I don't think it is possible to write much during the semester. I save writing for summers and holidays.
16. ☐ I put off writing tasks that intimidate me.
17. ☐ My coauthored pieces move forward, but my solo-authored work is languishing.
18. ☐ I'm not sure exactly what the promotion requirements are in my department.
19. ☐ I don't know who is appropriate to include on my list of outside letter writers for my promotion.
20. ☐ My spouse or life partner is also an academic, and we have not been able to find appropriate positions in the same geographic area.
21. ☐ I am proud of my work but am not sure if important people in my field are familiar with my research.
22. ☐ I would like to have more collaborative projects but have not been able to find research partners.
23. ☐ People like me, but I'm not sure if they respect my authority.
24. ☐ I say something in a meeting and no one responds, and then someone else says the same thing, and everyone thinks it's a great idea.
25. ☐ Teaching is a significant part of my job, but the training I received for it was inadequate.
26. ☐ Too many students are not mastering the material in my class.

27. ☐ Since I earned tenure, my service load has increased, and my research is suffering.
28. ☐ I know or suspect that I am underpaid, but I hate negotiating.
29. ☐ My supervisees don't come through or are often late on work they promised to complete.
30. ☐ I took on a leadership role because I had ideas I was excited about implementing, but instead I spend most of my time managing crises.

- If you checked off even a single item on the list, then you are likely under stress, and there are solutions in this book to help you.
- If you checked off any of the items numbered 1 to 8, then you are overcommitted and need help with setting boundaries to protect your time. There are answers to these problems in chapter 1, "How to Have More Time"; chapter 3, "Teaching"; and chapter 4, "Work-Life Balance."
- If you checked off any of the items from 8 to 12, then you are struggling with balancing work with personal life, and chapter 4, "Work-Life Balance," will be especially useful.
- If you checked off any of the items from 13 to 17, then your writing is not getting the attention it needs, and you will find solutions in chapter 1, "How to Have More Time," and chapter 2, "Establishing a Productive Writing Practice."
- If you checked off numbers 18, 19, or 20, then you are in need of more information about promotion and/or an academic job search. Chapter 6, "Tenure, Promotion, and the Academic Job Market," will provide ideas to fill in the gaps.
- If you checked off numbers 21 or 22, then you would benefit from a stronger professional network and can find guidance in chapter 5, "Networking and Social Support."
- If you checked numbers 23 or 24, then see chapter 7, "Authority, Voice, and Influence," for methods to strengthen your authority and get your voice heard.
- If you checked items 25 or 26, then your training neglected sufficient attention to teaching, and you will benefit from the information and resources offered in chapter 3, "Teaching."
- If you checked number 27, then chapter 9, "Life After Tenure," will help you to navigate midcareer challenges.

- If you checked off number 28, then you will appreciate the tips in chapter 8, "Negotiation."
- If you checked numbers 29 or 30, then turn to chapter 10, "Leadership," for leadership strategies.

Regardless of your primary challenges, my goal is to support you in finding satisfaction in your life as a whole. To do her best work, a professor needs to be nourished in all areas. So a writing plan may include not only when and where a professor will write but also how she will fit in time with her kids, for exercise, or for lunch dates with friends or colleagues. Your personal plan for change may also integrate your practice of yoga or meditation, your spiritual or religious beliefs, or your understanding of behavioral change, motivation, or knowledge of project management techniques. Coaching views the client as resourceful and whole and sees the coaching as an act of cocreation. I invite you to partner with me as you read *The Coach's Guide for Women Professors* to craft the solutions that are best for you.

1

HOW TO HAVE MORE TIME

Deirdre was in tears talking to her best friend on the phone. "This is my dream job. I'm surrounded by great colleagues, I have super-smart and motivated students, and I can study topics that excite me, but it's just too much. Every day I'm sure I'll be able to work on my writing tomorrow, and then my day is completely full, and I fall into bed exhausted, and I still haven't opened my manuscript."

Deirdre is a highly competent professional who knows how to do each part of her job well; however, she is experiencing tremendous stress because she can't find enough time. Although I work with people who find writing challenging, many of the professors I support love engaging in their research and writing but can't find time to do it. They have all kinds of responsibilities with near-term hard deadlines. The lecture must be written before students show up for class on Monday, the applications must be read and ranked before the admissions meeting on Wednesday, and the report must be submitted to the granting agency next week. The writing that must be done on their own articles or book is put off until they can find the time, but the time never comes.

The "No's" Challenge

When I get a call from someone like Deirdre, who is eager to write but is drowning in other commitments, the first thing I do is issue a challenge to

find 10 things to say "no" to in the next week. I explain that in coaching, a client can respond to a challenge by accepting, declining, or making a counteroffer. Deirdre was daunted by the prospect of having to find 10 things to turn down, but she made the counteroffer that she would try to find five "no's." I accepted and explained that in addition to obvious "no's" like turning down an invitation, she could count "no's" to herself and delay tactics. Thus, making a decision to use last year's lecture rather than reworking it with updated information, sitting on her hands when her department chair asks for a volunteer to pick up the cake for a retirement party, or telling a student she can't meet this week but will schedule something for next week would all count as "no's."

When we next spoke, Deirdre reported that she had found four items for her "no" list and was contemplating a fifth. She told her students they could skip a reading, which meant that she didn't have to reread the article herself; she decided not to travel over a holiday break to give herself some much needed time and space; she decided against attending a conference; and she chose to skip some parts of a program that her department was sponsoring. The fifth item she was considering was postponing an industry collaboration that would have provided some exciting opportunities for her students.

Deirdre struggled with each of the decisions. She had chosen the class reading because it illustrated something valuable. She recently moved across the country for her position and missed her family back home, so the decision not to travel was a tough one. The industry collaboration depended on connections that had taken her time to forge, and she worried about whether the relationships would hold up if she delayed the start of the program.

It helped when Deirdre identified what each "no" would allow her to say "yes" to. "Yes" to a bit of time for writing rather than class prep, "yes" to getting more settled in her new environment, "yes" to having a good start on her research and teaching before adding on the major logistical challenge of the industry collaboration. As an energetic and creative person, Deirdre was drawn to new ideas and projects and had to grapple with how to prioritize competing demands. However, she was highly motivated to change, because her job and her physical and emotional health depended on freeing up some time for writing, exercise, and adequate sleep.

Although the "no's" assignment is difficult for some professors, others find it remarkably easy once they get on a roll. One professor gained an incredible 16 hours from the four "no's" she found. She declined to judge a science fair, let colleagues handle a hospital orientation visit without her, skipped a committee meeting, and asked her husband to take their sons to music lessons, karate, and soccer practices. You wouldn't want to say "no" to everything that comes your way, but if you can find even an extra hour a

week by looking for "no's," it can make a significant difference in getting out a paper or getting home to your family.

There are certainly trade-offs. A management professor told me I had to be the most expensive coach on earth, because she turned down several lucrative consulting gigs to create time to write. Someone else told me with a laugh that she had skipped a meeting and missed her surprise baby shower. There is no single right answer to how to spend your time, but in these cases my clients wanted the long-term career benefit of time for their research more than the things that they gave up.

In contrast to the difficulty of saying "no" to a well-paying side job, the Internet provides opportunities for easy "no's." Several presidential elections ago, I was working with a professor who is a self-proclaimed news junkie and spent hours reading Internet news sites. After I realized we had similar political convictions, I asked if she thought her Internet news hobby could influence the outcome of the election. "No," she laughed, "unfortunately not."

"Well, if it could," I continued, "I'd encourage you to spend even more time online!" Instead I challenged her to go "cold turkey" and quit the news. She wanted to stay in touch with what was happening and countered with a plan to set her timer for 15 minutes, and when the timer went off, she would turn to her research. When we spoke the next week, she had successfully followed her plan and happily exclaimed, "You've changed my life!"

"Great! Are we all done then?" I couldn't resist asking. We ended up working together for several more years, and she has been highly successful in reaching a number of goals, including publishing articles in top journals and serving as dean of her school, but that simple initial action of limiting her Internet news habit made a huge difference.

Other easy places to save time include forgoing electronic games and online shopping or sports sites and limiting time on social media. If you find it hard to stay away, there are software programs that you can set up to block yourself from specified sites during your work time.

The Internet "no's" are easy and obvious, but there are many legitimate academic activities that you may also want to say "no" to. If peer-reviewed publications are the key to promotion in your field, then invitations for book chapters may be tempting distractions that will eat away at your time without adding much to your CV. All academics do some peer reviewing, and if there is a journal you would love to edit or if you'd like to be in a particular editor's good graces, then there are reviews you will want to accept. But if you aren't completing your own articles, then you may want to look for review requests to turn down. Guest lectures in other departments may also

bring minimum reward. I know a professor who agrees to one guest lecture a semester and is particularly skilled at giving an upbeat "no." If asked to guest lecture when she has already scheduled her once-per-semester gig, she says that she would love to do it but is full up for this semester and hopes they will ask her again. She initially came up with this strategy when she was desperate for more writing time, but then she realized that far from hurting her career, conveying that her time is full actually increases her clout by making it clear that she is in demand.

There are times to make exceptions and say "yes." If you are invited to give a guest lecture in a department that your spouse is courting for a job or the preeminent scholar in your field invites you to coauthor a book chapter, by all means say "yes." The political ramifications of accepting or declining a particular request may not always be clear, so ideally you will develop relationships with mentors who can help with these decisions.

Organizing experts advise people with overflowing closets that they cannot buy any new clothes without finding an equal number of items to discard. We can bring the same concept to our overflowing calendars. One of my colleagues made a rule that he couldn't take on a new activity without choosing a current activity to forgo. So when he was asked to be on the board of his professional organization, he was pleased to accept, but he was also clear it would mean giving up one of his two choirs, despite it being a joyful part of his life.

A helpful coaching question is, "If I say 'yes' to this, what am I saying 'no' to?" And its corollary is, "If I say 'no' to this, what am I saying 'yes' to?" Some of my clients make a computer file that they label "My 'No' List," and each time they find a new "no," they add it to their list. They periodically review the list and bask in the knowledge that all those "no's" bought them many hours of research time. They get excited about finding new items to add, as each one symbolizes more space carved out for their own work.

INTO ACTION

Start a file on your phone or computer labeled "My 'No' List."

This week, find 10 "no's" and write them down on your list.

Continue to look for more "no's," and when you find them, add them to your list.

Review your list periodically and savor all the time you gained by saying "no"!

Delay

Another strategy to gain time is delay. One of my clients agreed to check with me before saying "yes" to any requests. Her colleague sent an email asking for someone to cover a hospital shift, and although she wanted to say "yes," she emailed me first. In the intervening time, another colleague agreed to cover the shift, so my client never had to decline the request. It went away by itself.

Your Own Worst Enemy

Efia, who has a particularly broad network of friends, extended family, and professional contacts, told me that she is constantly asked to do favors such as helping a cousin's friend from Ghana who is applying to her university or meeting with someone about careers in her field. When I asked her to bring the requests to coaching before responding, she was surprised by what she learned. She recounted, "When I started paying attention, I was horrified to realize that sometimes the favors I thought were initiated by others were initiated by me. If I was discussing someone's work and knew about a relevant article, I was saying, 'I'll send it to you.' This gave me one more thing to keep track of and carry out. Now I say, 'Probably if you search under this topic, you'll find it,' and I give them my best guess of what I'd search under. Or I give them the name of the person at the university who can help them, rather than offering to meet for coffee."

Positive "No's"

Language and tone make an important difference when saying "no" to requests. A positive way to say "no" is to grant a request in wish: "I wish I could take on the seminar series, but I just can't this semester" or "I'd love to speak to your department, but I'm full up for speaking slots this year. Please keep me in mind for the future." If your boss asks you to do additional work when you already have too much on your plate, a helpful technique is to ask the person making the request to choose what you should let go of. For example, "I'd love to do that. Because I'm carrying a full load of service commitments, what should I give up to free up the time to take that on?"

How to Say "No, Never!"

Inez, the chair of the English department at a top East Coast research university, is constantly triaging her schedule to identify activities she can skip

or put off in order to find time for her research. Besides teaching, chairing the department, editing a journal, and doing research, she also has a husband and three school-age children. Inez told me, "Last night I spent two hours giving a talk to a Rotary Club meeting at the home of the owner of a local chain of dry cleaners. I can't believe I agreed to do that. But I've known the woman who asked me for years, and she asked me last December, and I didn't feel like I could say, 'No, I'll be busy in June. How about never—is never good for you?' (Have you seen that *New Yorker* cartoon?) But I'm always busy! I need a way of saying 'no' to requests that are for months in the future, where I can't say my schedule is full. It's so crazy. I'm saying no to so many things. I've become invisible to the elementary school; the middle school doesn't even have my email, which has actually caused me to miss knowing that a few things were canceled; I said no to all these talks; and I got out of traveling to Sweden next summer. And here I was giving a two-hour talk at a Rotary Club meeting." (See Figure 1.1 for the *New Yorker* cartoon Inez referenced.)

"It doesn't sound as if it is central to your mission, to what is most important to you," I reflected.

"No, I have a meeting for this charity I'm involved in, and I'm helping my bipolar former grad student get his feet on the ground. I have enough 'do-gooding' that is personally satisfying and important to me. I don't need to add anything."

Figure 1.1 How About Never?

"No, Thursday's out. How about never—is never good for you?"

Note. Mankoff, R. (1993, May 3) [cartoon]. *The New Yorker.* Reprinted with permission.

We brainstormed and came up with this language for future "no's":

Dear X,

Thanks so much for thinking of me. With my busy schedule as chair of the department and my family responsibilities, I am not able to fit in outside talks.

"Maybe I should say that my schedule is just too unpredictable to plan something so far in advance," Inez mused.

"NO!" I countered. "That sounds like an invitation for the requester to come back and ask closer to the time."

"Oh, that's right. I don't want to leave the door open for them to come back to me. Okay, I'll just say that with everything I need to do at work and home, I can't take on more.

"Okay, here's another thing on my plate that's going to take a ton of time. I have this former student who has been out of school for four years, and now she wants to go to grad school. She asked me to help with her essay, and she doesn't have anyone else who would do this for her. She's really bright, and she deserves to get into grad school, but she's been away from the literature for four years, and if I don't help her, she won't get in. But it's going to take me all this time."

"Well, this one sounds much more relevant to your mission than speaking to the Rotary group," I replied, "but I wonder if there is anyone you could assign to assist her? Maybe one of your grad students?"

"That's great. I do have a grad student who I could ask to talk to the student about what other literature she needs to include. I'll still need to do some work to help her shape her essay, but my grad student could get her started, and that would save me some time."

Preserving Leave Time

I often work with people who look forward to the opportunity a leave provides to give sustained attention to their own work, only to find themselves caught up in the tasks from which they are supposedly on leave. Constance, an associate professor of civil and environmental engineering, had an intensive teaching schedule at the start of the winter semester. She got through the grueling weeks of teaching and grading with the thought that once it ended, she would be on leave for the rest of the year and would finally be able to breathe.

Constance did such a great job teaching her sustainable building class that the students invited her to come back and do a guest lecture in another

course, teaching Sustainable Building 2.0. When we spoke the week after the lecture, Constance, who is one of the hardest working and most optimistic people I know, was feeling completely overwhelmed. "Just kill me now," she said. "I can't see how I'll ever get all this done."

It turned out that the students were so inspired by her talk that she had received numerous requests for student meetings. She had added five 30-minute student meetings since we last spoke. I asked, "Aren't you supposed to be on teaching leave?"

"Yes, but I love how passionate they are, and they are making all these connections, and they tell me that I helped them put together things in ways that will take them in really different directions, and they are so excited by that. They don't get that from anyone else."

"When you have these meetings, do they fill you in a way that nothing else does, that brings renewed energy to your other work? Would you do them if you didn't feel guilty saying 'no'?"

"No, I find them exhausting. I really want to be doing my research right now. I find *that* energizing." ·

"So you do a great job, and you're rewarded by all this extra work! Maybe you need to do a crappy job with the teaching!"

"It was such an honor that they invited me. They vote on who they want to give a guest lecture, and it's never been a professor they just had before."

"Well, if you told me that this energizes you and keeps you going, I'd have a different response. But that's not what you said. You said it is draining, and you're supposed to be on leave. You also told me that your son is being a bear lately, and you think that he senses that your patience is razor thin. So it's not just your research but also your family that's affected by all these meetings. Do you have others wanting to meet with you?"

"I think there are about five more requests from students in my in-box."

"Would it help to compose an email response right now?"

"Okay. I'm typing."

Dear X,

Thank you for your email.

I'm very flattered that you would like to meet.

Unfortunately, I am currently on teaching leave, and my schedule of travel, research, and writing allows no time for other activities (and, in fact, my schedule is quite overbooked).

I cherish these kinds of meetings and am inspired by the thoughtfulness and energy of students in this program, so I am truly sorry that I am not able to meet with you at this time.

If it would still be helpful, please contact me next year.

"Wait, strike the part about next year."

"Just say 'no' and don't suggest they try next year?"

"That's right. It's a lovely letter."

"It doesn't sound like I don't care and am blowing them off?"

"No, it sounds like you care a lot and are busy. Can it be enough that you got them thinking about this subject? Maybe your students are resourceful enough to find other ways to move forward with the new awareness they gained in your class."

Alice, the mother of a preschooler and a new baby, was also struggling, but her situation was different because she was on maternity leave. She had arranged child care for two days a week so that she could move papers forward. However, there was a search committee meeting she wanted to attend and a problem with her lab equipment that needed immediate attention, and she wanted to keep her graduate students on track with their research, because that would also result in joint publications for Alice. Between the departmental responsibilities and student meetings, the two days a week were mostly filled.

Alice realized that if nothing changed, her leave time would be over without her making progress on her highest priority articles. She decided to explain to her graduate students that she would not be available to meet with them for the final part of her leave. She framed it positively, explaining that she had stayed engaged in order to get them to the point where they could continue to work independently and that they were now at that stage. She also encouraged them to exchange work with one another and to ask their other committee members for feedback. Alice breathed a huge sigh of relief once she finally cleared space for her own research.

Strategic Use of "Good Enough"

Academia is full of conscientious people who got through undergraduate and graduate programs by giving their all to everything that they did. The problem with being a professor is that you have so much on your plate that you can't give equally to all parts of the job and still complete the tasks that are essential for promotion. This is not just true in the professorate; it is true in most jobs. The upshot is that the most successful professors do not do everything well; they assess what must be done well and what can be done "good enough." "Good enough" might mean teaching well enough to get above average scores on your evaluations but giving yourself a break on grading by assigning two essays instead of three. Rather than updating your curriculum every year, you might update it every three to five years. (This varies by field; for example, in a computer course, a few months could make the technology you are teaching obsolete.) It might be ideal to attend every departmental meeting, but "good enough" might mean missing one on occasion.

How to Keep Teaching From Taking Over Your Life

After spending over 40 hours in the basement of the library grading papers, Suzanne was adamant. "I will NEVER give this assignment again, NEVER, EVER! It doesn't count with the school. Last year I team taught the class and had 100 to grade. This year we added a group, and I taught the class alone, so I had 250 to grade, without a colleague to do half. My in-box was up to 600 emails, and I beat it back to 400. I finally took a long shower and shaved my legs. I am just starting to feel human again."

When Suzanne next taught the class, she wavered: "I'm wanting to cave and do the old assignment, but it would be suicide for a week, and I would hate myself. It's a reflective essay, and the students love the feedback I give them. Last time I wrote over 300 words of feedback for each person. They don't get that kind of personal interaction from anyone else here, and they're so grateful."

I asked Suzanne, "If you stopped being such a hero to your students, who would you be a hero to?"

"My work, me."

"I can see why it's compelling; you get a nice 'hit' of appreciation from your students. Your research doesn't give you that immediate sense of making a difference."

"They are so thankful, and that feels great. But it will kill me."

"Can you give less feedback? I wonder if you can trust the assignment and the value of the course you put together, without your having to give a pound of your flesh in the process."

Suzanne decided to keep a good part of the assignment but make the papers one third shorter. She also reduced the amount of feedback she wrote, keeping the longer comments for the students who did truly exceptional work and being briefer with the rest. It was still a major grading job, and students still loved the class, but Suzanne did not feel quite as spent by the grading. Chapter 3 offers additional strategies for keeping grading manageable.

Teaching Prep

Teaching can easily expand to fill the time available. The most common solution is to do all the teaching prep and office hours on the days that you teach, with other days designated for writing, research, and meetings. Even if you have new classes, extensive reading, or other time-intensive preparation and need to schedule additional prep time, strive to keep a minimum of one day,

and preferably two, that are only for research and writing. An alternative is to schedule uninterrupted research and writing times in shorter sessions but on a daily basis.

Multitasking

Research on multitasking confirms that we accomplish more when we do one task at a time. When we think we are doing two tasks at once, we are actually switching our attention back and forth between various areas of focus. The result of that mixed focus is that we do neither task as well, and the tasks take longer to accomplish (Ophir, Nass, & Wagner, 2009). We are more productive when we structure our activities to prevent interruptions.

You may need to train those around you to respect your time. Lorna complained that when her office door was open, the administrative assistants, students, and colleagues assumed that they could interrupt at will, but they treated the male professors differently. "They assume the men are doing something important and shouldn't be interrupted. It's not fair!"

Despite her frustration, Lorna realized it was up to her to protect her work time, so she started closing her door when she was working. Some months later she happily reported that a shift had occurred. "I think people finally got the message that I am busy. Now I can leave my door open partway, and people are really cautious about bothering me. The secretaries ask, 'Do you have a minute, or should I come back later?' It's so much better."

Because norms vary, you will need to assess your own group's culture and make choices that take into account both your own needs and group expectations. Many people are more productive away from the office, but if the norm is to be in the department, you will want to be strategic about putting in some face time when your colleagues are in the office. If the norm is open doors, you might compromise by leaving your door open just a bit to signal you are present but busy. Another solution is to put a note on your closed door that says, "I am working on a deadline but will be available after 2:00 p.m." (or whatever time you choose). Your students and colleagues don't need to know that the deadline is your self-imposed writing goal and not a grant that is due tomorrow.

Whose "Urgent" Is It?

A major challenge is to keep someone else's "urgent" from becoming our "urgent." This can happen with a chair who frequently sends emails marked "Urgent, please reply immediately" or with students who wait until the last

minute to request a recommendation or ask for help with an assignment. It helps to do some education up front, for example, by explaining to students and colleagues that you stay off email during your designated research hours but will respond within 24 hours. In conversations with people who have legitimate claims on your time, you can add that if something is urgent, you are available by telephone.

Everything Takes Time

We often have a fantasy that some things don't really take time or don't take much time. Earlier, I mentioned Inez, the endowed chair, who kept bumping her head into the same fact over and over again. "I think I can say 'yes' to reading a paper or being a discussant at a conference because it doesn't involve travel and is right here on campus, and I tell myself it won't really take much time. Then I spend hours reading the literature to prepare adequately and realize how absolutely ridiculous it was that I agreed to do that. *Everything* takes time."

Mission

The exercise that began this chapter—"The 'No's' Challenge"—works well if a person is very clear about her priorities. However, to be most effective, it is essential to know exactly *why* you are doing this job and *what* you hope to achieve. Companies and nonprofit organizations get clear about their priorities by writing a mission statement. When considering how to spend time and other resources, they go back to their mission as a way to rank options and make choices. Writing out and posting your mission can be equally useful to you as an individual researcher.

A common mistake in writing a mission statement is focusing on *what* you want to achieve before getting clear about *why* it is important to you. My colleague Fritz Seyferth, a coach and consultant to top-performing businesses and universities, differentiates between first-order and second-order goals. Earning a six-figure salary is an example of a second-order goal. Asking *why* a person desires a six-figure salary gets at the more primary, first-order goal. If you want a six-figure salary in order to be able to spend more time traveling, then a job with a high salary but little time might seem enticing, but it won't help you achieve your first-order goal.

A mission is a very large achievement that has a long-term timeline and encompasses first-order goals. You may have many goals and objectives to reach as part of your mission, but there is generally only one mission. A mission can

be modest, but I encourage my clients to be as ambitious as they'd like when writing out a mission statement. The statement can include both work and personal goals. Some examples of mission statements include the following:

- Engage in research, publishing, and teaching that contributes to our understanding of climate change and impacts public policy
- Conduct and publish basic research that stimulates my brain while raising responsible, happy, and hardworking children
- Run a lab empire with a multi-million-dollar budget that lets me use my analytic and organizational skills while maintaining positive connections with fun, smart people inside and outside of academia

INTO ACTION

Write down your career mission and, if you'd like, your personal life mission. Post your mission in a prominent place (if you'd like to keep your mission confidential, your prominent place could be your bathroom mirror). When making choices about what projects to take on, you can now refer back to your mission.

Mantras

In the book *Mama, PhD*, Jean-Anne Sutherland (2008) told the story of how she got through graduate school as a single mother to her daughter, Savannah, by repeating the mantra "Savannah, Dissertation, Self Care" (pp. 219–220). The "Self Care" was included because it was essential to her performance as a parent and a graduate student. A friend with a sense of humor had her add the tagline "not even a casserole." As a single parent with a young child, if she was going to succeed, she had to constantly remember what was and was not central to her mission. Even a casserole for someone who had a new baby or was recovering from an illness could not fit into her very busy days.

Categorizing Tasks by Urgency and Importance

In *The 7 Habits of Highly Effective People*, effectiveness guru Stephen Covey (1989) laid out four quadrants into which activities can be categorized: (a) both important and urgent, (b) important but not urgent, (c) urgent but not

INTO ACTION

Think of a mantra that supports either your larger mission or a shorter term goal (or both).
Sample mantras include the following:

"Done not perfect."
"Grants and papers first."

Write down your own mantra, and review it first thing each morning for a week.

important, and (d) neither urgent nor important. Some examples from my academic clients follow:

Important and urgent
> Finishing a grant application that is due tomorrow
> Responding to a revise and resubmit for a special issue with a near-term deadline
> Writing a letter for a talented advisee who is on the job market

Important but not urgent
> Finding a data set to use for a new quantitative research project
> Working on your own peer-reviewed articles or book manuscript
> Networking with potential collaborators

Urgent but not important
> Responding to a computer icon that is jumping up and down to alert you that a new email has come in
> Responding to a knock at the door from someone who frequently stops by "just to chat"

Neither urgent nor important
> Playing games on your phone
> Searching for old acquaintances on Facebook

Spending more time on activities in the "important" quadrant reduces the number of tasks that wind up in the "both urgent and important" quadrant. The less you have to work to meet last-minute deadlines, the calmer you will feel, and being less harried certainly creates a sense of having more time.

INTO ACTION

This chapter outlines a number of approaches for how to have more time. Rather than trying to implement them all at once, choose one or two as a place to start. As a coach, I hold my clients accountable by asking them, "What will you do, when will you do it, and how will you and I know that it was done?" Being very specific about your plans increases the likelihood of success.

It often helps to state your commitment to another person and to make a plan to check in after a set period to report on your progress. At the very least, write down your commitment in your planner with a reminder to do a self-assessment after a few days or a week. You may also want to put a reminder on your refrigerator or in your calendar. Once you have had success with one or two changes, you can build on that by making a new change every week or two.

Here is a list of time-saving strategies from which to choose:

1. Find 10 things to say "no" to. Create a "My 'No' List" file, and continue to add to it over time.
2. Set email rules for yourself, such as "no more than 15 minutes on email before I start my work" or "no email before noon."
3. Use timers and/or apps to limit time spent on nonessential Internet activities, including social media.
4. Work in a space where you are unlikely to be interrupted, such as in a library or café or in your office with the door closed.
5. Design homework and tests with an eye toward keeping grading manageable.
6. Limit class prep to the days you teach.
7. Write a mission statement, and use it to set priorities.
8. Use Stephen Covey's (1989) four quadrants to classify the importance and urgency of work tasks.

2

ESTABLISHING A PRODUCTIVE WRITING PRACTICE

Although writing is essential to their success, most academics receive little guidance on how to maintain a productive writing practice. Even professors who enjoy writing experience angst when they face a daunting revise and resubmit or return to a paper that has been languishing. Others tell me, "I don't like to write, but I love having written." Because professors want to present a competent image to their colleagues, many keep writing difficulties to themselves, which leads to feelings of isolation. When I present writing workshops, professors often report that the realization that they are not alone in their writing struggles is almost as valuable as the tips and strategies covered. Academics often assume that their most prolific colleagues are just naturally motivated, and they are surprised to learn that many professors who have achieved prominence also face writing challenges. The difference is that productive writers consistently employ strategies to conquer those challenges.

First, this chapter offers strategies to overcome external obstacles to productive writing. Then, the chapter offers solutions for internal blocks, such as worries about critics tearing the work apart or negative assessments of one's own efforts. Finally, the chapter covers a range of writing topics, including planning, determining how many projects to work on at once, and managing coauthor relationships.

External Obstacles to Productive Writing

"After I Attend to My Other Responsibilities, There's No Time Left for Writing"

If you struggle to find time to write, follow the advice of financial experts to "pay yourself first." It is hard to build up reserves if we pay bills and go shopping first and only add any funds leftover to a savings account. But if we transfer a set dollar amount into savings each month *before* paying others, we still manage to take care of our needs, and our savings will grow. The same is true of writing. Schedule writing in your calendar each week *before* adding meetings and other obligations, and do the writing first thing in the day. If you work on everything else with the thought that you can write in the time left over at the end, that time may never come.

Many people are most energized and alert in the morning. If this is true for you, try to shift meetings and teaching to the afternoon, and use the best part of the day to write. Later in the afternoon, when fatigue starts to set in, it is much easier to answer emails or order books than it is to craft a new theory or analyze data.

"I Don't Have Long Enough Blocks of Time to Write"

In *Advice for New Faculty Members*, Robert Boice (2000) made an empirically based case for writing in what he called "brief daily sessions" rather than binges. Boice studied professors who preferred to write in binges when the mood hit them, as well as those who wrote regularly in shorter sessions. The brief daily writers spent about 7 hours a week on writing, as compared with about 3.5 hours a week that the binge writers spent writing. Even more striking was the fact that although the regular writers put in only twice as much time writing, the number of pages the regular writers produced and the number of manuscripts submitted and accepted were much greater than double the output of the binge writers.

One explanation for the difference is that regular writers don't forget where they were in a project, so they can jump right back into their work. One client said to me,

> *I found some work I think I had done earlier, but I'm not even sure if the words are my own words, since I've been away from it for so long. Sometimes I write on what I think is a new topic, only to discover later that I had written a section on the exact same material earlier. When I work regularly, I don't have any problem knowing what I've already completed and what I need to add.*

Another strong argument against binge writing is that it's not sustainable. I've worked with academics who put themselves on a miserable roller coaster

of binge writing to the point of exhaustion in order to meet a deadline, followed by an illness, then falling behind schedule, then working in a binge to catch up, followed by another bout of illness. With greater physical limitations and more outside responsibilities, most professors can no longer get away with the all-nighters they used in earlier years to meet deadlines.

An additional benefit of writing in regular, moderate sessions is that our minds continue to work on problems even when our conscious focus is elsewhere. Someone is in the shower or out for a run and a solution arrives seemingly out of the blue. But those ideas come only when we have been putting in regular work time.

After reviewing Boice's compelling data, even professors who have resisted regular writing are willing to give it a try, but they ask, "Exactly how long is 'moderate'?" and "How often do I need to write?" Start with an amount that is small and achievable. A scholar who hasn't done any writing for several months might start by writing just 20 minutes three times a week. A professor who has been writing for 60 minutes three times a week might expand to three 90-minute writing sessions. Whatever goal you choose, be sure that it is more than you are currently writing but still an amount that seems manageable. Just as an athlete training for a marathon doesn't run 26 miles her first day out, writers are most successful when they develop a regular writing habit and then extend the length of the sessions over time. People with many competing demands find it useful to have both a writing goal and a sacred minimum. For example, Gretel's goal is to write six hours a week, but on weeks that are unusually busy, she focuses instead on getting in her sacred minimum of at least three hours.

To be effective, your brief, regular writing sessions need to be focused. An easily distracted writer might need to block out four hours to do two hours of writing, whereas someone who stays on target completes two hours of writing in two hours. Timers are a useful way to stay honest about how you are spending your time. A few years ago, clients started telling me about the Pomodoro Technique of time management. Its inventor, Francesco Cirillo, used a kitchen timer shaped like a tomato, so he named the technique after the Italian word for tomato. The method is simple. You set a timer for 25 minutes and then work consistently during that time. When the timer goes off, you take a 5-minute break and then start your next 25-minute stretch. Each 25-minute increment is called a "Pomodoro," and the key is that a Pomodoro cannot be broken up with any other activity. After every four Pomodori, you take a longer break. The technique spawned a small industry of related apps with names like Marinara Timer, Tomighty, and Pomodorable (Burkeman, 2010; Cirillo, n.d.; Henry, 2014).

Building a sustainable practice includes knowing when to stop. One professor relished her sabbatical on the Mediterranean coast, during which she

wrote for eight hours a day, with evenings free to stroll about town and watch the sunset. But that is not typical. I've worked with successful professors who max out at three to four hours of writing and then devote the rest of their day to other tasks. Because there is no "one size fits all" pattern of writing, the trick is to experiment until you find an approach that is both sustainable and sufficiently prolific to reach your goals.

Some authors get on a roll and want to continue to work on their book or journal article even though there are classes to prepare, letters of recommendation to write, and reviews that were supposed to be sent last week. The danger of building up a backlog of unfinished tasks is that the writing will need to be completely dropped while the professor plays catch up, and then she will be right back in a binge pattern of working.

Although authors fear losing their train of thought, stopping in the middle of a section can make it easier to pick up the next time one sits down to work, as opposed to having to figure out what to write next. Some even recommend stopping in the middle of a sentence, because the need to finish a thought gives you an obvious starting point. A helpful practice is to jot down some notes to yourself about the next few steps to take when you return to the project. In *Writing Your Dissertation in Fifteen Minutes a Day*, Joan Bolker (1998) explained that MIT writing teacher Kenneth Skier called the practice of writing notes about next steps "parking on the downhill slope" (pp. 46, 96, 97) because the notes will provide the momentum needed for an easy start.

INTO ACTION

Open your calendar and schedule times for regular, moderate writing sessions for the next week. If you are able to write daily, that's great, but if you have days that are completely booked with teaching or other duties, block out times on at least three of the next seven days. Give yourself at least one weekend day off, if possible. Remember, this is a marathon, not a sprint, and you need rest time to keep yourself energized. Make a note at the end of the week to evaluate your progress and plan times for the following week.

"My Deadlines Are All Far in the Future"

When you choose a grant for apply for, it comes with an automatic deadline; signing on for a conference presentation or a visiting lecture gives you an intermediate goal on your way to a publication; and coauthored projects often have a natural momentum based on deliverables promised to the other

authors. However, writing deadlines don't always come so easily. Grants have deadlines, but there is always the next cycle you can try for in six months or a year. After you have presented at a conference, your article may be nowhere near ready for journal submission and, until it is, the only deadlines are your own. Sometimes a writer looks to a coauthor for motivation, only to realize that the coauthor has more serious procrastination issues than she does. Professors can create a variety of support systems with colleagues to maintain momentum on projects that don't have a near-term deadline.

Accountability partners regularly check in by phone or email to commit action steps and report on progress since the previous check-in. Check-ins can take place weekly, monthly, or even daily. Often these partnerships are two-way exchanges, but they don't have to be. When Joanne was racing against the clock to finish the book she needed for tenure, her colleague Lucy inquired if she could do anything to help. Lucy is a tenured professor in another field, so Joanne wanted her respect but would never need her vote for promotion. Joanne asked if she could commit to sending book chapters to Lucy by specified dates and explained that it didn't matter if Lucy read her work; she just needed to know that someone was expecting it. This structure was key to Joanne completing a prize-winning book in time to earn tenure at a top research university.

Another kind of accountability structure is the writing date, in which two professors meet in a mutually convenient spot where they each work silently on their own projects (Toor, 2008). People who blow off commitments to their own writing will show up when they know a colleague is expecting them. The writing date can occur anywhere from a café to a conference room, but for chatty colleagues who are in danger of talking instead of working, a quiet library is a better choice. Some professors think they can't work away from their home or office because they need to have all their books on hand. Most people *can* write without every last source as long as they notate where they need to add a citation or fill in a paragraph at a later date. A group version of the writing date is called a "write-on-site" group.

"I Don't Get Enough Feedback"

Many of my most successful clients send articles to journals only after they have undergone friendly reviews by supportive colleagues. A step beyond friendly reviews is seeking input from an expert in your area, even if you fear that person as a critic or a competitor. Some say it is *especially* important to seek feedback from potential critics and/or competitors. Acknowledging their expertise and incorporating their input may positively impact their view of your work. Work that goes to an expert should be more polished than that which goes to a close friend or colleague. In one writing group, members put

percentages on the level of completion their work needs to achieve for various audiences. They lightheartedly agreed that their writing group is okay with 40% completion, whereas friends from graduate school need 60% completion, senior colleagues need 80%, and work going to an expert in the field must be above 90% polished.

Most often the mistake academics make is to wait too long before asking for feedback. If you spend hours wordsmithing beautiful sentences, and the feedback persuades you to reframe the whole section, you will have wasted a lot of precious time. Academics sometimes worry, "If I show someone my ideas before they are fully developed, they will conclude that I am a second-rate scholar." This fear is usually alleviated when people are selective about whom they ask, and they explain to the reader that they are experimenting with sharing work at an earlier stage than they have done in the past. Another risk in sharing work is that someone will take your ideas and publish them before you do. If there is good reason to worry that someone will scoop your project, only share your writing and ideas with those you trust unequivocally.

Writing groups offer the benefits of both deadlines and thoughtful feedback on the content of your work. A group may include members of

LEARN MORE

How to Ask for Feedback

When I advised asking for more feedback, Geri replied with frustration, "I'd love more input, but everyone I ask tells me they don't have time. Or they say, 'Looks good,' but they don't provide any substantive feedback. I can't even get my best friend, who works in my department, to respond to my work."

If you are lucky enough to be in a discipline where sharing work and offering input are part of the culture, this might not be a problem, but what if it's not a common practice in your area? Here are some approaches that have worked for my clients:

1. Hand colleagues a section and ask what they think. One professor found that when she asked her colleague if he had time to read something, he said "no," but when she gave him a couple of pages and asked for his thoughts, he responded immediately and graciously with insightful comments.

2. Send a short section rather than the whole manuscript, and ask very specific questions. Colleagues are often more willing to respond to short sections and to provide targeted feedback.

3. Give readers the option to discuss their comments in person or by phone or Skype. Some people who are daunted by the thought of writing up extensive feedback are glad to get together for coffee or a meal and offer their responses verbally.

4. Offer a trade: "If you'll read my article and give me your thoughts, I'll promise to do the same when you're ready for feedback on your current work."

5. Ask for feedback from people who are rising stars but are not yet universally known. These people will have content expertise but are not as inundated with requests as more established names in the field.

6. Don't take it personally if someone you ask says "no" or someone who agrees to read never gets around to it. Your colleagues have their own time-management challenges. Move on and ask someone else.

a specific discipline, or it may be multidisciplinary. There are advantages and disadvantages to each group type. Because many journals have audiences from multiple constituencies, an outside perspective can be valuable for understanding how readers will perceive your work, but those from other disciplines won't be able to suggest alternative sources or recent works that you may have missed. Scholars within the same area bring subject expertise and awareness of the writing conventions in the field, but they may overlook jargon that will be confusing to readers from outside the discipline.

Writing groups often serve multiple functions. In addition to deadlines and feedback, members receive reassurance that others face similar challenges,

INTO ACTION

How to Start a Writing Group

1. Limit groups to three to seven members. For the group to succeed, everyone will need to commit to regular attendance. A smaller group gives each member more turns to share work and receive

feedback. A larger group provides a broader range of input and is easier to sustain if members have travel schedules or other activities that periodically interfere with attendance.

2. Invite colleagues personally or send a notice out to a broad group of academics announcing a time and place for an organizational meeting.

3. Agree on a page limit for the work that will be shared. You can accept an entire journal article or book chapter or limit reading to 5 or 10 pages to keep the workload manageable.

4. Agree on a deadline by which work must be distributed to allow everyone time to read and jot down feedback. Authors should let readers know what level of feedback they are seeking and any specific questions they are hoping the group will address.

5. Set up a schedule for presenting work, with one or two members receiving feedback at each meeting.

6. Appoint a group facilitator to keep the group on focus so that it fulfills the intended purpose and does not become a social club.

7. Set a positive tone by starting with a round of what members like about the piece before turning to constructive criticism.

8. Remind members to couch criticism supportively and to own their personal opinion rather than make declarations of what the writer "must do."

9. Allow authors to choose whether they will bring revised work back to the group. This allows writers to receive feedback without any obligation to incorporate ideas with which they disagree.

For more detailed instructions, including lists of readers' and writers' responsibilities, and questions to consider when reading a draft, I recommend "Appendix A: Organizing a Writing Group" in Elizabeth Rankin's (2001) book *The Work of Writing.*

get the moral support of people who cheer on their scholarship, and have a network for learning about grants, talented student assistants, and other resources and opportunities.

Some people eschew writing groups, concluding that the feedback they receive is not worth the time spent responding to other people's work. An alternative is a two-person exchange. This limits the input to one source but ensures that 50% of the time you are receiving feedback on your own scholarship.

A book conference is a one- or two-day workshop in which several scholars read a full draft of a manuscript ahead of time and then meet to discuss its development and placement with the author. Although a book conference can take place with colleagues from an author's own campus, some departments provide funds for authors to travel to meet with outside experts or pay an honorarium and travel costs to bring a scholar to the author's home campus to take part in the book conference. You can ask your chair if your university offers funding to set up a book conference. Generally the author selects the readers in consultation with her publisher, chair, or other advisors.

"There Is So Much Literature to Read, I Can't Keep Up"

A difficult aspect of managing a large writing project is determining when to stop reading and start writing. Marketing professor Aaron Ahuvia said, "There are two kinds of professors, those who read and those who write." He went on to explain,

> For most people, reading too much is more of a problem than not reading enough. Reading is interesting, it is easier than writing, and there are a huge number of things to read. Fifty years ago it was possible to keep up with the reading in one's field. With the advent of the information age and the huge proliferation of journals online, this is no longer possible. Women are particularly prone to have an imposter complex and want to over-read to prove that they know enough and belong, when compared to men, who more often feel that the world is entitled to their opinion. For professors at top research universities, the proliferation of journals makes it even more important to be published in the very best journals, because they are curated. The difference in the amount of work required to publish in top tier versus middle of the road venues is enormous, and professors need to find a way to manage the workload.

Ahuvia advised,

> Only read the good journals. Read the papers in the journals you intend to publish in, and then stop. Don't read the other stuff. It's too much. Think of journals like a funnel: Read the best most broadly, and as you go down in quality, only read the things that are right on target for your topic. Reviewers love to tell people they need to read x, y, and z. I do just in time reading—I don't read it until I need it for the next paragraph I am writing. If you miss a big chunk of the literature, you might get dinged, but if you just miss one article, don't worry, the reviewers will tell you.

Professors often complain that when they go into the literature, they feel like Alice falling down the rabbit hole because they are easily lost or distracted by irrelevant information. One strategy is to write out questions you hope to answer through your literature search, so that you go to the reading in a more directed manner. Another technique is to "write then cite." Work out what you have to say and then go back to the literature to find supporting material.

Internal Writing Blocks

Framing the Process of Writing

When Caroline contacted me for coaching, she explained,

> *I have this paper that I was working on when I was denied tenure at my first job. I never completed it, and now I have a bunch of other articles I want to publish that refer back to that article, so I need to get that paper out to open up the bottleneck. But I have such negative feelings about this paper—I think of it as "my failure paper."*

After hearing her story, I replied, "Wow. No wonder you don't want to look at that paper. Sometimes people find it helpful to come up with a metaphor as a way to shift how they feel about a project. Is there a way to think of this that would be more inspiring?" After some brainstorming, Caroline decided to imagine herself as the protagonist on a heroic quest to conquer the paper. Once she adopted this new attitude, she completed the paper in just a few weeks.

The first time I asked professors in a writing workshop to think of a metaphor for the process of writing, they immediately began offering images such as pushing a boulder up a hill or being sucked into a black hole. "No, no," I clarified. "I want you to think of a *positive* metaphor." The group succeeded in coming up with more appealing metaphors, but the initial negative imagery they associated with writing was telling. Who would be eager to engage in such an excruciating and hopeless undertaking?

When I asked one client if writing could be fun, she replied, "No, I never thought of writing as being fun. It's drudgery." This academic is a well-organized person who breaks down her topic into its component parts, outlines, and then fills in the material for each section. "When you describe your writing process," I told her, "I think of a puzzle." "That's funny," she exclaimed. "I love puzzles. In fact, when I finish this project, my husband promised to buy me a special mat that I can use to roll up my jigsaw puzzles so I can put them away when I'm not working on them."

"Well, I wonder if you would enjoy the writing more if you pictured putting the pieces together with the same sense of discovery that you bring to working on a jigsaw puzzle," I said. She agreed to give this a try, and I asked if she could post a picture of a jigsaw puzzle as a reminder.

"Sure," she replied. "In fact, I subscribe to a jigsaw puzzle catalogue, so I can post one of the catalogue covers on my office wall." She found that the visual reminder helped her to take more pleasure in putting together the pieces of her work.

The most effective metaphors connect with activities the author enjoys outside of academia and encompass both challenges and rewards. Mountain climbing combines a difficult hike with dramatic views, and runners have to push through pain to get a "runner's high." A professor who hated editing came up with the metaphor of thinning plants in her garden. She removes perfectly healthy plants in order to create enough light and air for those that remain. When she needs to cut ideas from her papers, she now thinks about providing more space for her other ideas to be seen and to flourish. She also moves the cut sections to a file of unused ideas, mindful that they can be "planted" in future articles.

INTO ACTION

Identify your own metaphor for the process of writing. If nothing comes to mind right away, discuss this assignment with a friend and play with different ideas until you come up with a metaphor that is right for you. Once you've chosen your metaphor, find a representative picture to post in your writing space or use as a screensaver. However, if you spend more than 10 minutes finding a picture, you are procrastinating and should turn back to your writing!

Responding to Difficult Reviewer Requests

> *I have this R&R that has been sitting for much too long. I don't even know whether the editor will accept it as a revision or if I'll have to submit it as if it were a new manuscript. I'm afraid to even look back at the comments because, when I read them before, the changes the reviewers are requesting seemed impossible.*

Most often, revisions that seemed insurmountable upon first reading turn out to be manageable after all. Because the first reading is often overwhelming, a crucial action is to set the comments aside *but only for a day or two.* When you make a second pass through the comments, code them into different categories, and note the issues that are the "low-hanging fruit" and can be easily addressed and those that will take more thought.

Although you do need to send the revised article back with a letter that addresses every point that the reviewers raised, you may not need to follow every suggestion. If you are asked to make changes that would involve many months of additional data collection or that are impossible given the parameters of your study, don't immediately give up or take on a time-consuming new project. Consider if you can satisfy the reviewers by justifying the study as it was done and attending to their other concerns. When in doubt, consult with an experienced colleague. Authors often tell me that they or a colleague arrived at an easier fix for an issue they initially feared would be a huge time sink.

Managing Rejection

Like difficult revise and resubmits, people often procrastinate on reworking papers that have been rejected because they feel demoralized. In *How to Write a Lot : A Practical Guide to Productive Academic Writing*, Paul Silvia (2007) pointed out that the most prolific authors are also the ones with the most rejections: If you are not receiving frequent rejections, you are probably not submitting enough manuscripts. A useful strategy is to decide on a "plan B" before you send your manuscript in for review. If the paper is rejected, you can then immediately begin to revise it for the next journal on your list.

LEARN MORE

For those in the social sciences and humanities, Wendy Belcher's (2009) book *Writing Your Journal Article in Twelve Weeks: A Guide to Academic Publishing Success* is an indispensable resource that a number of professors I work with have used to rework their articles and place them in good journals.

An astute professor said, "All papers are boomerangs. You throw them out into the world, and they boomerang back to you. If you are lucky, the paper boomerangs back as a revise and resubmit, and then you go through multiple iterations until the reviewers are satisfied. But the process is not really that different when the paper is rejected, since you still need to revise, send it out to a new journal, and continue the process."

Disarming Gremlins

As I start to write I'm thinking, "Oh my God, I only get a sabbatical every seven years, and my family is suffering because I'm away from

them, and I'm already letting them down. There's no way I will be able to complete the projects that I wanted to finish, and I've already let them sit for much too long." (a full professor at a West Coast university)

I don't remember how to do this kind of writing anymore. I keep getting credit for my bluffing, but I haven't done anything I'm proud of lately. I've lost the basic criteria for membership of this society, whose membership my career depends on. I looked at what I recently wrote, and mostly it's mundane. (an endowed chair at a major research university)

When professors suffer angst about writing, they often feel as if they are alone in their struggle, but it is a normal reaction to the pressures of academic work. In coaching parlance, we call those negative thoughts "gremlins." I've come to think of those gremlins as being well intentioned in communicating their fears. The gremlins know that there is danger out in the world, and they want to protect you from it. If you go back to bed, they reason, you don't have to risk your ideas being rejected or criticized. Most people find that when they argue with the gremlins, they become louder and more insistent. Instead, I suggest treating the gremlins kindly, as you might treat an older aunt who worries about you. Thank them for their concern for your well-being, and then go back to work. One writer thinks of the gremlins like an anxious child interrupting her writing. She pauses to give the child some quick reassurance and then lets him know that she needs to return to her project. For most people, this isn't something they do once and are done with but a thought process they have to repeat regularly. Over time, the gremlins' volume and the frequency of interruptions diminish, but they still might be stirred up when a project is in a difficult stage or when the writer is tired or stressed.

For many people, the gremlins are loudest before they actually start to work. A great tool for getting through anxiety or procrastination is to set a timer for a very short period. Most people are willing to write for 15 minutes even if they can't imagine writing for an hour, but once they get started, they become engaged in their project and find it easier to continue.

People sometimes ask if they should give themselves a reward once they complete a goal. I caution against this, because working toward a reward (extrinsic motivation) actually reduces intrinsic motivation (Deci, Koestner, & Ryan, 1999). Instead, focus on how the project fits with your mission, what the work means to you, whom it will help, or which aspects of the project you enjoy. Those things will be more motivating in the long run.

Quieting Internalized Critics

No matter what I write, someone will say, "Well, what about this literature? Why didn't you do this other type of analysis? You can't really draw that conclusion from your data. Your data collection method was flawed." (a junior faculty member)

It is helpful to distinguish between the global concerns of gremlins and the very specific commentary of internalized critics. Academic authors want to consider how experts in their field will analyze and judge their work so that they can address those issues thoughtfully. However, a problem arises when the writer is in an early stage of drafting, and she is constantly bombarded with thoughts of how others will tear her work apart. She is likely to go into a tense and defensive writing mode that makes it difficult to think creatively. In *Bird by Bird: Some Instructions on Writing and Life*, author Anne Lamott (1995) encouraged authors to write "shitty first drafts" (p. 21). The shitty first draft is your chance to have a go at the subject without worrying about what anyone else will think.

It isn't always easy to set aside the critics. Some people imagine shrinking their critics down to a tiny size and putting them in a box while they work. Even if the critics yell at the top of their lungs, they are too small to make much noise. When their input is desired, the critics can be brought back to full size so their perspectives can be considered. One professor imagines her critics as beautifully carved stone statues that she places carefully in the closet. She respects the wisdom of the statues and can take them out to hear their perspective when she is ready for them, but as long as they are frozen statues in the closet, she can write more freely.

The benefit of expert feedback is worth another mention here. Scholars often slow down or stall out when their work incorporates topics outside of their primary area of expertise. They worry, "What if I get it wrong or leave out something obvious and important?" If the scholar is working in isolation, these concerns can lead to seemingly endless reading of more and more literature, procrastination, or endless rewrites because of the fear of making an embarrassing error. Asking scholars with more expertise to review your work and check for any errors or gaps provides a safety net that will allow you to move forward with greater ease.

Another technique is to imagine a friendly audience in the early stages of the writing. Pilar chose her graduate students as her imagined audience, because they are at a high enough level to follow her argument but are respectful of her expertise. Others write early drafts to friends from graduate school, a colleague who has expressed admiration of their work, their spouse, or a supportive mentor. They may or may not actually send the writing to

those people, but they find it helpful to have the friendly audience in mind. Once an early draft is completed, the writer brings the critics back into focus to address likely points of debate and strengthen her argument.

How to Plan Writing Projects

Backward Planning

When Dr. Jean Waltman was directing the Junior Women Faculty Network at the University of Michigan, she told me, "Professors come to me in the year before they go up for tenure, and they are in a state of panic. I'd like to get to them earlier in their careers and have them work backward from the time they will turn in their tenure portfolio, so they identify what needs to be in place one year out, two years out, and so forth. This would save people a lot of grief." Jean's suggestion became a key part of my writing workshop, and backward planning turns out to be useful for both tenured and pretenure faculty members. Although professors are often daunted when they first lay out this plan, they appreciate the clarity and realism it provides.

INTO ACTION

Setting Goals and Timelines

1. Consider a long-term goal. It might be going up for tenure or for full professor or completing an important project. Write down the date by which you would like to meet this goal.
2. Write down what you want to have accomplished by your goal date. This might be the articles and/or books you want to have in your tenure portfolio, the items you want on your CV when you go up for full, or a clear and detailed description of what your finished project will look like. Be as specific as possible. If you know the titles and topics, write them down. Include the number of publications. How many single authored versus coauthored? How many chapters will be in your book? What will each chapter cover?
3. Work backward to one year before your goal date. What must be done by this time? Write it down. Consider the possibility of obstacles and setbacks. Build a time cushion into your plan that takes these into account.
4. Continue to work backward a year at a time, and write down what must be done two years out, three years out, and so on.

5. Write each year's goals in your planner including those for one year from today.
6. Consider what you would like to have accomplished in six months. Write these goals in your planner six months from today
7. Consider your goals for 90 days from today. Make a note of these goals in your planner for 90 days out.
8. Write a reminder in your planner one year from today to write down new 90-day, six-month, and one-year goals.

New professors may not know how to determine a reasonable timeline. Your chair or a mentor can be enlisted to help you identify realistic goals to reach by the end of your first year, the end of your second year, at the time of your third-year review, and when you go up for tenure. Some respond to the timeline with frustration, saying, "Big deal, so I made another plan. I'm good at planning. The problem is in executing. Something always goes wrong and throws my plans awry, so now I don't even bother." Another common concern is, "How can I determine how long a project will take? I really have no idea how much time I should budget."

Planning as an Iterative Process

For those frustrated when their plans go awry, a key principle to understand is that planning is an iterative process. One plans, executes, evaluates progress, and then plans again. Planning a research project is like navigating with a compass rather than a map. Following a map is straightforward. Although we have to account for detours and traffic jams, if we take the lefts and rights where indicated, we can predict about when we will arrive at our destination. Finding our way with a compass is different. We check our compass and set off, but we may come to an impassable river and need to change direction until we find a crossing. Once we get over the river, we reset the compass and head off again. Research is both more exciting and more frustrating than following a set of directions, because the outcome is not known in advance. The unpredictable nature of research projects does not negate the need to plan. Rather, it requires researchers to regularly reevaluate and readjust their plans. Instead of throwing up your hands when things change, revise your plan in light of current realities.

Estimating a Project Timeline

Although project planning is an inexact science, the following strategies can help:

1. Ask experienced colleagues how long they estimate a research task new to you will take.
2. Look for opportunities to carry out two or more parts of a project simultaneously. Write up your methods section or the literature review while you are still collecting data. Ask a coauthor to write up one section while you are working on another. Overlapping tasks will shorten the total time to complete the project.
3. Limit the scope of your project. If a complicated paper can be broken up into two articles, the result is that your work goes to press sooner, and you will get an additional publication out of the research. If a book project is beginning to become unwieldy, consider whether some of the material belongs in your next book.
4. Build in a cushion of time to deal with the unexpected.

How Many Projects at Once?

Although this varies from person to person, many people seem to be able to handle three writing projects simultaneously. I recommend always having one project that is on a "fast track," getting your prime writing time and being the first project you pick up in the day. I've worked with professors who are attempting to manage too many projects, with the consequence that nothing is ever finished and published. Because there will be inevitable delays in receiving feedback or waiting for a coauthor's analyses or delinquent reviewers, it is ideal to have other projects at various stages that can be picked up when there is a lull in your primary project.

Communicating With Publishers and Editors

If you are not sure how to choose the best publisher, start with an inventory of your bookshelves to see which publishers are active in your core areas of interest. Once you have selected a few potential publishers, ask colleagues who have worked with the presses on your list to make introductions. You will also want to meet with publishers at conferences. Publishers who attend disciplinary conferences are there as much to seek out authors and learn about new trends as to sell books, so they are very open to talking to professors about their writing projects. It is helpful to start talking to publishers early in the process rather than only after completing a polished draft. The publisher may have useful ideas about topics to cover or leave out, as well as knowledge of the marketplace. If the entire manuscript is completed when your publisher suggests broadening or narrowing your focus or making other substantial changes, you will have to discard much of your hard work.

Disciplinary society conventions often incorporate sessions about their journals and sometimes "meet the editor" events. The general sessions provide valuable information on what journals are looking for, and one-on-one conversations with editors are a chance to promote your specific project and receive guidance on developing and placing your article. The editor might let you know if your article is appropriate for his or her venue, give suggestions for the piece, or even suggest a special issue that would be a good fit for your work.

Wendy Belcher (2009) suggested a query letter as another method for communicating with editors. In the query letter the author describes the piece and asks if it sounds like a good fit for the journal. Sometimes authors hear nothing back or receive a very general response; however, some editors will let the author know if a piece is not a good fit, saving the author both the effort of framing the piece for that journal and months of waiting for a decision. Another possibility is that the editor provides feedback that, although brief, is akin to the kinds of suggestions reviewers would offer. Belcher (2009) wrote,

> Some editors will even give you a mini-peer review by sending you a response such as, "Your article sounds very interesting, although we usually only publish quantitative articles" or "It sounds like your article would be suitable for our journal, although your sample size might be a problem." (p. 131)

The author can then make changes based on the feedback or submit elsewhere.

Whether writing a book or revising an article, much can happen to throw an author off her schedule. When this happens, the most important thing is to keep everyone who has a stake in the project apprised of one's progress. Very often deadlines can be negotiated and extended. Even if a deadline cannot be changed and the author needs to withdraw from that particular opportunity, she will have more peace knowing that she was forthright about the situation and did not hold up the rest of the project.

Coauthors

I've been iterating with Sanjit on the Traits Paper, and it's almost done! That guy is amazing. I don't think he sleeps at night. He gives me something to revise but then the next day tells me, "I went ahead and took a stab at it; what do you think?" And the thing is that he's not just fast; the work he does is high quality.

Working with coauthors can be invigorating. At their best, collaborations solve many problems that arise with single-authored writing. Writers often find it easier to keep commitments to coauthors than to stick to deadlines set only to themselves. Coauthors may have complementary skill sets. A senior professor in a social science field explains, "There are a surprising number of people who are good statisticians but who can't write well. They need to publish too, so they are grateful to enter into collaborations." Although many nonnative speakers have impeccable written English, those who don't may find it helpful to team up with a coauthor who brings English proficiency while the nonnative speaker provides analytical skills. Some authors are particularly adept at theory or framing the article in the literature, whereas others have expertise in a related field or a specific technique. Even when nothing is needed from a colleague, the process may be more fun when colleagues can think through ideas together. Inevitably, though, there are times when coauthor relationships become difficult and must be managed. Some examples of challenges my clients have faced and some possible ways to handle them follow.

Student Coauthors

While struggling to revise a student-coauthored paper that was in poor shape, Alexandra realized that although she had a good rate of acceptances on single-authored articles, those she cowrote with students were frequently rejected. She had always encouraged her students to take the lead on their papers, as she had believed this would provide them with an optimal learning experience. Alexandra reconsidered this strategy when she became aware of the discrepancy in acceptance rates. Although her own advisor had given her considerable responsibility and autonomy, Alexandra realized that most of her students were not prepared for that degree of self-reliance. Instead, those students could learn through her example. She also realized that when someone else put together tables and figures, she didn't have the hands-on interaction with the data that she needed to do her best thinking. She decided to ask the student to send her all of his material, including the raw data, and after putting the paper together in a way that made sense to her, she finally landed it in a journal. Realizing that students are not ready for the level of independence that they handled as students is a common experience among the professors with whom I work.

Slow-Moving and Unresponsive Coauthors

Before embarking on a collaboration, do your best to gauge the other person's work habits. Some senior scholars are desirable collaborators because

they bring expertise and connections, but others are overcommitted and lack a sense of urgency. One professor suggests that the best coauthors are people who are not yet tenured but have proved themselves by hitting the top journals. He explained, "They are early enough in their careers to be eager for publications and they are serious workers, but they are not as inundated with requests as the more established stars in the field." But despite your best efforts to vet your partners, there will be times when coauthors are not moving at the pace you would prefer.

Some tips to keep coauthored projects moving forward include the following:

1. Send an email informing the group that everyone who wants to have input should respond by a specified date, after which the paper will be sent. This works well when there are multiple authors on a project and one is not responding to requests for feedback.
2. Arrange time to work face-to-face with your colleague. This could include stopping by the office of a coauthor who works at your university or, if he or she lives out of town, planning a working visit. If your colleague lives across the country or the ocean, plan for you both to arrive a day early or stay a day late at a professional conference in order to work together.
3. Increase involvement of those outside your physical proximity by scheduling a few days or a week to do a "blitz" on the paper. During this time the work is divided up, and all authors agree to be fully available to work on their assigned sections of the paper and to respond immediately to any iterations that are sent their way.
4. Use a cheerleading approach to motivate your team. You might proclaim, "I think we can get this out by the end of the month. How about if I handle the reframing of our argument, Joe adds the literature the reviewers suggested, Sue works on the discussion section, and we meet again in two weeks?" Coauthors will often respond to your energy and optimism about bringing the work to completion.
5. Have several projects underway at all times. If collaborators go AWOL, you can turn to other work until they resurface.

Coauthor Disputes

I'm so angry! I spent hours working on the revision and then my coauthor threw out all my text and revised it his way.

Tamiko and I are in agreement, but Ken insists that a different inter-pretation is the correct one. He is just plain wrong, but I don't know how to resolve this.

I think the paper is ready to go, but one of my senior coauthors keeps coming up with one more thing he wants us to do. If this doesn't go out soon, I won't be able to include it in my tenure packet.

As in any relationship, there are plenty of opportunities for research collabora-tors to disagree. These relationships are further complicated by differences in seniority and status. The following strategies for managing coauthor conflicts have helped my clients to resolve conflicts or even avoid them in the first place:

1. Agree on a general outline for a paper *before* you start writing. This will reduce the chances of spending significant time and energy writing text that your colleague decides to discard.
2. If you disagree on how to run the analysis or interpret the data, identify a neutral third party to consult and then agree to abide by his or her opin-ion. If you are senior to your colleagues, you may decide to pull rank and explain that because of a short time frame and your greater experience, you are going to make the call. If you are a junior member of a team, proceed with caution when disagreements arise. If possible, allow a more senior colleague who shares your view to be the spokesperson for your way of thinking.
3. How to best handle a colleague who is not ready to let go of a revision depends on the situation. If your coauthor is senior to you and has a strong publication record, you may want to take a deep breath and follow her suggestions until she deems the paper complete. If you know your coauthor is overly cautious, and you have a great relationship or equal or greater rank, you might argue for submitting the paper and using the review process to revise further.

Author Order Disputes

Author order has different meanings in different disciplines. In most social science and humanities disciplines, the first author is the one who made the largest contribution. In some fields, such as economics and mathematics, the norm is to list authors alphabetically, and in some of the sciences, the prin-cipal investigator is always listed last. Disputes over author order most often arise when the topic is not explicitly discussed ahead of time.

Some tips for avoiding and resolving author order conflicts include the following:

1. Learn the guidelines for authorship in your field, including what kinds of contributions deserve authorship versus acknowledgment.
2. Discuss author order and division of labor up front to avoid later misunderstandings.
3. Discuss any potential changes before taking action. If the planned first author is tied up with other responsibilities and you have time available, check if he or she would like to switch authorship to get the paper out sooner or prefers that you wait until he or she has time for the project.

LEARN MORE

Former Harvard psychology professor and dean Stephen M. Kosslyn (2002) devised a point system for determining authorship in his lab. The criteria are shared before the project starts. When the research is near completion, but before the paper is written, everyone shares his or her self-assessment based on the criteria. If someone is close but does not quite meet the threshold for authorship, she or he will then be invited to take a larger role in writing up the work or analyzing the data, which allows him or her to get the points needed to become an author. Kosslyn's criteria for authorship can be found at this link: isites.harvard.edu/fs/docs/icb.topic562342.files/authorship_criteria_Nov02.pdf

3

TEACHING

At major research institutions, masterful teaching alone will not earn a professor tenure, but weak teaching can derail a tenure case even if the research record is strong. At teaching colleges, professors are expected to excel in the classroom while still producing original research and doing service. Although some receive support and mentoring for teaching as part of their graduate training, many are thrown into the classroom to sink or swim. Even for experienced teachers, classroom dynamics are unpredictable—in the best circumstances, there is passionate engagement by both students and teachers around the subject of study, but sometimes teachers must contend with students who challenge their authority or competence or, even worse, do not engage at all. My goals for this chapter are to increase your confidence and effectiveness as a teacher and provide strategies to manage the workload. Topics covered include assessment, classroom climate, student engagement, online and blended classes, efficient grading, students' biases, and support resources for teachers.

What Is Assessment of Student Learning, and Why Should I Care?

Research on learning has established that students learn best in classrooms that require active involvement with the material and that even in traditional lectures, students retain more information when instructors include several brief opportunities for students to interact with one another about the material (Freeman et al., 2014; McCarthy & Anderson, 2000; Prince, 2004; Ruhl, Hughes, & Schloss, 1987). A professor at a premier teaching college told me

that she loved her undergraduate experience at a small liberal arts college but said, "I can't follow the model of my own education. My classes were mostly lectures, with a few papers, a midterm, and a final. That won't cut it today. I am expected to provide a more interactive learning experience." Deborah Field, a professor of history at Adrian College, commented,

> If you think about a lecture, it's from the Middle Ages, so it made sense when books were made out of animal skins and there weren't very many of them. And the priest who was teaching would read something from St. Augustine and then talk about it, and then everybody would have to listen. So it is kind of strange that we still have that.

Learning experts call for universities to bring the same evidence-based standards of practice to teaching that professors bring to their research. In *Assessing Student Learning: A Common Sense Guide,* Linda Suskie (2009) explained that at one time, it was assumed that if students were not doing well, the fault was mostly in the students, who either were not putting in the time necessary to master the material or were not smart enough to succeed. Although students are responsible for their part of the educational process, similar students will succeed or fail depending on the quality of the instruction, including the curriculum and teaching methods.

Improved understanding of the process of learning and calls for accountability mean that colleges and teachers are now expected to engage in a set of practices that are grouped together under the term *assessment of student learning.* Teachers will increasingly be judged not only on students' ability to memorize what they have for the short term to pass the test but also on their ability to retain and apply their knowledge in future situations. Aside from external pressures, it is worth the effort to understand and engage in assessment practices because they will improve your teaching, and your students will get more out of your courses.

Assessment has four steps:

1. Thinking deliberately about your goals for the students.
2. Determining how you will help students achieve learning goals.
3. Evaluating whether your students are achieving the goals you set for them.
4. Using the results of your evaluation to make changes to improve outcomes.

The process does not end with step four but continues with more assessment and adjustment for continuous improvement. Because these activities of assessment are exactly what the best teachers do naturally, many of the examples and stories in this chapter are organized around these steps.

Assessment links to every part of teaching. To make decisions about the syllabus, including required reading, assignments, and the types and number of tests and quizzes, as well as decisions about the presentation of the material, you must answer the question of what you want students to be able to *do* (R. B. Barr & Tagg, 1995; Suskie, 2009). In *Effective Grading*, Barbara Walvoord and Virginia Johnson Anderson (2009) explained that even how you name an assignment influences what students will learn. A sociology professor who wanted students to be able to conduct a literature review stopped calling an assignment a "term paper" when he realized that students had preconceived ideas about what a term paper meant, and those ideas did not fit with his expectations. When he renamed the assignment a "literature review," it was something new to the students, so he gave more direction, the students paid closer attention to the instructions, and they had better outcomes.

Assessment Step One: Setting Learning Goals

To set learning goals, write out as specifically as possible exactly what outcomes you expect for your students. What do you want students to be able to *do* after taking your class? Consider not only the methods or knowledge students will learn in your course but also how they will apply what they have learned in the future, both as students and as members of the workforce and of society.

Many professors teach classes that are part of a required sequence of courses that are based on standards against which the whole program is assessed. In this case, step one of the assessment process is predetermined by the program as a whole. But even when you have limited latitude on setting course objectives, thinking carefully about what you want students to be able to do will help you keep your eyes on the goals of the course.

It is legitimate to include learning goals that are more difficult to assess, such as developing a passion for lifelong learning or an appreciation of fine art. You don't have to evaluate every goal, but because we tend to pay more attention to the things we evaluate, coming up with assessment methods is worth some effort. The more clearly you can define a goal, the easier it will be to evaluate. In *Assessing Student Learning*, Linda Suskie (2009) suggested two methods for assessing goals that are hard to observe, such as attitudes and values. They are (a) asking students to engage in reflection and (b) looking at behaviors. Students might be asked to write a reflective piece on how the course has changed the way they approach works of art or to complete a survey of behaviors such as reading for pleasure.

Students don't necessarily arrive at college knowing how to learn and how to study, so when you are setting learning goals, it is important to consider not just the content area of your course but also how to help your students become metacognitive. *Merriam-Webster* defined "metacognition" (n.d.) as "awareness or analysis of one's own learning or thinking processes." John Flavell (1979) identified three categories of metacognitive knowledge: person variables, task variables, and strategy variables. Person variables are the conditions that work best for your own learning. For example, I do my best writing in the morning, when I use a timer and stay off email. Task variables have to do with the nature of the task, for example, knowing that reading a philosophy paper will usually take longer and require more rereading than reading the same number of pages of a social science article. Strategy variables refer to methods one uses to learn the material, such as doing a self-test to check one's knowledge and making a plan to master any material that was missed. Although especially important for students who are underprepared for college, all students can benefit from understanding their individual learning processes and the ways to approach and master the tasks needed to succeed in a specific discipline.

Students are supported in becoming metacognitive when instructors ask them to reflect on their learning processes. For example, after handing out an assignment, the professor might ask the students to work in groups to discuss how each of them will go about planning the project and overcome specific barriers. Alternatively, students might be asked to post on a class site one problem they encountered in carrying out the assignment and how they solved it. This gives students the opportunity to reflect on their own process and also learn from their peers.

INTO ACTION

In the 1950s, Benjamin Bloom chaired a committee that created a taxonomy of learning goals to encourage educators to consider higher order thinking rather than just rote learning (Bloom, Engelhart, Furst, Hill, & Krathwohl, 1956). Anderson and Krathwohl (2001) updated the taxonomy in the 1990s. An online search of "action words for Bloom's taxonomy" yields a plethora of useful words for writing learning objectives. Just the "a's" and "c's" include the following:

apply, analyze, articulate, assess, argue, assemble, contrast, convert, cite, calculate, construct, chart, compare, classify, categorize, criticize, convince, critique, compose, and collaborate

An entire alphabet of learning goals can be found at these links:

> Oregon State: a-assessment.uoregon.edu/ResourcesandTraining/Writing StudentLearningOutcomes.aspx

> Texas A&M University Galveston Campus: www.tamug.edu/faculty/ Blooms_Taxonomy_Action_Verbs.pdf

Use action words from Bloom's taxonomy to write outcome goals for the students in your courses.

Assessment Step Two: Determining How You Will Help Students Achieve Learning Goals

A professor at a small teaching college told me, "One of my colleagues is an amateur actress, and she is hilarious and high energy and loud and breaks into song. I don't think that I'm boring, I don't talk in a monotone, and I don't read from my notes, but I'm not a performer. I'm not. So I had to find my own way. I'm always experimenting." The good news for this professor and others like her is that recent research on best practices shows that it is more effective for professors to play the role of facilitator or coach rather than performer. Although the change in role relieves professors of the pressure to put on a show, it also means that they need to become familiar with a new set of active learning strategies and carefully plan their courses to implement those strategies. This section offers examples of more interactive styles of teaching and suggests resources to learn more about pedagogical methods in your own discipline.

In *The Courage to Teach*, Parker Palmer (2007) presented an example of a method to engage students in medical education. Traditionally, medical students spend their first two years listening to lectures, memorizing huge amounts of information, and taking exams. It is not until their third year that medical students begin to work with patients. One medical school became concerned that although their students came into the program with a focus on caring for people, the intensity of the competition and disengagement from their original purpose in the first two years was desensitizing the physicians-in-training to patient concerns. The medical school decided to try a new method, in which students began working in supervised groups with real patients from the start of their education. Students met with their patients and attending physicians, learned to take careful histories and perform exams, pooled their prior knowledge, and used their classroom learning and time in the library in service of helping an actual person.

This method caused concern among some of the medical faculty, who worried that their graduates would be more caring but less capable. When the program was evaluated six years into the new curriculum, the result was that students not only were more caring but also showed *improved* test scores. It turned out that material learned in context was more memorable than it had been when the students memorized facts divorced from personal stories (Palmer, 2007).

History professor Deborah Field gave an example of a new way she engages students in her courses:

> *There's this kind of curriculum that we've become interested in at our college. It's called Reacting to the Past, and it's these elaborate simulations. It started at Barnard. It puts the students in a historical moment, and they get parts, and they have to debate. I did one that was about the French Revolution where they were all members of the National Assembly with different agendas, and there was the king, and there were the radicals and then these people who were in the mob who would come through and disrupt things.*

Although this method is different from the active learning done by medical students, both methods have the common factor of engaging students in participatory activities rather than lecturing at them and asking them to regurgitate what they were told.

LEARN MORE

Choosing Pedagogical Strategies

Each field has its own pedagogical methods. If your graduate school experience did not cover learning theory or the pedagogy of your field, you can fill in the gap by attending workshops on teaching and learning and reading articles on teaching in your discipline.

Kennesaw State University's Center for Excellence in Teaching and Learning has a comprehensive list of disciplinary and interdisciplinary journals focused on teaching undergraduate and graduate students, available at this link: cetl.kennesaw.edu/teaching-journals-directory

Despite the disadvantages of the lecture format, budget-conscious institutions are not likely to abandon it anytime soon. However, there are strategies to modify the lecture to increase learning. One of the most radical changes to the large lecture is the concept of the "flipped classroom." In these

courses, professors turn the typical formula of students listening to lectures in class and doing homework on their own time on its head. Instead, students listen to prerecorded lectures outside of class and use classroom time to work through problems either individually or in small groups. The professor is on hand to assist students when they need help, and students also learn through their interactions with one another (Brame, 2013).

Even when lectures maintain a more traditional structure, the professor can take steps to foster engagement. By physically circulating throughout a lecture hall and making eye contact with students, the professor conveys that everyone has her attention and will be included.

"Think, Pair, Share" is a phrase coined by Frank Lyman (1981) to describe his strategy to engage the entire class, rather than just the students who are outgoing and quick responders. Everyone is given a few minutes to think before discussing a question with a classmate. Only after students have thought about the topic and talked in groups of two or three are they invited to share their thoughts with the entire class (Lyman, 1981). A sophomore at Bowdoin College told me, "I had a class this semester where there were five students who always dominated discussion, and then for the last few weeks of class the professor had us first write down some things to think about from the readings, and then get into groups and talk, and then each group shared the highlights of the discussion with the class. After that, other people were more willing to chime in to the discussion. I really appreciated that because I don't contribute as much in class, I'm a little more hesitant, but I did speak more when she used that technique."

Another strategy to engage students in large classes is the "Entrance Ticket." These are short papers on the readings that must be handed in immediately upon entering the classroom. They guarantee that each student will have done at least a minimum of preparation for the class, which brings greater vitality to classroom participation. Anthropology professor Alan Aycock (2012) also insists that entrance assignments be printed on a word processor, which requires a greater degree of thought and planning than a handwritten note, and he expects his students to hand them in personally rather than electronically, which ensures that students show up to his class on time.

Transmitting Expert Knowledge to Students

Mr. Russell, my seventh-grade English teacher, explained to his students, "I teach English because I'm good at math. Math comes to me intuitively, so it's hard for me to explain it. English was much harder for me, so I had to work to understand it, and it makes me a good English teacher." As Mr. Russell pointed out, experts often have blind spots when it comes to teaching their subjects. Because they have advanced to a point where they are

not always conscious of what they know, experts tend to skip steps when they try to pass their knowledge on to others. Other common mistakes are underestimating just how much practice students will need before they can master a skill and failing to sufficiently explain how a skill matters and how to apply it in a variety of situations (Ambrose, Bridges, DiPietro, Lovett, & Norman, 2010).

In *How Learning Works: Seven Research-Based Principles for Smart Teaching*, Susan Ambrose (2010) and her colleagues suggested strategies to successfully translate knowledge to students, including the following:

1. Ask graduate students to look over your undergraduate lesson plans and assignments to see if you have divided tasks into sufficiently small steps. Graduate students have a grasp of the material, but because they are newer than you are to the subject, they are more aware of the process that went into learning it.
2. Borrow teaching materials from colleagues to see if they include steps that you might have missed and to find out how much practice time they provide.
3. Separate parts of the task so that students can practice one skill at a time. For example, a statistics professor might have students practice statistical methods in one class and in another class ask them to choose the correct method to use in various situations, without actually applying the methods. This separates the skill of using a test from that of identifying the situations in which it should be applied.

Student Engagement

The better you know your audience, the easier it is to engage your students. Even when the lecture size precludes a personal connection with every participant, it is worth learning something about the demographics of the group. This is particularly important with the increasing numbers of first-generation students and students from underrepresented groups. Students are more responsive to culturally relevant examples, so it helps to tailor the material to their experience.

In addition to knowing something about your students' cultures and interests, it is helpful to administer diagnostic assessments (also called preassessments) to get a sense of your students' level of preparedness. Determining where students are starting from is important. If the material is too hard to master, students will lose motivation, but they will also lose interest if the work is too easy, because they will fail to see any value in what they are being asked to do. Awareness of the students' prior knowledge also helps

the instructor to determine the students' development and progress over the course of the semester (Ambrose et al., 2010).

Brigham Young University professors Kenneth Alford and Tyler Griffin (2013) pointed out that learners are more motivated when they understand the relevance of what you are teaching in the classroom, so you should be constantly asking: So what? Why should my students care about learning this material? In *What the Best College Teachers Do*, Ken Bain (2004) offered a vivid example of communicating relevance:

> Donald Saari, a mathematician from the University of California, invokes the principle of what he calls "WGAD"—"Who gives a damn?" At the beginning of his courses, he tells his students that they are free to ask him this question on any day during the course, at any moment in class. He will stop and explain to his students why the material under consideration at that moment—however abstruse and minuscule a piece of the big picture it may be—is important, and how it relates to the larger questions and issues of the course. (pp. 38–39)

Professors can invite students into the process of finding relevance by asking them to reflect individually or in groups on how the learning will be useful in their work or personal lives.

Classroom Climate

Bain contrasted professors whom he included in his study of excellent teachers with those who were considered brilliant teachers by some students but whom he ultimately rejected as models. The professors who were left out of the study were critical, dismissive, or arrogant toward a large portion of the students in their classrooms, and even students who rated them highly acknowledged that they did not treat all students equally well (Bain, 2004). Bain excluded those teachers because an atmosphere of fear or criticism inhibits questions and shuts down participation, with adverse effects for learning.

I experienced the power of a respectful climate as an undergraduate student in an introductory women's studies course. At the start of the class, I frequently made mental judgments about my classmates' comments, dismissing them as naive or underdeveloped. But our instructor consistently brought out the significance of the contribution and took it to another level. Following her model, we all began to listen and think more carefully about what our peers had to say, and consequently students began to relate the material to their lives in deeply personal and meaningful ways.

After the course ended, I expressed my admiration of the instructor's ability to find value in each contribution. She explained that she is a member of the Society of Friends (Quakers) and that in Quaker meetings for worship, there are often long silences, but when people feel so moved, they speak. She explained, "We believe that it is not the job of the person speaking to say something valuable, it is our job to find the value in what we hear. I try to bring that frame of mind to my classroom." I have come to call this practice "Quaker Listening." I strive to bring it into my own teaching, and I invite my audiences to do the same.

Some professors hope to motivate students with a warning about how tough the course is and the assertion that not everyone will make it to the end of the semester. Instilling this kind of fear in students doesn't work, because for students to be motivated to learn, they need to both value the goal *and* believe that they have the ability to succeed (Ambrose et al., 2010). Ken Bain explained that the best teachers set high expectations, but they frame the expectations in terms of the benefits the students will receive. Bain gave the example of how Derrick Bell, the first African American to win tenure at Harvard Law School, introduces one of the requirements of his constitutional law course:

> When he talks about the "op-ed" pieces they will write, he says that "students will have the opportunity . . . to post eight to ten such articles . . . unless they feel strongly motivated" to post more. Rather than stressing the minimum requirement, he emphasizes that they should post "no more" than twelve. (Bain, 2004, p. 147)

Bell explained the quality he was expecting by asking students to write something that they would be comfortable submitting with their name to a newspaper. Excellent teachers might stress that a course will require many hours of work and should be taken at a time when students can devote the hours required, but they put this in the language of opportunity, emphasizing how rewarding it will be for those who make the commitment.

Assessment Step Three: Evaluating Whether Students Are Achieving the Goals You Set for Them

Assessment Step Four: Using the Results of Your Evaluation to Make Changes to Improve Outcomes

Because these steps are so closely linked, I discuss them together.

In a graduate class on research methods, the teaching assistant stopped midsentence and surveyed the puzzled faces staring back at her. "You're not

following this, are you?" she asked. As her perplexed students all shook their heads, she quickly scrapped her planned lecture and said, "This obviously is not working; let me explain it a different way." By paying attention to her students' quizzical looks, the TA had conducted an instant assessment of student learning and changed course using that information. Student assessment is usually a bit more formal than this, but it need not be overly complicated.

Assessment experts differentiate between formative assessments and summative evaluations. Formative assessments are used early or midway through a course to gauge learning and occur at a point when the professor can make modifications on the basis of what she learns. Summative evaluations, such as a final exam or paper, are used to assign grades that show an individual's level of achievement in the course. Although summative evaluations don't change teaching methods for the current students, they are useful in planning for future cohorts of students (Banta, Jones, & Black, 2009; Suskie, 2009).

Ideally, the assessment activity itself will enhance learning. For example, One-Minute Memos (sometimes called Exit Tickets) require that students use the last minute of class to summarize a point made in the lecture, write a question, or write down "the muddiest point" (something they are still unclear on at the end of the session) (Angelo & Cross, 1993; Banta et al., 2009). Just the act of writing a summary reinforces the learning. Students pass in their memos as they leave the room, or in an online course, they send them electronically after they have viewed the lecture. Having read the memos, the professor has a good sense of the level of understanding of the class as a whole and any misconceptions she needs to clear up. She might then start the next class by reading a few of the best summaries and clarifying the areas that students found difficult. This exercise also supports learning by ensuring attendance and attention during class.

LEARN MORE

Classroom Assessment Techniques: A Handbook for College Teachers by Thomas A. Angelo and K. Patricia Cross (1993) includes a collection of 50 techniques for assessing a wide variety of learning goals from skills and knowledge to values and attitudes.

Some professors fear that conducting assessments will create additional work, because they will need to respond to what they learn. It is possible to make positive changes without taking on an undue burden. If a professor previously assigned two papers, but students show weakness in writing a clear

research question, the professor might change to assigning just one paper but ask the students to complete a number of shorter assignments in which they focus on one element of a paper at a time. Working on one aspect in isolation calls attention to its importance and allows students to focus on that area more carefully than they would if it were part of a longer project (Ambrose et al., 2010; Suskie, 2009).

Assessment and Grading

Effective grading is tied to effective assessment because assignments, quizzes, and tests are best designed only after the professor has identified what she wants the students to be able to do after they have taken her class. Although most professors aspire to teach higher order skills such as critical thinking, it is all too common to base evaluations on rote learning, because it is easier to create and grade an exam that is based on simple recall. However, it is possible to evaluate more complex skills and still keep grading manageable. Justine told me apologetically that she had begun cutting and pasting feedback on student papers. "I found that I was writing the same thing over and over again from one paper to the next. I still add some individual comments," she was quick to explain, "but this saves me time. I keep a file of comments. If they're not italicizing book titles, I can just stick that in quick, or if they're not commenting on how the passage is written, they're just commenting on what it says, I can copy that. Having that preset language is really helpful." Far from being a reason to apologize, time-saving shortcuts are essential for your own well-being and also make sense pedagogically. For feedback to be most useful, it needs to be timely (Suskie, 2009; Walvoord & Anderson, 2009). Using efficient strategies lets you return work when the material is still fresh enough for students to benefit from your feedback.

A few of the many strategies that Barbara Walvoord and Virginia Johnson Anderson (2009) offered to reduce time spent on grading include the following:

1. Write only comments that pertain to learning goals. If a paper is turned in with an unacceptable number of grammatical errors, and you are not teaching a writing class, you might ask the student to work with a peer or someone in the writing center to edit the paper before you grade it, rather than comment extensively on grammar and punctuation.
2. Give the students a checklist and ask that they comment on how well they completed each item on the list. If a student notes that he should

have worked more on a particular section but ran out of time, there's no need to write extensive comments about how to improve that section.

3. Grade some assignments on a scale with fewer levels, such as a check, check plus, or check minus, or A, B, C, without pluses or minuses. As the authors point out, "The fewer the number of levels, the faster assignments are to grade." (Walvoord & Anderson, 2009, p. 103)

Another option is to choose a few samples to comment on in class, rather than respond extensively to each individual's work.

LEARN MORE

For a thorough discussion of grading, I recommend *Effective Grading: A Tool for Learning and Assessment in College* by Barbara E. Walvoord and Virginia Johnson Anderson (2009).

Influenced by the research on learning and calls for greater accountability, many institutions are implementing formal university-, college-, or department-wide assessment programs. These programs may evaluate student learning by looking at elements already embedded in courses, such as assignments or exams, and they may also add on additional assessments, including published instruments. There is a good chance that at some point you will be asked to participate in, or even lead, such an assessment process.

LEARN MORE

Resources for those leading or taking part in an assessment process beyond the level of their own classroom include the following:

1. *Assessment Clear and Simple: A Practical Guide for Institutions, Departments, and General Education* by Barbara E. Walvoord (2010).
2. *Assessing Student Learning: A Common Sense Guide* by Linda Suskie (2009).
3. *Designing Effective Assessment: Principles and Profiles of Good Practice* by Trudy W. Banta, Elizabeth A. Jones, and Karen E. Black (2009).
4. Brigham Young University's website describes learning outcomes for each of its departments and programs: learningoutcomes.byu.edu

Rubrics

In *Introduction to Rubrics*, Dannelle Stevens and Antonia Levi (2005) explained, "Rubrics divide an assignment into its component parts and provide a detailed description of what constitutes acceptable or unacceptable levels of performance for each of those parts" (p. 3). Rubrics are useful in every part of the assessment process. Writing a rubric helps the professor to think clearly about her goals for an assignment or test, and when the rubric is passed out along with a new assignment, it facilitates the clear communication of expectations to the students. Rubrics are also helpful on a program level. If a professor teaching an upper-level course has access to introductory course rubrics, she will know what has been covered at earlier levels.

Use of Rubrics in Grading

A rubric allows the professor to grade the assignment quickly and fairly. Rather than cutting and pasting text, the professor can simply circle the appropriate section of the rubric and add a few personal comments, if needed. Professors can also examine the rubric to identify areas where students are consistently falling short.

A professor at a small teaching college described how rubrics help her to grade the 1,000 pages of homework that she receives in just one humanities course. Her rubrics lay out clear expectations with the criteria for an A, the criteria for a B, and so on. She said,

> *It's good because it forces you to think about what you are really asking them to do in any given assignment, and it makes your teaching much more intentional. And I have to say that now I totally sympathize. I remember in college being totally mystified by my grades. I remember a course I took where there was a hard TA and an easy TA, and I got the hard TA and my friend got the easy TA, so that didn't seem fair.*

Grading may never be perfectly objective, but if all the teaching assistants for a large lecture use a common rubric, it ensures that students in different discussion sections are being graded on the same criteria.

This professor had another experience that solidified her commitment to providing the rubric to students *before* they start an assignment, rather than using it only as a feedback tool:

> *Faculty members had to turn in these assessment reports, and they didn't give us the rubric until after I had already written the report. And then I got the results, and I was criticized for some things, and I was so mad! This was an incredible moment of empathy with the students, because I thought, "I didn't know what you wanted!" . . .*

I don't think it's such a bad thing for people in authority to have to make their expectations clear.

Creating Rubrics

One professor explained, "A colleague who had invested a lot of time into coming up with a rubric was willing to share his rubric with me. I only needed to change it slightly to fit my course." With his or her permission, using a colleague's rubric as a template is a helpful shortcut. *Introduction to Rubrics* by Stevens and Levi (2005) offers more detailed instructions on how to create a rubric, and the website for the book includes blank templates and a number of sample rubrics from a variety of disciplines (www.introductiontorubrics .com). A sample rubric by Dannelle Stevens is reprinted in Figure 3.1.

Figure 3.1.

Changing Communities in Our City

Task description: Each student will make a 5-minute presentation on the changes in one Portland community over the past thirty years. The student may focus the presentation in any way he or she wishes, but there needs to be a thesis of some sort, not just a chronological exposition. The presentation should include appropriate photographs, maps, graphs, and other visual aids for the audience.

	Excellent	Competent	Needs work
Knowledge/ understanding 20%	The presentation demonstrates a depth of historical understanding by using relevant and accurate detail to support the student's thesis. Research is thorough and goes beyond what was presented in class or in the assigned texts.	The presentation uses knowledge that is generally accurate with only minor inaccuracies and that is generally relevant to the student's thesis. Research is adequate but does not go much beyond what was presented in class or in the assigned text.	The presentation uses little relevant or accurate information, not even that which was presented in class or in the assigned texts. Little or no research is apparent.
Thinking/ inquiry 30%	The presentation is centered around a thesis, which shows a highly developed awareness of historiographic or social issues and a high level of conceptual ability.	The presentation shows an analytical structure and a central thesis, but the analysis is not always fully developed or linked to thesis.	The presentation shows no analytical structure and no central thesis.
Communication 20%	The presentation is imaginative and effective in conveying ideas to the audience. The presenter responds effectively to audience reactions and questions.	Presentation techniques used are effective in conveying main ideas, but they are a bit unimaginative. Some questions from the audience remain unanswered.	The presentation fails to capture the interest of the audience and/or is confusing in what is to be communicated.

(Continues)

Figure 3.1. (*Continued*)

Use of visual aids 20%	The presentation includes appropriate and easily understood visual aids, which the presenter refers to and explains at appropriate moments in the presentation.	The presentation includes appropriate visual aids, but these are too few, are in a format that makes them difficult to use or understand, or the presenter does not refer to or explain them in the presentation.	The presentation includes no visual aids or includes visual aids that are inappropriate or too small or messy to be understood. The presenter makes no mention of them in the presentation.
Presentation skills 10%	The presenter speaks clearly and loudly enough to be heard, using eye contact, a lively tone, gestures, and body language to engage the audience.	The presenter speaks clearly and loudly enough to be heard but tends to drone or fails to use eye contact, gestures, and body language consistently or effectively at times.	The presenter cannot be heard or speaks so unclearly that she or he cannot be understood. There is no attempt to engage the audience through eye contact, gestures, or body language.

Note. Stevens, D. D., & Levi, A. (2005). *Introduction to rubrics: An assessment tool to save grading time, convey effective feedback, and promote student learning.* Sterling, VA: Stylus. Reprinted with permission.

Online and Blended Learning

Online and blended courses take a variety of forms and are areas of rapid development. The debates on online education run the gamut from utopian visions of access to an elite education for anyone in the world to a distinctly dystopian scenario in which all but a few star professors are displaced and the majority of students no longer have any direct contact with instructors. Although the practical and ethical implementation of online education will continue to be deliberated, most institutions are already committed to offering some form of online education, so the following section addresses considerations and strategies for successfully running an online or blended class.

Creating Community

Online courses have lower student retention rates than face-to-face programs. Professors cannot control the fact that online courses appeal to nontraditional students, many of whom have families and careers competing for their time and attention (Garrett, 2013). However, professors can design courses to

build a strong sense of community, which is key for engaging and motivating students in online environments. Building community starts with icebreaker activities in which students have the opportunity to get to know each other on a personal level. Sample activities include pairing up students to interview each other about their hobbies and passions and then posting introductions of their partners on a class bulletin board or inviting students to post photos of themselves with their friends, pets, or family members.

In the article titled "5 Ways to Build Community in an Online Course," Rob Kelly (2007) profiled techniques used by Wayne Hall, a psychology professor at San Jacinto College in Texas, whose students write rave reviews of his online course. Hall expects students to log on to the course site at least three times a week, and he regularly posts questions, student surveys, and other activities that keep students engaged. He also models and requires one-on-one communication in addition to large group discussions. Hall sends each of his students a couple of personal emails in the first week of the class and requires that they contact at least two other members of the class individually. When students ask for guidance on how to make those connections, Hall refers them back to the personal information they posted to find points of commonality. When Hall first noticed that the students spent a percentage of their time chatting on unrelated topics, he was concerned, but then he realized that this is exactly what occurs in face-to-face classrooms. In addition to making progress on classwork, students get to know one another and connect around common interests, and so side conversations are a positive sign that a class is becoming a community.

Hall offers an optional real-time chat session with students once a week, posts video clips so his students get to know him on multiple levels, and requires group projects (Kelly, 2007). Group work is an essential element of effective online instruction. In a three-year longitudinal study that compared online and traditional undergraduate courses in an information systems program, Starr Roxanne Hiltz and her colleagues found that online instructors who did not require collaborative work believed their face-to-face students had a better learning experience than their online counterparts, but when online students were asked to work in collaborative groups, their work was of higher quality, and instructors reported that they performed as well as or better than students in face-to-face classrooms (Hiltz, Coppola, Rotter, Toroff, & Benbunan-Fich, 2000).

Managing the Time Commitment of Online Teaching

Instructors often spend more time facilitating online courses than running face-to-face courses, so they must balance between engaging students and attending to other responsibilities. Providing students a schedule of when

you will log on is a way to limit your commitment while also reassuring students, who like to know when you will be accessible. For example, students might be informed that you will check emails once over the weekend, at 8:00 a.m. on Sunday mornings, so those who email later on Sunday will not receive a reply until Monday. Professors also save time by requiring that all questions be posted to an online forum. In the book *Blended Learning*, Francine Glazer (2012) described how she directs students' questions back to the public space:

> If someone emailed me a question, I posted the question on the Instructor's Office forum, answered it there, and replied to the student's email with a brief, "Great question! I posted the question and my response on the Instructor's Office forum so everyone else could see it, too. Please check there for any follow-up questions you might have." (p. 41)

Her students quickly learn to work with her through the public forum, which saves Glazer from having to answer many individual emails on the same topic.

Another challenge is responding to lengthy online discussions. Some instructors explain that they will respond to the posts only if things are going seriously off track. Alan Aycock (2012) suggested that professors can keep the grading manageable by assessing online posts with a very basic grading system, such as assigning posts a grade of zero, one, or two in accordance with predetermined criteria. Providing frequent opportunities to earn a few points gives students the incentive to participate but reduces the likelihood of arguments over grades, because the stakes are so low in any one assignment.

Online Assessments

Students learn more from frequent, low-stakes assessments in which they receive feedback soon after being tested and are given the opportunity to achieve mastery, as compared with a few high-stakes assessments (Roediger, 2014). Professors maximize learning when they create online assessments that allow students to see the correct answers to a quiz immediately after they complete it, along with an explanation of why one answer was correct and the others were wrong.

An important consideration when creating online tests and quizzes is making it difficult to cheat. A professor of literature gives her face-to-face class the option of doing an in-class exam or a take-home essay exam. She gives the same option to her online students, but her online equivalent of the in-class exam is a timed exam that requires her students to know the subject

well enough to answer quickly. For timed tests, you should generate a very large question bank so that each student has a slightly different test, and you should change the questions each semester. In tests that are not timed, you can make cheating more difficult by asking questions that involve higher order thinking and requiring that students explain their reasoning. Given the rapid changes in technology, best practices for online assessments will continue to evolve.

Effective Online Presentations: Lecturing to a Camera Lens

The facilitator of a distance-learning program told me that there is considerable variability in the ability of even seasoned professors to connect with an audience online, and when offered the chance to watch their own lectures, most presenters quickly decline. For students to feel actively engaged, the professor sitting alone in a room must look directly into the video camera and communicate as if the audience is directly in front of her. Many professors become nervous in front of the camera and avert their gaze, which gives the impression that the speaker is detached from her audience. Effective online presentations require practice. Watch video footage of yourself to accurately gauge your performance, and experiment until you appear engaged and connected.

Contending With Students' Biases

Expectations of Nurturing

Students expect female professors to play a more nurturing role than their male professors (Tierney & Bensimon, 1996). A study of college instructors by Diane Kierstead, Patti D'Agostino, and Heidi Dill (1988) found that women who smile more are rated significantly higher than those who do not smile. Men who smile more are actually rated somewhat *less* favorably than unsmiling men. Likewise, when students read a description of a female professor who made herself more accessible outside of class by having weekly lunches with students and hosting a barbecue, they rated her significantly higher than a female professor who did not do those things, but additional student contact made no difference in how male professors were rated.

The expectation of nurturing also means that students are more likely to ask for your advice about personal problems or burst into tears in your office. An academic who teaches an identity-related course responds kindly to student disclosures but discourages students from processing their experiences in her office by quickly providing a referral and encouraging the students to follow up with outside support. A dean shows support without encouraging

a drawn-out interaction by offering tearful students M&Ms rather than a Kleenex. The message is "cheer up" rather than "tell me more."

Credibility Challenges

Students more often challenge the credibility of professors from historically underrepresented groups, regardless of subject matter. African American law professor Jerome Culp (1991) described how every year students asked him, "Where did you go to law school?" This question revealed the students' suspicion of Culp's qualifications to teach. In the chapter "On Being Special" in *Presumed Incompetent*, Serena Easton (2012) wrote about her experience as an African American woman teaching at a predominantly White institution in the South. She explained,

> And while I may have been as articulate as any white male professor, my race and gender were obvious barriers to their respect. I didn't realize that this was the case until I started talking to my fellow first-year TAs, all of whom were white. As we sat in the mailroom commiserating over how hard it was to teach four discussion sections and be first-year grad students at the same time, I began to realize that their stories sounded very different from mine. In my sections, everything I said was questioned, scrutinized, and cross-examined.
>
> Fully expecting my cohort to complain about the same problems, I was stunned when they began looking at me as if I had just grown an eyeball on my forehead. They weren't having these difficulties in their sections—it was just me. Only I was forced to pull up statistics, photos, theories, graphs, and charts constantly as evidence that what I was saying was true. (p. 153)

Besides being demoralizing, the credibility challenges were burdensome because Easton had to overprepare for her sections and be ready to prove every point that she made.

Authority challenges are exacerbated when professors from historically underrepresented groups are teaching about their own group. When students' assumptions and beliefs are challenged, some respond to the discomfort they feel by attacking their professor as being biased or having a personal axe to grind, and these attacks may take the form of direct challenges during the class and in critical evaluations (Vargas, 2002).

An educator can distance herself from controversial material by taking a neutral stance and commenting on issues raised by "the authors" rather than raising the issues directly. The downside is that this requires a degree of self-silencing, and your students lose the chance to hear your own voice and

thoughts on the subject. In her chapter "Lessons From the Experiences of Women of Color Working in Academia," Yolanda Flores Niemann (2012a) suggested a number of approaches to manage bias. A few of them include (a) make a point of alternating each term between classes on more controversial topics and courses that are more neutral, both to give yourself a break from the stress and to balance out your teaching evaluations; (b) invite a supportive senior colleague to visit several of your classes to serve as a witness to your experience and to strategize with you on the best way to manage affronts to your authority; and (c) provide a syllabus that includes very clear guidelines about the work that will be expected and your grading policies to help prevent accusations of one-sidedness.

In their paper "Instructor Identity," Diana Kardia and Mary Wright (2004) suggested a number of other strategies White women and women and men from underrepresented groups can employ to establish and maintain their credibility in the classroom:

1. Lay out strong expectations at the start of the semester, but also express a commitment to helping students succeed so that the high standards are paired with a communication of warmth and caring.
2. Dress more formally, at least early in the semester, and until your authority is secure.
3. Limit the amount of personal information that you disclose.
4. Ask to be addressed by your professional title (professor) rather than by a first name to avoid confusion about your role.
5. Post and keep regular office hours to signal availability (but don't be constantly available).
6. Acknowledge students' contributions and connect the material being taught to students' lives, either by giving relevant examples or by inviting students to share their experiences.
7. Collect student feedback before the end of the term, and use that feedback to correct misconceptions or modify teaching.

Kardia and Wright (2004) pointed out that many of these strategies match the best practices that teaching and learning experts recommend for all academics.

Because there is less disapproval when we take a stand on issues that don't involve groups to which we belong, we can also make a difference as allies by speaking up on behalf of other groups. It is safer for a White woman to point out racism, for a cisgender professor to point out bias against transgender people, and so forth (a cisgender person is someone whose identity matches the sex they were assigned at birth; anyone who is not transgender is cisgender).

Given the stress that can come with this work, it is important to build a community of support. A community can be developed by planning regular meals or gatherings with others who teach on similar topics within your department or on your campus, by setting up regular phone calls with supportive colleagues around the country, or by connecting with supportive people from outside of the academy in your local area.

In a chapter on Latinas in political science, Jessica Lavariega Monforti (2012) described another kind of bias, in which people assume that just because someone is a member of an underrepresented group, they are qualified to teach about that group, even if it is not the area in which they trained. For example, people often assume that Latinas who study political science are experts on Latin America and on ethnic and racial politics or that African Americans can teach Black politics (Lavariega Monforti, 2012). Individual scholars may need to remind their colleagues of the areas in which they are trained, and allies can help by pointing out when others are making assumptions that have no relation to the facts.

Support for Teachers

Learning Communities

Learning communities (sometimes called teaching circles) are groups of faculty members that meet on a regular basis to discuss an aspect of teaching or research. One professor described a learning community with a focus on teaching about race and ethnicity:

> *The community was made up of 15 professors from a variety of disciplines on campus, and we met monthly. Sometimes we shared how we handled common challenges in teaching issues of race. We also watched Harvard scenarios on race in the classroom, and read and discussed a book on the subject. What was great about it was the variety of perspectives. I'm very different from Debbie Rodriguez, so I may not be able to do just what she does, but maybe some of her ideas will work for me, but I'm a lot like Al Jackson, so I can use him as a role model. The other great thing about the teaching circle was that it gave me 15 people I can go to across campus who aren't in my department and won't be voting on my tenure case. We may not agree on everything, but we have this connection from our common interest in race. Some people feel like they don't have time for something like this that focuses on teaching, but we found that we could do research together as well, so it led to some new collaborations and projects for me.*

Communities can be organized around innovation in large lectures, team-work in online classes, the use of case studies in teaching, or any other topic of common interest. Although some colleges provide institutional support for teaching circles, they can also be initiated informally by inviting others who are likely to share an interest in the chosen theme. It is helpful to have a facilitator keep the group focused, but because people will have unique per-spectives to contribute on what works in their own teaching, the nature of a teaching circle is to provide a nonhierarchical forum to explore a topic and share ideas. It is also a good idea to agree on ground rules for conversations, including a guideline that members speak from their own experience rather than tell other members what they should do.

Additional Sources of Support for Teaching

Most institutions have a campus center that is staffed with experts on the scholarship of teaching and learning. These professionals provide confi-dential support to faculty members seeking assistance with any number of teaching challenges, including class design, technology, difficult class-room dynamics, running an effective discussion, assessment of learning, and creating an inclusive environment. They offer one-on-one consulta-tions and are also available to observe a class session and make suggestions for improvement. Many centers also publish websites with short articles and resources, including sample syllabi, information on how to create a teaching portfolio, write a teaching philosophy statement, and much more. If your own institution does not have such a center, you can still make use of the rich online resources provided by large universities. Publishers that special-ize in higher education titles also offer books on a wide range of issues in college teaching.

LEARN MORE

Teaching Resources

Websites

- The University of Michigan Center for Research on Learning and Teaching's website includes an excellent Occasional Papers series and many other resources: www.crlt.umich.edu

- The University of Virginia Teaching Resource Center's website includes a list of Teaching Tips on a variety of topics and links

to over 40 other websites for centers across North America: trc.virginia.edu

- The Purdue University Online Writing Lab (OWL) includes discipline-specific resources for those teaching subjects ranging from writing poetry to writing engineering reports. Instructors can download handouts on how to design a research poster, use the inverted pyramid structure in a journalism article, summarize the difference between modernism and postmodernism, and much more. The materials are free and available to teachers worldwide. The writing lab is at this link: owl.english.purdue.edu/owl

Newsletters

- *Tomorrow's Professor* is a free email newsletter, edited by Richard Reis of Stanford, that features brief, previously published articles on a range of topics but with an emphasis on teaching and learning. Individuals can subscribe to the newsletter at this link: mailman.stanford.edu/mailman/listinfo/tomorrows-professor

- *The Teaching Professor* is a subscription newsletter with both print and online versions. The newsletter summarizes recent research in higher education, with a focus on practical applications for teaching. More information is at this link: www.teachingprofessor .com/newsletter

4

WORK-LIFE BALANCE

My husband and I have a standing dinner date on Thursday nights, but some days I am so stressed, that I can't even think of anything to say. We just kind of sit there and stare at each other. How can I be more present with my husband, when I have so much going on at work?

I got the call from day care that the baby was sick on Wednesday, and then he was home for the rest of the week. I don't know how I'm going to meet this deadline, since I lost two good writing days. My friend suggested I hire my sitter for some extra hours, but my son spends so much of his life at day care, and I don't get to see him enough as it is.

We had another crisis with my mom, so I made the three-hour drive to go with her to her doctor's appointment and get things straightened out. My sister had been down for a week, but this happened right after she flew home. Caring for mom has really impacted my productivity. I was given incorrect information about my eligibility for the FMLA, so I never applied for leave, and therefore I was told that I'm not eligible for an extension on the tenure clock.

The previous vignettes show just a few examples of my clients' struggles to balance their academic careers with their personal lives. For some the issue is one of mental fatigue after pushing for a number of weeks with little time for personal rejuvenation. For others it is the challenge posed by the dual roles of academic scholar and caregiver for children and/or relatives with disabilities. Still others are managing their own physical or mental health challenges while working to maintain an ambitious research agenda. Some scholars have thriving careers but crave more personal connections, companionship, and space for nonacademic pursuits.

Some criticize the phrase "work-life balance" because it implies a scale with work on one side and the rest of life on the other. The perception is that if work is up, personal life will be down, or vice versa. The interaction is more nuanced than that. Sometimes one domain interferes with the other, but when things are going well on one side of the equation, it often invigorates the other realm. Research bears out the idea that career and personal satisfaction more often support than impede each other. Some academics think they must sacrifice other parts of their lives for career success, when in fact self-care, personal time, and time with family and friends are essential to performing at the highest level.

Dual-Centric

In a collaboration between the nonprofit Families and Work Institute, Catalyst, and Boston College Center for Work and Family, Ellen Galinsky (2003) and her colleagues asked both male and female executives whether they were family focused, work focused, or dual-centric (equally invested in work and family). Those who were dual-centric reported being more successful and less stressed than both their work-centric and family-centric counterparts. When the researchers followed up the self-reports with other evaluation tools, it was clear that the dual-centric executives did not just *feel* better about their lives, they were actually more successful and less stressed by objective measures. So the investigators took a closer look to identify the characteristics that might explain these positive outcomes. It turned out that there were four distinguishing practices of these dual-centric people:

1. They set strict boundaries between work and personal life.
2. They worked to be fully present when home, even if not home every night.
3. They took time for rest and recovery and engaged in interests that require focus.
4. They were very clear about priorities and intentional about how they spent their time (Galinsky, 2003).

This chapter will help you to implement these practices to achieve the balance you want. Topics covered include delegation, maintaining energy at work, role conflict, and issues of particular interest to parents, people with disabilities, and those from historically underrepresented groups.

Set Strict Boundaries Between Work and Personal Life

Although academics have the benefit of being able to set their own hours, they also have the challenge of work that is never completed. There are always more papers to write, more emails to answer, or more grants to apply for. For many this means working during the day and then putting in additional shifts at night and on the weekend. This kind of schedule can lead to burnout.

Megan told me that she frequently feels stressed and resents the fact that she is never off duty. When the conversation turned to managing email, Megan explained, "I'm a smartphone addict. I check my email when I'm walking to my car, standing in line at the grocery store, or at intermission at a concert. I figure that's better than spending my office time on email." "Maybe," I mused, "but perhaps all that checking is contributing to your stress. Would you be willing to run an experiment for a week, in which you turn off your phone from the time you leave work until after dinner, to see how that works?" Megan reflected, "It will be hard, because it's such an automatic thing for me to check my phone, but I guess I'm willing to try it for a week." When she reported in the next time we spoke, Megan said, "That phone thing was a great idea. I thought it would be a problem to have my email build up, but I can't answer the complicated messages on my phone anyway, and I was much more relaxed in the evening."

Planning the number of hours you will dedicate to research each week is another way to partition work time and time off. Some scholars resist a schedule because it seems restrictive, but once implemented, they find it to be freeing, because after they put in their planned hours, they get to be off duty.

Separating Work From Parenting

Often, expectant first-time parent-scholars have a fantasy of multitasking that involves bucolic scenes in which they write while the baby sleeps peacefully in a cradle at their side. With a flexible schedule, they imagine that if they can just find child care to cover their teaching time, they can be present at home with their child while still making progress on their research. Occasionally babies cooperate with this plan for a bit, or at least until they start to crawl and explore the hazardous world full of tiny objects to put in their mouths and bookshelves to pull themselves up by. But more often,

new parents are shocked that such a tiny being can keep them so very busy with holding, rocking, diaper changing, feeding, doing laundry, and pumping milk for when the mom goes back to work, and then repeating the whole cycle. For many new parents, it becomes strikingly obvious that to survive, they will need to separate their personal life from their work life and have safe, reliable child care that will put them at ease so that they are able to concentrate on their research and writing.

As a young expectant mother, I was struggling with the notion of outside child care until someone suggested I think of the baby's time in day care as sharing my baby with the universe. This was more appealing than my earlier conception of day care as "abandoning my baby." My partner and I were lucky to find providers who gave our babies good care and affection and gave us useful guidance as well. And as much as I loved the time with my children, it was wonderful to be able to exercise my adult brain when I was immersed in my own work. Of course, there were occasional challenges with child care, but not every moment at home with us was perfect either. On balance, sharing our babies with the universe of dedicated child care professionals was enriching for all of us.

Maximizing Outside Help

Work and personal tasks spill over into each other when women have too much to do in either realm. To successfully set strict boundaries between work and personal life, women need to delegate, pay, and negotiate for as much outside help as possible. Internist Dr. Beverly Tomlinson wanted to support her aging parents in their desire to stay in their own home, even when they could no longer manage many of the day-to-day chores. She drove to her parents' home every weekend, even when taking calls from the hospital. She personally did grocery shopping, bill paying, and personal care, and she hired out all the lawn care, house cleaning, and laundry. But because she had to keep her medical practice going, Dr. Tomlinson explains that "the magic equation was Doris," the woman she hired to be with her parents throughout the week while she was at work. Doris "watched over them, took them out on drives, cooked for them—she was just there for them." She knew how to reach Dr. Tomlinson at any time and was skilled with seniors and knew when to call. Doris also knew who their friends were, whom to let in, and when they needed protection from scammers. Dr. Tomlinson's parents were able to live out their lives in their own home despite her mother's dementia and her father's declining strength. Women professionals are much more likely than their male siblings to provide and coordinate care of their aging parents or disabled relatives, and hiring as much help as possible is essential for maintaining their own careers.

Even when managing only your own household, you might consider hiring a housecleaner, a weekend sitter to free up extra time to write or to have a regular date with your spouse, or a service to deliver your groceries. If your children are in full-time care and hiring additional sitters is the last thing you want to do, invest in assistance with tasks that will support your career *and* free up time to spend with your kids.

Some women struggle with the idea of a woman from less privileged circumstances cleaning their toilets and washing their floors. At the same time, people depend on domestic work for their livelihoods. A middle path between trying to do all the housework yourself and hiring someone but ignoring issues of class and privilege is to hire outside help with a commitment to pay fair wages and benefits. The Domestic Employers Network offers a checklist of best practices (domesticemployers.wufoo.com/forms/welcome-to-the-employer-checklist).

Free or Low-Cost Alternatives

Parents who could use additional child care but don't have the budget for it sometimes find creative solutions, including swapping care with another family or creating a babysitting cooperative. In some cooperatives, families take turns watching everyone's children. In others, members earn coupons when they sit for another family that they can later redeem for babysitting for their own kid(s). A low-cost option is a preadolescent parents' helper who will play with your young children while you are working in another part of the house but available if needed.

Another strategy is to get as much value as possible from the people you are already paying. For example, ask your sitter to put together new shelving for you or to work with your kids to sort through toy bins and separate out items that they have outgrown. Some sitters do dinner prep, wash dishes, or fold laundry. If additional chores were not included in the job description, you will likely find it harder to ask for the help; ideally you will want to discuss household assistance at the time of hire, so you can later ask for those jobs (mostly) guilt free.

The same concept of getting maximum value from your assistants also applies in your research and teaching. Teaching assistants can set up the class Wiki, suggest exam questions, or take notes on ways to run things more smoothly next semester. When I asked a professor named Angela if her students could be doing more to move their joint research forward, she said she worried about protecting the students' time for their own work. She noticed, though, that a colleague expected much more of his students, and although the students might experience that as a burden, they were also completing their degrees with more publications on their CVs. After realizing that the

additional work would give her students more impressive portfolios, she went ahead and asked for more.

Work to Be Fully Present When Home, Even If You Are Not Home Every Night

In her book *Ask the Children*, Ellen Galinsky (1999) presented the results of a survey that asked children how they feel about their parents' work. It turns out that children are just as happy with mothers who work as with mothers who are full-time stay-at-home parents, but children want their parents to be fully present when with them, not distracted by other tasks. When a busy academic administrator wanted to think through ways to enhance her home life, I explained the concept of being fully present and suggested they designate a place to park electronics during the dinner hour. The administrator responded, "That's excellent. I bet my kids will be so happy that I am turning off my phone, they won't complain about having to turn off their phones."

The first vignette at the start of this chapter described Teresa's frustration that she could not enjoy a date with her husband because her mind was still racing through everything she had left undone at work. Teresa wanted to know how to make a mental shift so that she could enjoy her family time. Some solutions come from David Allen (2001), the author of *Getting Things Done*. Allen insisted that we need to have systems that we trust to keep track of all our tasks. If there are important items that have not been captured in a reliable tracking system, those "open loops" will clutter our brains and impair our ability to be fully present with what we are doing in the moment. Closing open loops includes having to-do lists that we regularly check. Allen also suggested maintaining a "waiting for" email folder of items that require action on the part of another person but that we will need to monitor to confirm that the action occurred. Teresa decided to keep a notebook of tasks that she needed to do, and when her mind started to race through everything that was left undone, she would remind herself that "it's in the notebook" and then gently bring herself back to being present with her husband.

Take Time for Rest and Recovery, and Engage in Interests That Require Focus

I worked with a middle-aged professor who was sure that her memory was declining, because she couldn't remember at the end of a proposal what she had read at the start. She was quite concerned about this and wondered if there was some kind of brainteaser activity that she should be practicing to

strengthen her memory. Shortly after we had that conversation, she went on a long-planned two-week vacation to France. In our first session after the vacation, she told me not only that she had a great vacation but also "I'm reading the rest of the proposals, and I'm not having any trouble retaining what I've read!" It wasn't brainteasers that she needed but rest and recovery.

Stephen Covey (1989) emphasized the importance of renewal as Habit 7 in *The 7 Habits of Highly Effective People*. Covey told the story of a man who was exhausted after five hours of trying to saw down a tree. But when someone suggested he sharpen his saw to make the work easier, the man insisted that he didn't have time, because he was busy sawing (p. 287). Covey explained that engaging in activities that promote renewal is akin to the lumberjack sharpening his blade, and thus he called these activities "sharpening the saw." As a scholar, your primary instrument is your brain, and one way to sharpen that instrument is through rest and relaxation.

Going on vacation is one way to get the rest we need, but professors also need to build rest and recovery into their everyday work routines. In a study of knowledge workers, Charlotte Fritz, Chak Fu Lam, and Gretchen Spreitzer (2011) surveyed over 200 employees to learn the best strategies to maintain vitality during the workday. Fritz and her colleagues looked at two kinds of strategies: "microbreaks," which are short activities unrelated to work, and "work-related strategies." It turns out that most of the microbreaks and work-related strategies that workers regularly use when they are tired are not actually revitalizing. These include the following:

- having a caffeinated drink
- snacking
- surfing the web
- reading and sending email
- venting about a problem
- shopping
- smoking
- talking with coworkers about common interests such as sports or hobbies
- listening to music

Much of the list seems intuitive. Venting keeps you focused on the negative and thus is draining. Surfing the web and shopping are avoidance techniques. When we return to the problem, it is just as difficult, and we feel guilty for wasting our time. Eating might give us a sugar buzz with a short-lived pick-me-up, but then it leaves us even more tired than when we started. Even the strategies that appear benign, such as talking with coworkers or listening to

music, are attempts to find external solutions to our fatigue. The one micro-break that was associated with greater vitality was meditation.

Fritz, Lam, and Spreitzer (2011) found a number of work-related strategies that *are* positively associated with vitality. They include the following:

- learn something new
- focus on what gives me joy at work
- set a new goal
- do something that will make a colleague happy
- make time to show gratitude to someone I work with
- seek feedback
- reflect on how I make a difference at work
- reflect on the meaning of my work

The energizing strategies are all related to learning, relationships, and mean-ing. They involve thoughts and actions that shift our internal state or bring a new perspective to our work rather than ingesting food or drink or engaging in activities that take us away from our work.

The energizing strategies also help to address one of the hardest parts of sticking with major writing projects: the lack of short-term gratification. Often teaching and service tasks are prioritized so that you experience a "hit" of satisfaction when you feel that you are making a difference. The suggested ideas for energizing breaks give academic writers a similar hit of satisfaction within their more solitary work. For example, a scientist who does research on climate change and takes time to consider that this work could impact climate policy might feel an immediate sense of fulfillment in doing his or her work. Even if the focus of a professor's work is less altruistic, taking time to show gratitude or thinking about what brings you joy are ways to get a lift without leaving the arena of your research and writing.

Positivity

Researcher Barbara Fredrickson (2009), the author of *Positivity*, explained that people who are in a positive state more quickly identify creative solu-tions to problems. When researchers induced a positive mood in medical students, the students more quickly arrived at the correct diagnosis for a hypothetical case (Isen, Rosenzweig, & Young, 1991). Even our actual field of vision is broader when we are experiencing positive emotions (Fredrick-son, 2009). The method I frequently prescribe to induce a positive state is a gratitude journal. In his book *Authentic Happiness*, Martin Seligman (2002), one of the founders of the field of positive psychology, explained that having people write down a few things for which they are grateful each day improves

their level of happiness. Your items can be specific, such as "the sun-warmed tomatoes I ate from the garden today" or "I found a solution to the problem I was having with chapter 7," or more general, such as "good health" or "central heating and cooling."

INTO ACTION

Choose from the following activities that my clients have found helpful, or design your own revitalizing strategy from the list of positive work-related strategies provided in this chapter. Write a reminder note in your planner, or set a timer to go off during your work session to remind yourself to use your chosen strategy.

- Take a 10-minute break to meditate or do yoga.
- Set a new goal for the next 30–60 minutes.
- Write down 10 things you are grateful for.
- Write about how your work is meaningful.
- Write down 3 things that bring you joy.
- Send a short, appreciative note to a colleague or family member.

Some people tend to brood on worries. During the time that you are writing the gratitude list, you are practicing a different kind of thinking, which, continued over time, will change your emotional state. The gratitude journal has an even more powerful impact when shared, so if you want to invite a friend or spouse to practice this exercise with you and exchange daily lists, all the better.

Outside Interests

In her book *Composing a Life*, Mary Catherine Bateson (1989) wrote of her own career, including a stint as dean of the faculty at Amherst, and of the lives and careers of several of her close women friends. Bateson's friend Alice d'Entremont was denied an engineering scholarship she had earned through a high test score because she was interested in the arts in addition to engineering and because she was "a girl." The implication was that as a demanding occupation, engineering requires single-minded focus. Although this occurred in an earlier generation, some academics still believe that outside interests will detract from their productivity. However, in the book *Motherhood, the Elephant in the Laboratory*, physicist Deborah Harris (2008) pointed out that eminent physicists had outside passions, including Albert

Einstein, who played the violin, and Richard Feynman, who played the bon-gos. Einstein and Feynman provide vivid examples to back up the research that outside interests can support rather than detract from career success. For successful academics, those interests might range from physical activities such as jogging, yoga, or dancing to family activities, gardening, knitting, beading, cooking, and a variety of other pursuits.

INTO ACTION

1. What activities, outside of the academy, do you currently do that require focus and provide a rest from your academic work?
2. Are you satisfied with your current mix of outside interests? If not, brainstorm a list of activities you might enjoy. Once you have your list, choose an activity that you would like to implement. Get out your planner, and schedule time for the activity in the next week.

Be Very Clear About Priorities and Intentional About How You Spend Your Time

Leslie, a researcher and endocrinologist, was frustrated after losing a weekend morning to painting furniture at her kids' school. Leslie sighed and told me, "We really shouldn't have taken this on. We had thought that it was some-thing the five of us could all do together, but it turned out that the kids really couldn't help that much, and so they ended up playing in the next room while Jeff and I worked. I'm disappointed because we won't have had much time with the kids this weekend, and now school is starting, and things will get even more hectic." Leslie felt pulled to offer hands-on assistance despite making generous donations that would cover the cost many times over of having someone paint furniture.

In understanding why it can be hard for someone like Leslie to say "no" to volunteering, it is helpful to consider the concept of role conflict. Role conflict occurs when the characteristics needed to be successful in our work lives are at odds with the characteristics that we see as important parts of our gender or cultural identities. In Leslie's case, her gender role socialization told her that as a caring mom, she should spend more time helping at the school. The school's culture of volunteering created external pressure, but there was internal pressure as well. In the end Leslie realized that although she could not take on big projects or weekly commitments, she could occasionally take

off a couple of hours to volunteer in the classroom or watch her children perform in a play. This middle ground fulfilled her desire for involvement with her children's school, without causing undo stress.

Sally, an assistant professor with young children, faced a role conflict when planning for a visit with her in-laws. Her stress level went through the roof when she realized just how much the visit would interfere with her research schedule. I asked if she could ask her in-laws to be on duty with her kids for some of the visit. Sally found her in-laws to be challenging, so she was hesitant to carve out more work time, fearing that it might hurt their feelings. However, she decided to give it a try. When we spoke afterward, Sally told me that the grandparents took her kids on excursions to the park and the zoo and hung out with them at home while Sally worked. Having some time away every day allowed her to be more patient with her in-laws, and they not only were not hurt that Sally was less available but were also happy to have the time alone with the kids. In fact, at the end of the visit, her in-laws declared, "This was the best visit we ever had!"

Nicole, who was raised in a working-class household by parents who both punched time clocks, faced a conflict between the demands of her job and the expectations of her parents. Despite putting a huge emphasis on their children's education and being proud of Nicole's accomplishments, her parents were not familiar with the world of academia. Many academics were raised in middle- or upper-class families that accept that adult children might move away for career opportunities. They expect parents to support their children, not vice versa, and they assume that work will expand beyond a 40-hour week. Nicole's parents expected their adult children to stay close to home and to provide regular, hands-on help for their parents.

When she went on the job market, Nicole limited herself to positions within driving distance of her folks, and even with young children at home and the pressure to write and publish, she makes the four-hour drive to visit her parents every month to help them with household tasks. In spite of this, Nicole's parents sometimes complain that she does not do enough for them. They don't understand why Nicole works on weekends, and they worry that working so much might cause her to lose her husband. Although Nicole does her best to explain the academic work culture to her parents, over time she realized that they would never fully understand. She loves her parents and continues to help them as much as she can, but she has come to accept that there might always be a gap between what she can offer and her parents' ideal of how she should relate to them as parents.

As in Nicole's White, working-class family, emphasis on respecting and supporting elders is also more pronounced in Asian, Latino, and African American cultures than in White middle- and upper-class America. In her

book *Breaking the Bamboo Ceiling,* Jane Hyun (2005) explained that even second- and third-generation Asian Americans who are outwardly accultur-ated may continue to hold Confucian values, including having a focus on the collective good and filial piety. In traditional Chinese culture, the respect for age was shown even in how people are taught to refer to siblings as "older sister" or "younger brother" rather than by their given names. These cultural values (as well as language, economic, and cultural barriers) play out in care-giving, with Asian Americans, Latinas and Latinos, and African Americans all being less likely to use institutional care for their older relatives than White Americans (Bookman & Kimbrel, 2011; Dilworth-Anderson, Williams, & Gibson, 2002; Hyun, 2005; Torres, 1999; Weiss, González, Kabeto, & Langa, 2005). Academics who face these responsibilities will need to be even more protective of their time and, whenever possible, involve other family, friends, and community services as part of their care team.

Another barrier is the sense that a spouse "won't do it as well as I do." At the 2004 Conference for Women Physicians given by the Michigan State Medical Society Foundation, Dr. Linda Hotchkiss told the group about how she became fed up with being the parent who woke up with her son on both weekend mornings:

> When I brought it up with my husband, I was all pumped up with indignation and ready to do battle. His immediate response was, "You're absolutely right, I'll take over Sunday mornings. That seems more than fair." And there I had been all ready for an argument, and his prompt agreement took the air right out of me. And when Sunday came, he jumped right up when our son woke up, just as he had agreed to do. But I couldn't help listening to the sounds from downstairs, and I heard breakfast noises, but they weren't my break-fast noises, so I just had to go down to see what was happening. As I started into the kitchen, I realized my son had barbecue sauce all over his face! My husband and son were at the breakfast table eating the leftover ribs from the takeout we had for dinner the night before. Now armed with the incontrovertible evidence that only I could ensure our son would eat truly nutritional meals, my hands went up on my hips, my eyebrows went down, and I was about to start lecturing my husband about how ribs are not a balanced breakfast. Before I began to breathe fire, my husband looked me dead in eye and said, "Go back to bed. Either I am going to do this my way, or you can do it. Your choice." There was a very, very long pause. And I came to my senses—and mulled over the reality that maybe it wouldn't kill my son to occasionally have ribs for breakfast. In fact, the trade-off of a less than "ideal" morning meal was worth my

chance to catch up on rest once a week. So I quietly turned around
and went back up to bed.

There are many other tasks at which you might be more competent than your spouse. I suggest that you ask yourself, "So what?" "So what if our child is wearing clashing colors?" "So what if we don't give the perfect wedding gift?" If you can live with the "so what," then go ahead and delegate the task. Delegating to your children brings up the same issues of loss of control and comes with a steeper learning curve than delegating to one's spouse. It takes an up-front investment to teach your older kids how to cook a dinner or even to wash the dishes adequately. However, if you put in the effort, you will reap a long-term payoff in additional time, as well as self-confident children who have gained valuable life skills.

Role conflicts also occur when professors face competing pulls at work. An overstretched pretenure faculty member took on a struggling advisee because "I'm the only one who will put in the time needed to get him through the program." That may have been true, but that effort was jeopardizing the work she needed to finish to achieve tenure. Without tenure, she would lose the ability to mentor many more students for years to come.

Some women step back from more ambitious career opportunities because they are not willing to sacrifice the kinds of relationships they want to have at home. This includes physician researchers who move to a clinical track that offers more controlled hours and professors who decline opportunities to serve as dean or provost until their children are grown. These are personal choices that often involve much soul searching.

Before you pass up an opportunity, consider whether it can be negotiated to better fit your needs. One senior administrator regularly leaves the office at 3:00 p.m. to be home with her children. She arrives at the office early and works from home in the evening, but the flexible schedule allows her to be the kind of mother she wants to be. There are trade-offs: The academic who negotiated an early afternoon end time explained, "I would not recommend this to anyone who aspires to a university presidency, as research shows that when women work reduced hours, it limits their opportunities for advancement." However, the accommodation she negotiated allows her to do a job that wouldn't otherwise be possible at this stage of her life. Other modifications that might make a position workable include sufficient administrative support, a higher salary that would allow the purchase of more support services at home, a flexible schedule including a day to work off-site, a piece of the job split off and given to another professional, or a reduction in other responsibilities such as teaching.

Give and Take With Other Families

Most working parents make extensive use of carpools and playdates, and these connections provide a safety net when parents have late meetings or an unexpected snowstorm closes the schools. It can be hard to determine how much is okay to ask and how to keep the load relatively even between families. This issue came up for a professor whose son had recently received several invitations from a school friend whose family lived out in the country. The professor explained,

> *I felt bad saying he couldn't go, since I am technically available, but I just have to have time to write. The mom is a stay-at-home mom, and she keeps offering to bring my son back to our house after the playdates. I took her up on it the first time, but it didn't seem right for her to have to keep doing it. I'm torn, because I think she really wants her son to have the company.*

I suggested a token gift as a way to even the scales. Tokens need not be time-consuming or expensive to bring a sense of balance to the exchange, but they show that you notice and value the other party's efforts. After brainstorming possible tokens, the professor decided to ask her sitter and kids to bake a loaf of banana bread for the other family. She said, "I feel good about this. As a stay-at-home parent, I think she has more time than I do, but I'm sure she could use more appreciation."

Sequencing

A common saying to new parents is "You can have it all, but you can't have it all at once." In a chapter titled "Three Sides of the Balance," NASA atmospheric scientist Anne Douglas (2008) described how she practiced sequencing. Douglas began her career as a laboratory scientist, but with a growing family, she switched from working with lab data that she observed herself to analyzing satellite data. The satellites could work at all hours of the day and night, which allowed Douglas to leave the erratic hours of the lab behind and be home with her family in the evenings and on weekends. In Douglas's case, sequencing meant choosing work projects that best fit with her stage of family life. For others, sequencing might mean holding off on their desire to serve on a community board or putting off projects that require extensive travel until after their children are older or have left home.

Issues of Culture and Community

Because of the cultural emphasis on family and community, some academics of color and/or from working-class backgrounds put greater weight on

location when ranking job opportunities. These academics want a position that allows them to live close to important people in their lives or to live in an area where they can build connections with others who share their culture, even if it means working at a slightly less prestigious institution. A Latina/o academic explained that when evaluating positions, important factors included:

> . . . the type of community in the town or within driving distance from the town, the availability of Latino food, music, and cultural events, and the support for Spanish/English bilingual education in the local school system. Of course I also had to consider my geographical proximity to my family, especially mi Mama. Of all the variables in my job search I feared her reaction the most if I were to move too far away from her and take her *nieto* (grandson) away from her. (Delgado-Romero, Flores, Gloria, Arredondo, & Castellanos, 2003, p. 266)

Likewise, most academics across a spectrum of gender and sexual identities want to live in locations where they can find allies. In her chapter "What's Love Got to Do With It? Life Teachings From Multiracial Feminism," Kari Lerum (2012) explained, "My upper-class, white, graduate-student colleagues thought I was crazy for limiting my geographical options" (p. 269). But her colleagues who were "women of color, queer, and/or working class" (p. 269) understood her decision to give family and community equal weight with career goals. For lesbian professors, choosing one state over another has made the difference between having legal bonds to their children, being able to include their family members on a health insurance plan, and being able to legally marry with all the attendant rights. Although the legal climate is rapidly changing, the level of acceptance in one location versus another will continue to affect the quality of life for transgender people and lesbians.

When I presented at a conference for women of color at a prestigious university in a small, mostly White town, a running joke among the speakers was that their institution is "geographically challenged." One of my clients put it more bluntly, saying, "I do not want to raise my child here—no way. There is no diversity. You can't even speak of a Black community. There are few Latinos, and only slightly more Asians."

Those with children want to raise them in a culturally supportive environment. Single women of color who want to date and marry within their culture have to contend with the absence of a nearby pool of potential spouses. When I work with women of color who are in "geographically challenged" areas, they often feel they must be über-productive because their goal is not just to gain tenure at their current institution but also to move to an institution that will offer a more satisfying personal life. When a woman

of color goes on the market, it is not unusual for her to be faced with a difficult decision between the program that offers the best resources for her advancement in a more isolated location and a program with fewer resources in a more supportive social environment. One talented woman followed her mentor's advice to start early in her career at an institution that provided more career advantages but less social support. After making major progress on her research and publishing, she moved on to a university in a better location. She loves the greater diversity within both the institution and her neighborhood and started dating for the first time in a long while, but she still struggles with whether the move to what she described as a "scrappier university" was the right one.

Regardless of geographical location, academics from diverse backgrounds often experience a split between their cultural and academic identities. They grapple with whether expressing their full identity will be a liability in the academic workplace, and they have to make deliberate choices about how much to show or downplay their unique cultural identities. As an African American professor of law, Ruth Gordon turned to an African American colleague who is a few years ahead of her in career trajectory for advice on whether to keep her braided hairstyle. Professor Gordon wanted to know, "Would it hurt my chances for tenure, alienate my colleagues or students?" (Gordon, 2012, p. 320). This was not an unfounded concern, as African American women have been fired from jobs for violating workplace rules against braids, even with very neat and conventional hairstyles, and as recently as March 2014, the U.S. Army issued rules that severely limited or prohibited styles, including "cornrows, braids, twists, and dreadlocks" (Byrd & Tharps, 2014; Caldwell, 1991). Gordon's colleague supported her choice to keep her braids, and Gordon, who successfully earned tenure and went on to become a full professor, credits a supportive group of African American professors as being an important source of affirmation that helped her keep her cultural identity intact and still succeed in academia.

Similarly, a Latina professor explained,

> When searching for a position I had to make a decision about how Latino-focused I wanted to be personally and professionally and find an environment, both at work and in the community, that would fit my needs. I decided that I was going to use both of my Spanish surnames and insist that people not shorten my name or mispronounce it. A few search chairs seemed put off when I corrected their pronunciation of my name, but I felt it was worth the effort, especially if I ended up working with them for many years. (Delgado-Romero et al., 2003, p. 266)

At the same time, in a chapter on Latina/os in higher education, Edward Delgado-Romero and his coauthors (2003) pointed out that some scholars don't have a choice about "how Latina" to be—others decide for them, on the basis of their skin color, accent, or other characteristics. In still other cases, some people may be seen as not legitimately Latina/o because they do not speak Spanish or have lighter skin, or they are viewed as Black but not Latina/o because of their skin color or hair texture. Dealing with others' sometimes mistaken assumptions about your identity carries its own level of stress.

For faculty members who were first-generation college students, a sense of otherness at work may be accompanied by a loss of belonging in their home communities. Family and friends may rib a professor for being book smart but lacking in common sense, or her values and loyalty may be called into question because she is not perceived as sufficiently giving back. In the chapter on "Developmental Career Challenges for Latina/o Faculty in Higher Education" (Delgado-Romero et al., 2003), one of the authors wrote that despite efforts to be available to Chicana/o and Latina/o students, "many questioned whether I was a *vendida* (cultural sell-out). Why was it that I missed so many Chicana/o student events? Why didn't I make it to the MEChA social? Why wasn't I volunteering my weekend at the local Latino community center?" (p. 274). However, this professor concluded, "Ultimately, what use would I be to the Chicana/o and Latina/o students if I did not earn tenure and was required to leave the campus at which they needed my support?" (p. 274).

An antidote to this kind of isolation comes from spending time in arenas where a person can put down her guard, relax and recharge, and bring her full self—including her cultural and academic identities. Chapter 5 of this book, "Networking and Social Support," describes in more detail how women create and benefit from membership in supportive groups for women with a common cultural identity.

Faculty Members With Disabilities

Although she knew that I was pledged to keep what she told me confidential, Vivian was so concerned about keeping her illness private that she told me that she had multiple sclerosis only after we had worked together for many months. She worried that if colleagues knew that she had a disability, it would limit her opportunities. For the same reason, Joanna disclosed her chronic illness to colleagues after 11 years, only when she began to use a cane for support. But when I asked Joanna if she feared that the disclosure would limit her opportunities, she laughed and said, "I realized that my colleagues are so caught up in all the work that *they* need to do, it makes them kind of

oblivious. Right after I told them about my illness, they asked me to lead up a major initiative in our department."

For those whose challenges are not readily apparent, the choice of whether to be open about a disability will depend on one's personality and situation. Issues to consider include your stage in the tenure process, the atmosphere in your department, how others with disabilities have fared, and whether you believe it is possible to carry out the core functions of your job without reasonable accommodation.

A January 2012 report by the American Association of University Professors pointed out that universities have made greater strides in addressing the needs of students with disabilities than the needs of faculty members with disabilities. The report highlighted the value of supporting scholars with disabilities, outlined the rights and responsibilities of both the scholars and the academic institutions, and provided additional resources. It also gave striking examples of the contributions of faculty members with disabilities, including Temple Grandin, Stephen W. Hawking, and Kay Redfield Jamison (Franke, Bérubé, O'Neil, & Kurland, 2012).

I've coached academics with repetitive stress injuries, chronic illnesses, depression, and attention deficit disorders. Accessing support for ergonomic computer setups or voice recognition software is often the least challenging part of the equation. More difficult is being held to the same timelines as colleagues without disabilities. Voice recognition software can be a lifesaver for a person with a repetitive stress injury, but most of us use writing as a thinking process, not just a way to record what we already know. So losing the ability to type may also significantly slow down the process of crafting an argument, not to mention the fact that even for native speakers, voice recognition requires editing and correction. Professors who suffer from chronic illnesses, including mood disorders, experience episodes of fatigue that impact their productivity. Sometimes a person must make difficult choices to preserve energy. A colleague with post-polio syndrome loves to swim, but she came to a point where she had the energy to either swim or work full-time, but not both. The upshot is that it is even more crucial for academics with disabilities to take good care of themselves, protect their time for mission-critical activities, and delegate wherever possible.

Given that we all experience changes as we age, disability activists have suggested that the correct term for those without disabilities is *temporarily able-bodied*. Regardless of health status, professors in their 40s, 50s, and beyond tell me that they can no longer get by with the junk food and all-nighters they pulled in their younger days. To be maximally productive at work, they too must implement sustainable habits to move their research and writing forward, and they need to give more time and attention to the care of their physical and mental health.

Work-life balance is more than something nice to have on the side, along with a great career: It is part of the foundation needed to sustain oneself in order to work productively over the long term. The research on dual-centric people shows that it is a mistake to say, "I can't afford the time to exercise, engage in a hobby, or go on vacation." To function at the highest level, you can't afford not to attend to your physical and emotional health.

INTO ACTION

Use the following questions to assess how you are doing on work-life balance and where you might want to make changes:

1. Do I have regular times when I disconnect from electronics?
2. Do I demarcate between when I am working and when I am off duty?
3. Can I free up time by delegating, hiring more help, or asking for more assistance either at work or at home?
4. When I spend time with my spouse, friends, or kids, am I fully present?
5. Have I taken a vacation in the past year?
6. Am I getting enough sleep?
7. Do I pause for short, revitalizing breaks throughout the workday?
8. Do I engage in interests outside of work?
9. Where am I experiencing role conflict? Are there duties I take on out of a sense of obligation even though they don't match my priorities?

If the answers to these questions revealed areas that deserve attention, then I invite you to choose one or two changes to make in the next week. In his book *The Power of Habit*, Charles Duhigg (2012) explained that some "keystone habits" have positive carryover into other areas of life. For example, people who exercise also start to eat better, work more productively, reduce the amount they smoke, and get along better with other people, and people who keep food journals make healthier choices and lose weight (Duhigg, 2012). Both exercise and food journaling are keystone habits because they trigger other positive changes. For some, getting enough sleep is a keystone habit, because when they are well rested, everything else comes more easily. As you consider a change to start with, ask yourself what change is most likely to be a keystone habit.

5

NETWORKING AND SOCIAL SUPPORT

Social networks play a significant role in academic success. Despite the image of the individual scholar toiling alone, all the successful academics I know are part of strong interdependent networks of people who support one another's work. As a coach, I frequently strategize with my clients about how to build, manage, and maximize relationships. In this chapter I explain the importance of having a broad range of support, review barriers to networking and ways to overcome them, and offer practical strategies for how to develop your own network.

The Importance of a Broad Network

Many colleges offer official mentoring programs that pair a junior faculty member with a senior colleague, often from outside her own department, and encourage the pair to meet at least a few times a year. Although these relationships are often beneficial, most successful women do not have just one capital "M" mentor but a number of people to whom they turn for various kinds of advice and support. A senior member of the department may be helpful at explaining departmental priorities and politics, but someone outside of one's own department could be a better source for advice on how to balance work and family. A former advisor may have good counsel for going on the job market, but a peer from graduate school might be better able to offer tips on conducting a dual-career job search. Assistance does not always flow in one direction; for example, a full professor appreciated

that her junior colleagues could fill her in on resources that had not existed at the start of her own career. A network offers better support than any one person could provide.

Sponsorship

A *mentor* provides support and advice, whereas a *sponsor* goes a step further and actively promotes a protégé within an organization. A mentor might give you advice on how to move into a service role in your professional society, but a sponsor would suggest your name to the society's leaders as a good candidate to serve on or lead a committee, nominate your work for a prize, or otherwise champion your career. In their *Harvard Business Review* article "Why Men Still Get More Promotions Than Women," Herminia Ibarra, Nancy Carter, and Christine Silva (2010) reported on their research that shows that women in the corporate world are being mentored extensively, but men are moving up the ladder because they are not only given advice and support but also actively sponsored. The men's sponsors are senior executives who introduce them to the right people or who are part of the conversations in which promotion decisions are made. Furthermore, the men's sponsors have more organizational clout than the women's mentors.

The authors profiled Deutsche Bank, which realized that it was losing talented women who were leaving for other firms, not for greater work-life balance but because they were not being given the opportunity to advance within Deutsche Bank. When Deutsche Bank matched women with senior sponsors, the number of women in top jobs markedly increased. Unilever developed a sponsorship program in which it matched women with executives who had expertise in areas the women lacked and who were in positions of power. Because the sponsors often worked in areas different from those of the women they sponsored, the pairs had limited contact, but the fact that the sponsors had real power in the company made a significant difference. IBM Europe created a successful sponsorship program by making the sponsors, not the candidates, responsible for their protégés being ready to move into positions of greater responsibility (Ibarra et al., 2010).

What does this research from the corporate world have to do with academia? One lesson is to go beyond the people who are emotionally supportive and accessible and form connections with people who may be gruff or matter-of-fact but who have the power to support your goals. Men tend to focus less on making connections with people for whom they have an affinity and more on putting together the strongest possible team to meet their objectives. Women will also do well to develop networks that include people who have the power to support their ambitions.

The Significance of Weak Ties

In 1973 Mark Granovetter published an influential article in the *American Journal of Sociology* titled "The Strength of Weak Ties." Granovetter found that job seekers were much more likely to find a position through weak ties than strong ones. He explained that when people are part of a tight-knit group, they all generally have access to the same information. People further outside of the group who are part of other networks will be aware of a different set of opportunities (Granovetter, 1973). My own experience is that academics with a broad range of connections are much more likely to learn of funding opportunities, to be invited into collaborations, to attend small invitation-only conferences, and to enjoy other career-enhancing opportunities.

Cultural Support

For women of color and others who might be one of a few or the only member of their cultural group in a department, an important source of additional support may be affinity groups with other people in their discipline or at their institution who share their cultural identity. In the essay "Latinas and the Professoriate: An Interview With Patricia Arredondo," Arredondo explained,

> The Chicano Faculty and Staff Association (CFSA) is a great connection for me. In this association, I find that people really care about one another. . . . Hay un personalismo y un buen sentido de familismo (there is a sense of personal connection and a sense of family) that is just automatic; it breathes. (Arredondo & Castellanos, 2003, pp. 230–231)

Those who don't have the kind of support Arredondo described within their home institutions often build networks of support with colleagues in their larger profession. Ruth Gordon, an African American professor of law, described the invaluable role of one such network:

> When I began my teaching career, I felt that I possessed a secret weapon, a safety net, a connection with a much wider community. There was always the Northeast Corridor Collective, whose members I could count on to help with gender- and race-based slights, to assist in navigating tenure, to read and critique my article drafts, and to assure me that I could keep my braids and the rest of myself. (Gordon, 2012, p. 322)

Although more strongly represented in the sciences, Asian American women who are in the social sciences and humanities may find themselves to be the only ones from their cultural group in a department. In her chapter "Struggles

for Professional and Intellectual Legitimacy: Experiences of Asian and Asian American Female Faculty Members," Fanny P. F. Yeung (2013) explained that Asian Americans, more than international Asians, tend to feel solidarity and often build supportive alliances with other ethnic American faculty members (such as African Americans or Latinas/os). One woman profiled by Yeung discussed the benefits of staying in touch with a cohort of women of color she met as part of a fellowship that brought her together with others in her academic field:

> We just really formed a really tight-knit bond, and we've kept in touch ever since. . . . We're all kind of on the same trajectory in terms of where we want to publish. We're all working on books; we're all at competitive places. . . . I really benefited from it, and now I see why, kind of how White men do it. I'm a part of a network with women of color, and the thing that's interesting is that these women of color are pretty powerful. (Yeung, 2013, p. 286)

Another woman emphasized the effort that went into staying connected, as well as the value:

> We made this thing that we would e-mail each other monthly . . . and even had a format for what we wanted to tell each other . . . and it's something you have to work on and nurture. It doesn't just happen . . . I don't think I would have stayed sane without these women. (Yeung, 2013, p. 286)

INTO ACTION

If more culturally specific support would be soul nourishing, but you are not sure where to find it, start by inviting a colleague to meet for lunch or a writing date. If you are an "only" in your area of study, nurture cultural connections from outside of the academy and/or form coalitions with other ethnic Americans on your campus or in your profession. A small sampling of cultural and ethnic professional associations includes the following:

- National Latino/a Psychological Association
- Gay and Lesbian Medical Association
- National Society of Black Engineers
- Asian & Pacific Islander Caucus for Public Health

- American Association of Physicians of Indian Origin
- National Asian Pacific American Bar Association
- Native American and Indigenous Studies Association

A quick web search of your ethnic group and profession will identify any existing affinity groups.

Barriers to Making Connections

Some people are reluctant to seek out support from sponsors or mentors because they feel as if they are doing all the "taking" in the relationship. However, many seasoned professors had dedicated mentors and want to offer the same kind of assistance they received to a new generation of scholars. Others take satisfaction in being able to provide the kind of support they wish someone had given them. It is also true that as the mentee becomes established, she keeps her mentor apprised of new trends in the field and introduces her mentor to new people, adding strength to the mentor's professional network.

Another barrier is a lack of understanding about how one finds a mentor. Facebook chief of operations Sheryl Sandberg cautioned against walking up to someone you barely know and asking, "Will you be my mentor?" (Sandberg, 2013, p. 67). Outside of formal mentoring programs, these relationships usually develop incrementally. Start with small steps to reach out to those around you. You might invite a senior member of your department to lunch, ask someone who does interesting work to meet with you at an annual conference, or stop by the office of a colleague to ask for his or her input or advice. If you receive a warm response, you can continue to develop the relationship over time.

Many academics respond to the suggestion that they work to enlarge their social networks with a shudder of discomfort. These professors insist that they don't want to be artificially friendly in order to garner favor from everyone they meet. Wayne Baker (2000) professor of management and organizations at the University of Michigan, argued that Americans have a myth of individualism and like to think that our successes are based only on our own efforts, but the reality is that we are interdependent with other people. Baker asserted that the real issue is not whether to manage relationships but how to manage relationships ethically. We have no qualms about planning a regular date night with a spouse or periodically inviting friends to dinner in order to maintain the relationships. Keeping our distance from people

who drain our energy and nurturing connections with people who sustain us, whether through friendship or instrumental support, is only common sense.

In a piece titled "How Do You Teach Networking?" in *The Chronicle of Higher Education*, James M. Lang (2011), a professor of English at Assumption College, wrote about the new appreciation he gained for networking after spending time at a conference with his brother, who is a political scientist and scholar of ethics in international relations at St. Andrews in Scotland:

> We could not go more than five or 10 minutes without running into someone who greeted Tony by name, and who wanted either to catch up with him briefly or talk a quick little bit of shop—their plans for a forthcoming conference, comments on a recent controversial publication, questions about the editorial board of some new journal. Sometimes, after the person had moved on, Tony would explain the association. "He's a former Ph.D. student," he would say, "and he's teaching in England now." Or: "I wrote him a letter of support for his tenure case." Or: "We're planning a panel together for a conference I'll be at this summer." None of it ever struck me as unctuous, self-promotional, or even directed toward a specific goal. It looked to me like the way the business of his discipline was getting done, as he made and reaffirmed contacts with a host of people who were all invested in the enterprise of conducting research and teaching in international relations.

A friend of mine described his view of academic meetings this way:

> *When I first started going to conferences, I thought the point was going to see what people were presenting. When I saw people talking in the halls and realized they were going to stay out there and talk even though a session was starting, I judged them as slackers. When I got to know more people, I realized I had it completely backward. Meeting people, and having those conversations, is the primary purpose of the conference. The presentations are there so that the university will pay for you to be there networking.*

Many of the most successful networkers are people who simply enjoy helping others. They create value when they are able to fill gaps by connecting people with overlapping interests. This could include connecting an outstanding student with a colleague on a hiring committee, introducing two scholars with common interests who are then able to form a collaboration, or connecting a conference organizer with a presenter. Befriending others whom one may later call on for support is a natural part of being active in one's profession.

Networking for the "Schmooze Adverse"

Even when convinced that connections matter, some people can't stand schmoozing. A more comfortable strategy for these professors is to take on service jobs that provide a formal context for interacting with people they would like to get to know. When you plan a speaker series or a conference panel or invite visiting professors to your department, you are spared the challenge of making small talk. Instead, you have a prescribed role to play and are making connections while engaged in a professional task.

I frequently challenge clients to stretch beyond their comfort zone to make connections. If the client has an upcoming conference, I may give her an assignment to choose a few influential people to meet with at the event. Often professors are surprised that the responses they get are quite generous, and they realize that they can handle it if the person says he or she just doesn't have the time. Given the busy nature of professional conferences, it is best to schedule these meetings ahead of time.

INTO ACTION

Think about any conferences you plan to attend this year. A month before the conference, make a note in your planner to contact people you'd like to meet with during the event. Consider asking former advisors or colleagues to introduce you to their contacts. When you attend a conference with students or junior faculty who are doing good work, be sure to do your part as the more senior person by introducing them around and talking up their research.

Pam, my introverted partner, once brought home a J. B. Handelsman *New Yorker* cartoon that shows a couple walking up to a house in which a party is going on. The husband is saying to his wife, "I think I'm having pre-traumatic stress disorder" (Handelsman, 2005). Although Pam is socially astute enough to cover it quite well, she finds large social gatherings to be stressful, especially if she ends up trying to make conversation with another introvert. Even if she genuinely likes the person, if neither of them knows what to say, the interaction is awkward and uncomfortable. If you love the social stimulation and energy you get at a party, you can skip the following material However, if you're like Pam and are relieved when you can get back to a nice quiet book, you will likely be grateful for the tips.

LEARN MORE

A Primer for Conversing at Conventions and Other Social Events

1. Stay current in your field so you know what people are publishing. This provides you with a starting point for a conversation. Most people enjoy discussing their research. You might begin by letting a person know what you appreciate about his or her work or asking a question. From there you can make connections and segue into an aspect of your own research.

2. Choose a few work-related questions to have at hand. Memorize them so they come automatically. Examples include the following:
 a. What projects are you working on currently?
 b. What work in the field are you excited about?
 c. What are your thoughts about _____? (Fill in the blank with a current issue in the field.)

3. Think of it as your job to put the other person at ease. Prepare for both spontaneous and formal conversations. Casual questions include the following:
 a. How was your flight?
 b. How is your semester [or fall, winter, summer, etc.] going?
 c What presentations have you attended so far? How were they?
 d. What are you attending this afternoon?

4. If a conversational partner asks you a question, follow up your answer by turning back to the other person and inquiring, "And what about you?"

5. Plan an exit strategy. "It was good to talk with you" works well as a parting line. A professor told me that she engages well-known people with the opening line "There's something I've always wanted to ask you. . . . " If the conversation continues beyond the answer, that's great, but if it comes to a halt, she says, "I've always wanted to ask you that. Thanks so much," and then moves on.

Networking Strategies

Keep in Touch

Because some types of support are hard to come by, I began asking professors with a particularly helpful colleague or a productive collaborative research

group to explain how they formed those relationships. Statistical support is a common need, and sometimes it becomes a huge problem if a professor needs to get a paper out to make it through the promotion process, but the statistician who did the original work is no longer available or a coauthor with a better grasp of statistics isn't prioritizing the project. So when one of my clients told me that a colleague went beyond just answering a statistical question and suggested she send all the data for him to review, I wanted to know how she found such great support. She explained,

> *I have three people to turn to: One was a PhD student who got help from me with collecting his data in my classes. He's actually kept in touch with me. Another was a member of my dissertation committee whom I've stayed in touch with, and I visit whenever I'm back in the town where I did my graduate work. The other was a member of my undergraduate thesis committee. I hear about her from colleagues and email congratulations when I hear about her accomplishments. I probably do too much staying in touch with people—I even keep up with the woman who ran the kitchen at the job I had in college.*

She went on to talk about social capital more generally:

> *It fails if you just look at what you can get and take versus what you can do and how you can be useful to the other person. Not just when you need something. . . . It's important to think of people in your network when you have something that might interest them.*

The effort this professor puts into maintaining relationships has been hugely beneficial to her career. Sending colleagues articles of interest can also be a thoughtful way to stay in touch, as long as the sender exercises discernment in passing on only those articles that are an exact bull's-eye for that scholar's interests. Sending too much or irrelevant information puts the sender in a category with the well-intentioned but annoying friend who habitually emails alerts about urban legends.

Be Persistent

Mei works with a talented team of researchers, which has allowed her to take on a new area of investigation. As the main driver of the project, Mei does the bulk of the analysis and writing, but her group's regular conference calls provide her with the support to tackle this new area. When I asked Mei how this collaboration came about, she explained,

> *It was kind of a little miracle. My advisor told me about this group, so I emailed the principal investigator, asking to meet at a conference,*

but it turned out that he wasn't attending that conference. So I emailed to say I was sorry I would miss him at the conference and hoped we could connect another time. Then he visited the institution where I was doing my postdoc, but I was away during his visit. So I emailed to say, "I'm sorry I missed you. I would still love to talk with you." My philosophy was that until he said no, I would keep trying.

Mei persisted in following up with the principal investigator until they finally connected. She laid out her idea for a research study and asked if his team would like to join her on the project. He agreed, and it has been an incredibly fruitful collaboration. She went on to say,

On my dissertation, I had to figure out every step myself. I know how to do it that way, but it's the hard way.

Mei is determined to move at a faster pace than she could as a graduate student, and that means asking for help. She also acknowledges that sometimes it feels uncomfortable to lean on others:

In some ways I still feel like a grad student because my collaborators bring so much experience, BUT, of course, I do bring a lot of expertise to the table myself, and I work really, really hard.

Although Mei described the coming together of the collaboration as "a little miracle," she was incredibly determined in following up and very positive in her attitude. For anyone socialized not to be "pushy," this kind of persistence can feel quite uncomfortable. People are quick to assume that if things don't work out right away or if they don't get a response, it means that the person they contacted is not interested. In fact it often just means that the person is busy and/or lost track of the email. Until you hear a "no," you just don't know.

Another client, Naomi, saw that a scholar she admired would be visiting a nearby university. She contacted the program organizer and asked to be put on the scholar's schedule. The organizer slotted Naomi in for a half-hour conversation, and the next time we spoke Naomi was enthusiastic about her experience:

I wasn't sure how she would feel about meeting with me, but she was completely gracious. She just finished her fourth book, and she had good ideas about getting quickly from the first book to the second book. She suggested I think about essays, which would be more discrete chunks compared with the way that I wrote my first book. It is more manageable to think about six articles rather than 360 pages. You can write an article in six months. And in our discussion, she gave me ideas for two chapters.

Naomi had tended to hold back earlier in her career and felt that she had missed out on some valuable relationships and information as a result. When I commented on how much Naomi had changed, she concurred: "I'm being more bold in making connections. I'm not letting myself be overlooked."

Be Open to Many Kinds of Mutual Support

Support for your work can come from unexpected quarters. My friend Carla is a professor in an urban area. One night I presented a workshop for a campus-wide mentoring program she organizes. After the workshop, Carla offered to call her friend Malik, who works in security, to escort me to my car. As we were debating whether I needed an escort, she told me more about her friendship with Malik. Carla said, "I wouldn't have gotten tenure if it wasn't for Malik and Tina, the secretary in my department. I included them in the acknowledgments in my book." Carla continued,

> I could work as late as I needed to and teach any time the department requested, because I knew I could count on Malik to get me safely to my car. But not just that. He always said just what I needed to hear. At one point I was waiting to hear if my book was accepted, and I was thinking, "This is it. If it isn't accepted, I'm out of here." And Malik quoted Louis Pasteur, saying, "Chance favors the prepared mind." And I realized that I was prepared. If it was bad news, I was prepared to go on the market, and if it was good news, I was prepared to do the revisions needed and keep the book project moving. Another time Malik said, "You need to have faith." I'm not religious the way he is, so I had to really think about that. I realized though that I did have faith in myself and the work that I was doing, and that was very helpful.

As useful as it may be to have people to turn to for questions about how to structure a book or where to publish, there are times when it is of equal or greater importance to have supporters who simply listen to your concerns and cheer you on when you're dispirited. Malik's genuine friendship and encouragement were crucial supports to Carla in a difficult time.

Now I invite you to take positive action in developing your own network by following the instructions in the following exercise. This exercise will guide you to create a map of your professional connections and identify next steps to build or strengthen important relationships.

INTO ACTION

Creating a Networking Ecomap

An ecomap is a tool created by social work professor Ann Hartman (1995) to map a person's connections to others in his or her environment. I adapted it to help my clients identify where they have sufficiently strong relationships and which connections need to be forged or strengthened in order to create a dynamic professional network.

On the first networking ecomap (Figure 5.1), a professor has placed herself in a rectangle at the center of the page, with the names of organizations and people listed in rectangles around her, grouped by category. Categories include connections from graduate school, members of her department, journal editors, and so forth.

Lines between the scholar in the center and the other rectangles indicate whether she has any relationship with the person or organization, as well as the strength of the connection:

- A solid line ———— indicates a good relationship.
- A double line ════ indicates an especially strong tie.
- A dotted line - - - - - - - - - indicates a weak relationship.
- A dotted line broken by horizontal markers - - - - -||- - - - - shows a former connection that has not been maintained.
- The absence of any line indicates that the person or organization is one with whom the scholar would like to make a connection but no relationship exists at present.

Using Figure 5.1 as a model, make your own map showing your current and desired relationships and the strength of those relationships. Once your map is completed, use a highlighter to mark connections that need your attention. This could include past relationships you want to rekindle, existing connections you hope to strengthen, and people with whom you would like to become acquainted. See Figure 5.2 for an example of a highlighted networking ecomap.

Figure 5.1 Networking Ecomap

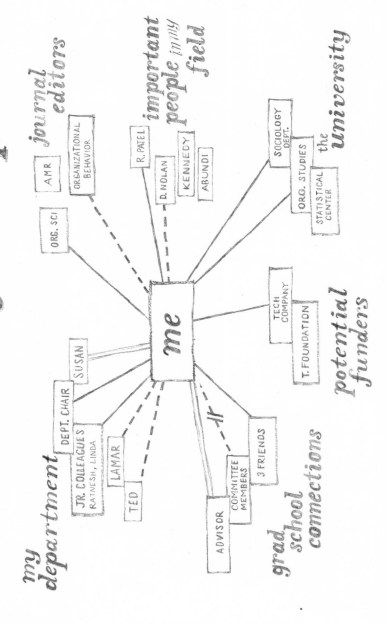

Figure 5.2 Highlighted Networking Ecomap

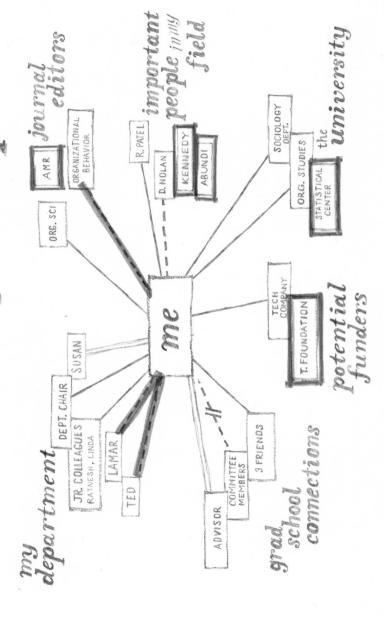

networking ecomap

INTO ACTION

After designing your networking ecomap and highlighting the connections that need attention, write down a plan for how you will initiate or strengthen those relationships. A sample plan might look something like this:

Networking Plan

My department

- Schedule lunches with Ted and Lamar.

My university

- Attend Statistical Center information session.

Journal editors

- Attend AMR professional development workshop at Academy this year.
- Ask *Journal of Organizational Behavior* editor to meet for breakfast at conference.

Important players in my field

- Ask Kennedy for feedback on networks article.
- Invite Abundi to speak here in the fall.

Funders

- Arrange meeting with foundation during visit to Philadelphia.

Each month, carry out one or two of the actions on your plan.

6

TENURE, PROMOTION, AND THE ACADEMIC JOB MARKET

Sonya was upset when her colleague was denied tenure at the college level despite having departmental support. She explained,

> *It isn't as if Dawn hadn't published a lot, but they are not giving her full credit because of the kinds of publications that she has. The senior people in her department didn't have the kind of record that they now expect. And there are fewer publishing outlets than there used to be. Dawn really believed in collaborative work, and our college encouraged that. When they told her to consider projects with this department and that group, she didn't realize that they also expected her to have some solo work. And they say that teaching is valued here, but they don't really mean that. And no one ever says exactly what the requirements are.*

Dawn was able to resubmit her portfolio the following year, and with some additional publications, she was granted tenure. But in addition to the stress on Dawn, it put a strain on her entire department, as well as other faculty in the college. Sonya explained,

> *Although the dynamics were different, Dawn was the second woman recently denied tenure in our college. She is a great collaborator and a close friend of mine—the kind of person I can relax and joke around with. I didn't know whether she would make it through the second bid for tenure, and it also brought back the stress of my own recent tenure bid, which took an emotional toll despite the successful outcome.*

The themes Sonya raised echo frustrations I hear over and over again. The bar has been raised at all levels of higher education. Universities are attempting to boost their research profiles in order to attract top students and to bring in grant funding to offset financial pressures. Assistant professors are expected to have more publications in top-ranked journals than was required 10 or even five years ago. A frequent refrain is "My senior colleagues wouldn't be here if they had been held to the standards expected of *me*."

Written guidelines are frequently vague enough that even for an exemplary teacher with a solid service record and solo publications in top-tier journals, promotion is not guaranteed. Despite the uncertainty, there is much that can be done to increase one's likelihood of success. This chapter starts with guidance on how to determine the expectations for tenure and promotion at your particular institution, and it goes on to cover the central areas by which professors are evaluated, including research, teaching, service, collegiality, and grant funding. Other topics discussed include outside letter writers, workplace grievances, challenges faced by women of color, going on the academic job market, and dual-career academic couples.

Learning the Requirements for Tenure and Promotion

To understand expectations for promotion, start by reviewing the written requirements for your department or institution, but don't stop there. You will need information from several sources to gain as clear an understanding as possible. Senior mentors can be helpful, but they are not always up-to-date. One professor said that although her graduate school advisor had some useful guidance, "she's also given me advice that worked for her in the 1960s and the 1970s, which is really different than me in the 1990s and aughts." Given changing standards, it is helpful to also look at the records of people in your department who went through the process recently.

Because many professors post CVs on their websites, they are easy to access and can be used as points of comparison. You can also ask successful colleagues who went up shortly before you if they would be willing to share their promotion files. In addition to showing the number and types of publications, these files include teaching and research statements that can be used as models.

If you do work that is off the beaten path, you may need to look farther afield for sample promotion materials. For example, public health researchers engaged in community-based scholarship cannot produce publications as quickly as their lab-based counterparts, so they need to provide context for evaluators to understand their body of work. Scholars whose work is outside of their department's mainstream can reach out to colleagues in similar situations, even if they are at other institutions, to ask for sample research statements.

LEARN MORE

The Community-Engaged Scholarship Toolkit (www.community engagedscholarship.info) is a website created "to provide health professional faculty with a set of tools to carefully plan and document their community-engaged scholarship and produce strong portfolios for promotion and tenure" (Calleson, Kauper-Brown, & Seifer, 2005).

Because the *unwritten* rules and expectations vary greatly among institutions and departments, it is crucial to understand your local environment. A professor who trained at a major research university but joined the faculty at a teaching college explains,

> *The advice I got from my advisor at a Research I university was not necessarily the same advice that my dean would give or that the committee deciding tenure would give. That was an important realization for me.*
>
> *The big advice my advisor gave was to negotiate for a lesser teaching load, and so I already had—I didn't know this until several years later—a negative mark on me from my department because here I was trying to get out of teaching in their minds.*
>
> *My advisor was giving me good advice if you're going to a research university, but if you're going to a university where teaching is more important, or teaching is the same importance as research, then that's not good advice. And my other advisor had told me, you need to publish already, and you need to publish, past tense, and you need to be going on your book, and that isn't at all what my department was telling me. Oh, and you need to be going to conferences all the time, and that wasn't at all what my department and my college was telling me.*

This professor *did* need to complete her book to get tenure, but with a lower overall publishing expectation, her colleagues were more concerned that she get off to a good start as a teacher than that she publish early. And because her program did not expect faculty members to have name recognition with the leaders in the field, presenting at conferences was not a priority.

When my clients ask senior colleagues directly about criteria for promotion, they are sometimes frustrated by replies such as "I'm not the best person to ask" or vague admonitions to publish "as much as possible." Professors often get further when they ask a specific question; for example, "I made a list of publishing venues and ranked them as A level or B level. Do my rankings look right to you?" Another approach is to explain that you value the

person's input but will be talking to others as well and don't expect him or her to be the final arbiter on the subject. People are often more willing to offer their opinions with this type of disclaimer. Don't be surprised if you receive different answers from different people. Although you may never get a clear blueprint to follow, having conversations with several senior colleagues and taking a look at the publishing records of those recently promoted in your department will at least give you a clearer picture of what is needed.

INTO ACTION

Sample questions about tenure requirements include the following:

1. How many articles should I be getting out each year? What do you think is a minimum number, a middle-of-the-road number, above average?
2. I made a list of possible outlets for publication. Could you help me rank them? How would you rank this newer journal or this online journal?
3. Is it better to have fewer articles in top-tier journals or many publications in less competitive outlets? Is there a minimum number that have to hit the top tier?
4. How important is it that I have some solo work? Is one paper enough, or do I need several? If most of my work is collaborative, could you help me think through how I might get a solo article out of my research? Would a review paper "count" for a solo work? What about a theory paper?
5. How do books count as compared to articles?
6. Do I get credit for book chapters or only peer-reviewed articles? If I can arrange to have my book chapter go through a blind review process, will that count?
7. What criteria are used to determine national/international recognition?
8. Is a particular type or size of grant required for promotion?

Research

Establishing Independence

Even in departments that value collaboration, review committees expect some solo-authored and/or first-authored work because it allows the committee

to confidently assess the contribution of the individual. Similarly, research you publish with a former advisor may be considered suspect, even if you are the first author. The assumption, even if unjustified, is that the senior person involved with the work had disproportionate influence. Accordingly you will want to mark out your own territory of study that, even if related, is sufficiently distinct from your advisor's work. Ideally, you will form new collaborations and also do some independent projects.

Interdisciplinary Work and Joint Appointments

Academics often receive mixed messages about interdisciplinary research. Most institutions are made up of disciplinary departments whose members may have difficulty making sense of those whose work cuts across boundaries. This presents challenges for anyone who publishes in journals in more than one discipline or who requires the approval of more than one department for promotion. These scholars need to translate the importance of their research to those unfamiliar with the methods or venues of another discipline. It also takes diligence and diplomacy to serve in two departments and avoid being burdened with a disproportionate share of meetings and service commitments.

The ideal would be to have conversations before accepting the position to learn whether anyone with a joint appointment has gone through the tenure process in the past, what kinds of issues arose, and how they were handled. Important questions include how committee assignments will be decided, which faculty meetings the professor is expected to attend, how teaching and advising will be divided, how the departments work together to determine the types of scholarship and publishing venues that will "count" for tenure, and who will make the tenure decision. These topics are best agreed on in writing as part of the job negotiation. But if, like the vast majority of faculty members I have worked with, you did not anticipate these issues ahead of time, begin to discuss these questions with your departments as early as possible (i.e., right now!) to avoid later difficulties. When the time comes to write your research statement, solicit sample statements from successful faculty members with joint appointments to get ideas about how to explain your research to multiple audiences.

Ethnic Studies Research

As with interdisciplinary work, the rhetoric does not always match the reality when it comes to institutional valuing of diversity in research. In their chapter "Developmental Career Challenges for Latina/o Faculty in Higher Education," Delgado-Romero, Flores, Gloria, Arredondo, and Castellanos (2003) explained,

Research quality and productivity may be evaluated on the impact rating of a journal or citation counts of an article, both of which are heavily influenced by the number of researchers doing similar work. These standards do not take into account that there are fewer academics doing culture-based research and that research in culture- or race-based journals are less likely to be cited by "mainstream" researchers. (p. 271)

A related challenge some scholars describe is that the work is sometimes seen as more subjective and less rigorous when a scholar is studying a historically underrepresented ethnic or racial group of which she is a member. Yolanda Flores Niemann (2012b) recounted the reaction of a colleague when she was choosing between an ethnic studies postdoc and a position in a mainstream department. The colleague asked, "What are you, a scholar or a Mexican American?" (p. 340). The implication is that one could not claim both identities at the same time or that by studying Mexican Americans, one automatically loses one's academic credentials.

Conversely, a woman of color who spent some time studying a cultural group of which she is *not* a member said,

> I had the distinct sense that what I had to say was not vested with the same authority as scholars who were from that group. So it becomes a double-edged sword: If the "only" problem was with studying "my own group," then the fix should be easy—study any other group. But that also has pitfalls.

I don't have easy answers for dealing with these biases, especially because they are often expressed in subtle ways. Flores Niemann chose to respond directly when asked if she is a scholar or a Mexican American. She wrote, "I replied that I hadn't ceased to be Mexican American by becoming a scholar any more than he had stopped being a man when he had gotten his PhD" (2012b, p. 340).

If you are concerned about publishing venues, one strategy is to inquire up front, either when interviewing or after being offered a position, about how cultural studies research is valued and whether the department gives full credit to publications in cultural studies journals. Once you have a position, another tactic is to ask mentors to assist in identifying appropriate venues for your work. Allies can make a difference by educating colleagues about the prestige of journals with which they may not be familiar and by insisting on promotion criteria that allow department members who study diversity to be successful.

Sometimes professors in ethnic studies must grapple with whether and how much to modify their work to hit the markers required for tenure and

promotion. Anjali, a scholar of Indian heritage who does work in India, explains,

> *There is a rift in the field between Anglo-Americans who study India and Indians studying India, even among feminist scholars. The senior gatekeepers in the field are Anglo, and they ask different kinds of questions and consider the questions asked by Indian scholars to be less enlightened. I've noticed that the kinds of projects that are funded usually take a patronizing view of India as a poor, backward place where women are oppressed. I suppose I could put some of that language into my proposals, but there is a limit to what I am willing to do. My friend Chitra says, "They're colonizing us all over again!"*

Again, there are no easy answers, but it helps to build a network of support with like-minded scholars and mentors both within your institution and across your field. It is also important to remember that others have succeeded despite the challenges. Yolanda Flores Niemann, who dealt with the biases against research on Mexican Americans, went on to become a full professor and senior vice provost.

Contending With Bias

Even outside of ethnic, race, or gender studies, standards that on the surface appear to be objective are sometimes distorted through the lens of racial and cultural prejudice. When Fanny P. F. Yeung (2013) interviewed Asian American faculty members, one participant explained that for a White faculty member, having a large number of coauthorships may be interpreted as a positive sign that the person is well respected by his colleagues who want to collaborate with him. An Asian professor with many coauthorships may be assumed to lack independence and to be leaning on, rather than leading, his coauthors. In a chapter on career challenges for Latina/o faculty members, Edward A. Delgado-Romero and his coauthors (2003) described similar credibility challenges. A Latina/o professor relayed, "I am still often and 'innocently' asked by both academic colleagues and students if I analyze my own statistics for my research" (p. 273). Even more offensive "was being told that I should not publish with students because it was assumed that students were doing the work for me" (p. 273).

Responding to credibility challenges can be difficult, because women have to find a way to convey authority and competence without coming across as arrogant or bragging. For many professors from Latina and Asian backgrounds, this is further complicated by cultural values of modesty and communality.

Although a professor may prefer to credit the team rather than highlight her own role in a project, it can be important to emphasize her role as a leader. For example, you may want to say, "when *I* did the statistical analysis" rather than "when *we* ran the analysis" or to point out ways that you supported your student coauthor's learning. Sometimes two colleagues make pacts to talk up the other person's accomplishments to the chair or other members of the department. This way, successes are publicized without the person scoring the "win" being perceived as self-promoting. Chapter 7 in this volume provides additional information on how to balance authority and likability.

It is heartening to note that not everyone experiences instances of bias. In a survey Jessica Lavariega Monforti (2012) conducted of Latina women in political science, 50% of the respondents did not report any credibility challenges. Although more of the women surveyed thought their gender or ethnicity had a negative effect on the "level or quality of mentoring" they received (31.5% and 22%, respectively), 16.4% of the respondents felt that their gender had a positive impact, and 15.1% felt their ethnicity had a positive impact on the mentoring they received (Lavariega Monforti, 2012, p. 399). Those who elaborated gave examples of senior colleagues who wanted to see more diversity in the field and went out of their way to help talented Latina faculty members to be successful.

Challenges Faced by African American Professors

In their book *The Black Academic's Guide to Winning Tenure—Without Losing Your Soul*, Kerry Ann Rockquemore and Tracey Laszloffy (2008) pointed out that although all junior faculty members are low in the institutional hierarchy, that status is a temporary one will change with the achievement of tenure. However, African American professors must also contend with a social hierarchy in the larger culture that confers more status to some groups than others and with the knowledge that this situation will not change with promotion.

Rockquemore and Laszloffy (2008) illustrated the kinds of assumptions people make on the basis of their conscious or unconscious beliefs about race and status with the example of Sharon Jones. As a new African American professor arriving for her first faculty meeting, Professor Jones greeted an older White male colleague whom she had not previously met face-to-face, and he responded by instructing her, "You can put the sandwiches over there" (p. 17). He had mistaken her for someone delivering food for the meeting. In another instance, a student knocked on Professor Jones's door and asked, "Excuse me, I'm looking for Professor Jones. Do you know where I could find her?" (p. 17). Professor Jones was the only person in her office, she was

dressed in professional attire, and her name was on the door, but as a Black woman, she obviously didn't fit the student's image of a professor. Although White women contend with credibility challenges at times, these experiences are more pervasive for African American women and other women of color.

Coping with bias can be disheartening and exhausting. Accomplished women of color in academe develop strategies to stay energized despite the challenges. One African American professor attributed her ability to get beyond setbacks to three things:

1. Enjoying a supportive partnership with her husband
2. Seeing the small wins that she achieved along the way
3. Taking heart in the success stories of other academic women of color

Another African American scholar said that in addition to strong mentorship and a broad network of support across her university and in her discipline, her involvement in her church community helped her to keep going. Expressions of religious faith are countercultural in some parts of the academy, but African Americans as a group have a stronger level of religious participation than the U.S. population as a whole, and African American women have a higher level of religious observance than any other group in the United States (Sahgal & Smith, 2009).

Many of my female African American clients tell me that in addition to attending church regularly, they read a daily devotional with a Bible verse or follow another practice of prayer and/or meditation. People of faith from all cultural groups do not always recognize that they can bring the challenges of their work life into their prayer practice, but when they make the connection, they find their faith to be an additional source of support and strength.

Although professors who belong to majority groups may find adequate social support within the workplace, individuals from underrepresented groups often have one set of connections for their professional life and also have friends outside of the academy who can provide cultural support, validation, and understanding about the challenges of living in a biased world.

Evaluation of Teaching

Teaching effectiveness is usually assessed using student evaluations and direct observation of the classroom. Don't panic if evaluators give you a number of suggestions after the first observation of your teaching, because it will count in your favor to show improvement. However, if your teaching evaluations are only average or below average, seek out support. Chapter 3 in this volume, "Teaching", offers a variety of sources of assistance.

A common concern is that students may rank easier teachers (and those who give them better grades) higher than those who are more demanding. In a summary of the research on teaching evaluations, Matthew Kaplan, Lisa Mets, and Constance Cook (2011) explained that although there is a small correlation between higher expected grades and better evaluations, the research suggests that this is not because students are biased toward easy teachers but because better teaching results in better learning outcomes and higher grades. In general, when student achievement is higher (as evidenced by final exam scores), class members rate their professors more favorably. This is nuanced, however, in that questions that ask about the instructor and the course *overall* show a correlation between higher evaluations and better student performance, but questions that ask about specific teacher qualities such as organization or enthusiasm do not. Kaplan et al. (2011) further stated that there is a connection between the perceived *fairness* of the grading system and higher evaluations. When students understand how they will be graded and believe the system is equitable, they give more positive ratings (Kaplan et al., 2011).

Given our knowledge about unconscious (and conscious) biases related to gender, race, ethnicity, and sexual orientation, another concern is that students will evaluate members of underrepresented groups more harshly. Higher education consultant Diana Kardia and her colleague Mary Wright addressed this issue in a paper published by the University of Michigan Center for Research on Learning and Teaching (Kardia & Wright, 2004). Although large studies have found that men and women receive similar scores overall on teaching evaluations, those statistics hide the fact that women and members of underrepresented groups may have had to put in greater effort to get equal scores.

In a study in which undergraduate students were asked to imagine that their instructors were the opposite gender, the students readily admitted their biases. One male student explained that he tolerated disorganization on the part of a male teacher but said he would be much more critical of that level of disorganization in a female instructor. Students also said that they respect men who are in control and knowledgeable, but they might consider a similar woman to be "a bitch," because they expect women to be more caring and nurturing.

Departments can mitigate these biases by using multiple measures to judge teaching effectiveness. Kardia and Wright (2004) suggested including a teaching statement and "peer observations, course material such as syllabi, and student work" (p. 6) in order to more fairly assess teaching. A useful tool for collecting this kind of information is a teaching portfolio.

The teaching portfolio is a selection of materials that show the quality and breadth of a teacher's work. It includes a statement of teaching

philosophy; examples of course syllabi or assignments, with an explanation of how they were designed; samples of students' work; and statements by colleagues who have observed classes or reviewed teaching material (Kaplan, 1998). The current emphasis on assessment also provides opportunities for professors to make a case for teaching effectiveness. If students are given a pretest at the start of the class, the change in learning over time provides a clear example of the impact of one's teaching.

LEARN MORE

The Ohio State University Center for the Advancement of Teaching has a guide for creating teaching portfolios at this link: ucat.osu.edu/read/teaching-portfolio

Service

Although it is necessary to support one's department, the junior faculty members I coach tend to take on too much service at the expense of their research. Karin, a pretenure professor who wanted to raise the profile for her area of scholarship within her college and who enjoys institution building, tended to say "yes" to large and small requests. When the museum director wanted to put on an exhibit, Karin was quick to get involved, and when she was asked to consider a major service position in her department, she was eager for the opportunity because it would allow her to strengthen her interest area. However, Karin began to realize that she needed to be more discriminating about her commitments, lest she build a great institution that she would not be part of. Pretenure, strive to do enough service to demonstrate that you are a team player, but your main focus needs to be on achieving the standards for promotion. Once your place is secure, you will have many years to work on strengthening your department or college.

Women of color often experience work overload because they are in high demand to be on every committee to represent diversity (Baez, 2000; Lavariega Monforti & Michelson, 2008; Tierney & Bensimon, 1996). They may also be inundated with requests from students from historically underrepresented groups, including students from other departments, seeking them out for support and mentoring. Turning down requests from students of color can be heartrending for a faculty member who is a woman of color, especially if she herself lacked support when she was a student and her passion and mission include supporting those coming after her.

Native American professor Beth Boyd (2012) confronted a similar issue when her mentors cautioned her against spending too much time working in her local Native American community, because that work would not count toward promotion. However, Boyd found that "being involved in my community was actually the lifeblood that sustained me in my professional life" (p. 279). Those who feel similarly will want to do some service with students or in the community because it energizes them and helps others; however, they will need to set limits on the number of mentees and frequency of meetings in order to make it through the tenure process. It helps to keep holding on to the big picture and remember that once you achieve tenure, you will have years to be of service. And because research is the coin of the realm in the academic world, a solid research and publishing record will put you in a stronger position to support your students over the long run.

Boyd (2012) managed the dilemma of how to advance in her career while still giving back by finding ways to incorporate community service into her research agenda. She explained, "Once I stopped asking *if* I could include those elements and started asking *how*, the ways presented themselves" (p. 281). She also said that the key is to balance between personally meaningful endeavors and work that is less fulfilling but still necessary. She wrote,

> The only rule is to make sure that something that gives me joy is always in my schedule. Sometimes that means my schedule for the day, and other times I have to adjust my schedule for the week. . . . When I always have something on my schedule that gives me joy, I can stay balanced and am able to give my best to those other things that are not as enjoyable. (pp. 281–282)

Collegiality

Granting tenure means that the current members of the department could be interacting with the promoted professor for the rest of their careers. This may explain why many institutions keep the criteria for tenure somewhat vague: If someone is a prolific researcher but also a demanding, quarrelsome jerk, he or she can be turned down. The problematic side of this is that someone who is perceived to be a poor fit can be denied tenure, even if she has done everything right. This presents a challenge for a female professor working in a predominantly male department or for anyone who doesn't fit the cultural norm.

Communicating Engagement

June, a professor who grew up in a reserved culture, realized that others were misinterpreting her reserve as aloofness, and she worried about being seen as

noncollegial. At one point, June mentioned that she didn't respond to emails that did not seem to warrant a response. For someone else, that strategy could be an excellent way to save time for more important tasks, but given June's concern about being seen as disengaged, we identified this as an easy area to show warmth and interest. June began to send quick responses saying, "Got it, thanks!" or "Thanks for the info!"

Kerstin, who worked in a mostly male department, told me that the guys regularly went out for Friday drinks, and although she was invited, she never went, because she didn't enjoy the atmosphere of drinking and off-color jokes. It is not surprising that a minority member of a department would prefer a different kind of socializing, especially after spending all week in a setting that is mostly White and/or male. But Kerstin was left out of the informational loop and risked being perceived as disinterested. We brainstormed ways for Kerstin to build stronger social connections with her colleagues, and she decided to host a barbeque for department members and their families. Although this did not provide the same access to information as socializing on a weekly basis, it did allow her to show engagement without having to regularly put herself in an uncomfortable situation.

Enthusiasm and Warmth

The most successful people I work with use words like *great, perfect,* and *excellent* in their email communication with me. When asked to serve on a conference panel or give a visiting lecture, they say, "I'd love to," or if they can't do it (or don't want to), they say, "I'd love to do it, but I'm booked solid." Whether they do this strategically to earn social points or just because they are genuinely happy, positive people, it is a pleasure to interact with these folks. Strategizing about how to present oneself as collegial can seem distasteful for professors who believe they should be evaluated on the merit of their work, not their social eloquence. It may help to remember that your coworkers are looking for clues as to whether they will be able to get along with you for many years into the future, and you may need to help them by forging a connection to which they can respond.

Grants

If funding is a consideration for promotion, you will need to ascertain the kinds of grants that are most valued by your department. In some programs, just showing that you have applied for funding is sufficient; however, at the other extreme, some departments require professors to be the primary investigator on a specific type of grant, such as an R01 (an NIH Research Project

Grant), and grants that provide no indirect funds to the institution are considered more trouble than they are worth. Your chair and other mentors will be crucial sources of information about expectations. If you are new to grant writing, ask successful colleagues to share samples of their proposals that you can use as models, but be careful to respect their proprietary rights to the specific ideas and aims of their research. Some institutions require that large grants go through a mock review prior to submission. Even if this is not required, setting an early deadline and asking for feedback from colleagues is a sound strategy for submitting the strongest possible proposal.

Sitting on a study section or other grant review committee allows you to see the process from the other side, which will strengthen your submissions. Being a permanent member of a review team such as an NIH study section is a time-consuming process, so pretenure faculty members are often cautioned to limit their involvement to serving as ad hoc, rather than permanent, members.

LEARN MORE

Making the Right Moves

A helpful resource for understanding the NIH grant review process, as well as many other aspects of a research career, is the free, downloadable book *Making the Right Moves: A Practical Guide to Scientific Management for Postdocs and New Faculty*, published by the Howard Hughes Medical Institute and the Burroughs Welcome Fund (2012). It's available at this link: www.hhmi.org/programs/resources-early-career-scientist-development

Because a large percentage of grants are not funded, the process can be discouraging. In her book *Survive and Thrive*, Wendy Crone (2010) pointed out that the work that went into a proposal can be used in writing future grants, and the feedback will make your next submission stronger. Once, when Crone repackaged an unsuccessful grant for a different agency, the new agency not only funded her proposal, but also approved a much larger budget than she had requested in the earlier, unsuccessful application.

Outside Letter Writers

The process for requesting outside letters varies. One model is that the professor and the promotion committee make lists of potential writers,

and letters are solicited from some of the people on each list. In other situations, the professor does not have any say in who is asked to review her case, and any suggestions she makes become suspect. A professor at Yale University explained that historically, her department sent a request to the leading scholars in the field asking them to comment on a professor, *without any accompanying information.* The assumption was that if the person was worthy of tenure at Yale, the letter writers would already be familiar with his or her work and would not need materials such as a research statement or CV. Savvy Yale faculty members made sure to keep their websites updated with research descriptions and listings of their publications to help interested parties easily assess their accomplishments. Regardless of the exact process, most programs do not include former advisors or coauthors, because they assume that close associates are biased in favor of the candidate.

If you are asked to submit potential letter writers, questions you might want to ask colleagues include:

1. Is it important to include prestigious individuals on the list? Does our university look for a certain number of fellows in our professional society or professors from top-ranked institutions?
2. Should I prioritize someone who is less well-known but can speak with greater authority about my work or someone who has a bigger name?
3. Are any of the scholars whom I am considering for my list known to write negative letters?

A less selective college or university will likely solicit letters from academics at peer institutions rather than from famous researchers, and those people are more inclined to make their recommendations purely on the basis of the information in the tenure file. However, if you are at a top research university, you will need to strategize early about how to become known to important people in your field and show evidence of having a national and international reputation. A dean at a large public research university said, "I got my first invited talk by making an agreement with a friend from graduate school that we would invite each other, and that's what I suggest to the young professors who I mentor." In addition to asking friends, inviting well-known scholars to your campus presents the opportunity to have one-on-one conversations when you take the guest out for a meal. Other ways to build relationships include organizing a speaker series or a conference panel, sending offprints of your published articles to those who do related work, reviewing for journals, and taking on service roles in your professional organization.

Workplace Grievances

During the extended apprenticeship that precedes tenure, some women confront situations that are blatantly unfair. This can range from discouraging but manageable wrongs, such as the assistant professors in a department carrying the lion's share of the service obligations, to serious academic misconduct, such as a full professor who takes credit for work that was done by a pretenure faculty member. I wish I could always counsel assistant professors to stand up for what is right, but, unfortunately, untenured professors are at risk when they take on dysfunctional systems. Senior people in the field act as gatekeepers and often have the power to promote or block a junior colleague's advancement. Even a chair who vocally champions labor movements may still resent a faculty member who organizes her colleagues to protest a joint grievance. And the rightness of your cause does not guarantee that a complaint will be found in your favor. A person must consider whether the possibility for justice is worth the potential risk to her career. Even if a senior colleague has stolen your work, sometimes the safest course is to write off a particular paper or line of research, move on with other work and different collaborators, and, ideally, move to an institution with a more hospitable climate.

Some departments harbor a senior faculty member who has a reputation for verbally lashing out at junior colleagues, including in faculty meetings, in the hall or lounge, and in other public spaces. One response is to speak to the person at a later time, when both of you are calm, to let him (or her) know that although you respect his point of view, you would appreciate if he could express it using civil language and a collegial tone of voice. Another strategy is to speak to a trusted senior colleague and explain that as an untenured member of the department, it may not be safe for you to speak up, and so you are asking that he or she let the offender know when he has crossed the line of acceptable behavior.

There are situations when you must advocate for yourself, for instance, when someone else's behavior puts your ability to gain tenure or a different academic position in serious jeopardy. If your institution has a faculty equity advisor or ombudsperson, that individual can be an important ally. When Linda Trinh Võ worked as an equity advisor, her role included "providing faculty with advice on procedures, directing them to available resources and, at times, advocating on their behalf with administrators" (Võ, 2012, p. 101). Võ explained that whether faculty members were dealing with a difficult chair, a challenging promotion case, or other issues, the earlier in the process that they came to her, the greater the likelihood that she could help them to achieve a positive resolution.

A person who is subject to egregious harassment also might rather risk having to make a career change than allow the perpetrator to continue to

harass her or others unchallenged. If you believe you are being seriously wronged, steps to consider are as follows (based in part on an interview with Anthony Walesby, associate vice provost for Academic and Faculty Affairs, senior director of the Office for Institutional Equity, and Title IX coordinator at the University of Michigan):

1. Save all evidence from the perpetrator. This might include but is not limited to emails, pictures, texts, letters, and messages on social media.
2. Document all related interactions with a note about what occurred, who was present, and when it occurred.
3. Seek the advice of trusted mentors. Ideally this will include supporters both within and outside of your department and institution whom you trust to hold what you discuss in confidence.
4. If you decide to move forward with a complaint, reach out to your department chair or dean's office to discuss your concerns.
5. If you are not comfortable identifying yourself but would still like the university to be aware of the problem, consider using your institution's anonymous compliance hotline. You don't have to share your identity or specifics that would identify you, but you can share enough information to prompt the institution to look into the matter further. For example, you can state, "In [department name], Professor [name] is known for always making female colleagues uncomfortable. He sits too closely to female colleagues at faculty meetings, makes sexualized comments about female students, and is always making inappropriate comments regarding sex and gender stereotyping."
6. In addition to university offices and resources, you may wish to reach out to your state or federal civil rights enforcement agencies, such as the U.S. Equal Employment Opportunity Commission.
7. Seek the advice of an attorney who has experience with the academic workplace.

Whether and When to Go on the Market

Although academic employment opportunities vary tremendously depending on the field, there are more positions advertised for assistant professors than for senior scholars, and so the common belief is that opening your search as an assistant increases the odds of finding a new position (Laurence, 2005–2006; Striver, 2006). One school of thought is that professors should go on the market when they are up for tenure, even if they have no desire to move. Sometimes a department will respond to an outside offer by putting

together a tenure offer early, and interest from another school can often be used to negotiate more favorable pay and benefits. If you are unsure about being promoted in your current job, going on the market provides either the security of another option or one more year to take a run at the market if something doesn't come through the first time around.

There are also good reasons for caution. A faculty member could go to her chair with an offer, but rather than making a counteroffer, the chair could say, "Congratulations. I wish you well in your new position." If your desire was never to move, this puts you in an awkward situation. A search can also be a time-consuming distraction from your research at a time when you need to be maximally productive. Given these drawbacks, it is wise to seek advice from trusted advisors before starting a search. If you do go on the market, these are the people you will be asking for letters of support and networking assistance, so they need to be aware of your plans.

Dual-Career Academic Couples: The "Two Body" Problem

When finishing their PhDs in the same program, Lakshmi's husband, John, received an attractive offer in the Midwest, and the couple decided that he should accept the position. Lakshmi felt lucky to find a position at a less prestigious but respectable institution located an hour and 20 minutes away. It would allow her to continue to research and publish, and she was able to arrange her schedule to work at home two days a week, cutting down on the commute time. But the long drive was tough, especially in the winter.

Early one March when Lakshmi was teaching, and John was away at a conference, the day care called to say their daughter was ill. As soon as Lakshmi reached the highway, it started to sleet, turning the road into a sheet of ice. The commute home took twice the normal time, and when Lakshmi made it to the day care, her daughter was spiking a high fever. Lakshmi made it home safely, and Tylenol brought down the fever, but after this experience, Lakshmi and John were determined to find jobs in the same town.

Jill met her husband, Eric, when they were graduate students in different departments at the same university. Because Jill was a couple of years ahead, they agreed that when she found a job, Eric would follow her and look for part-time work that would allow him time to complete his dissertation. Jill's institution found Eric a position teaching in his discipline, but there were no guarantees that he

would get special consideration in that department once he finished his dissertation. Jill is grateful to have a good job, but she feels the weight of responsibility for her family and puts pressure on herself to go beyond the tenure standards for her program so that she and Eric will both be able to take a strong run at the market when he finishes.

In many ways, these couples profiled are success stories, in that thus far they have been able to continue with academic careers while maintaining relationships and starting families. But the nature of the academic job market, with intense competition for jobs and few positions in any one geographical location, requires dual-career academic couples to navigate a unique set of challenges.

Dual-Career Hiring

In 2008, Londa Schiebinger, Andrea Davies Henderson, and Shannon K. Gilmartin at Stanford University published the results of their survey of 30,000 faculty members at major research universities in the report *Dual-Career Academic Couples: What Universities Need to Know.* They looked at married, unmarried, and same-sex couples to learn how universities and couples are navigating the increasingly common phenomena of couples in which both partners are serious about their academic careers. Schiebinger and colleagues found that 36% of professors are members of dual-career academic couples, but the percentage of women with an academic partner is higher than the percentage of men (40% and 34%, respectively). In the sciences, there is an even more striking difference between women and men, with 83% of women in a relationship with another scientist but only 54% of men. Dual-career hiring has increased from 3% of all hires in the 1970s to 13% in the 2000s, and academic couples tend to cluster in the same fields and departments.

Women are more likely to be second hires, because the man in a heterosexual couple is often a couple of years older and a couple of years ahead in completing his degree. Because the man's career is usually further along than his wife's, he is in a stronger bargaining position. When Schiebinger and her colleagues asked about how members of heterosexual couples value their respective careers, they found that women put *equal* importance on both careers, but a man is more likely to value his own career *ahead* of his wife's. The percentage of dual-career hires involving two men were equal to the percentage of gay men in the survey, 4%, but whereas 7% of couples surveyed were lesbian couples, they made up only 4% of those who were successful in working out dual hires. The study authors speculated that this could be due to institutions being in states with discriminatory laws, as well as possible fears about disclosing sexual orientation (Schiebinger et al., 2008).

Most people see efforts to accommodate dual-career couples as a positive, but there is still some stigma attached to the position of second hire, as evidenced by the term *trailing spouse,* which implies that the person would not have been hired were it not for his or her more qualified partner. Schiebinger and colleagues (2008) wondered if the stigma was based in reality, and so they compared the productivity of second hires to that of first hires in their study and found no statistical difference. However, the politics surrounding these hires can be touchy. Veteran department members may be disappointed that they have lost some autonomy in shaping the direction of the department and may be concerned that the hire will interfere with a planned request for an additional hiring line, perhaps, in a different subspecialty. Some department members may also resent the fact that their own spouses were not given the same kind of consideration at the time that they were hired in. Although these forces are all beyond the second hire's control, sensitivity to the challenges your hire might pose to your new colleagues will help you to build positive relationships.

The good news for members of dual-career academic couples is that this kind of hiring has become increasingly common over time, with more institutions realizing that in order to hire their preferred candidates, they must accommodate partners. Schools in more remote geographic locations may be especially amenable to hiring both members of a couple because they believe these faculty members are more likely to stay at their institution. Even universities in major metropolitan areas may see dual hiring as a way to add stability to their department, because two people may be less likely to leap if one of them receives a better offer. Although it is illegal to ask questions about marital or partner status in an interview, some institutions now distribute information on dual-career hiring to all applicants, as a way to signal that they are open to these types of negotiations.

Despite some positive changes, dual-career academic couples often face difficult choices. Although couples will not be able to decide on an exact course of action until they take a run at the market and learn their options, they can think ahead about joint priorities. Would they rather live apart for a time in order for both members of the couple to land the best possible positions, or would they rather take the two best jobs they can find in the same location? Is one member less invested in an academic career and willing to consider jobs in industry, government, or administration within an institution of higher learning? Will they take turns, with a move now that is more advantageous for one member but the other person getting the better move the next time around? There is no right answer, but thinking through the alternatives together will help a couple to make a choice that works well in the context of their own relationship.

INTO ACTION

Discussion Questions for Dual-Career Couples

1. Would we prefer to:
 a. Each find the best possible job even if it means living apart?
 b. Treat one person's career as primary?
 c. Look for the best positions we can find for both people in the same town?
2. Is one member of the couple more open to or more marketable for careers outside of academia?
3. Is there a limit to how long we are willing to live apart? Would the birth of a child change our feelings about this?
4. If we do live apart, how will we maintain our bond? How often will we visit?
5. Are we interested in or willing to share one job?
6. Would lack of a position for our spouse be a deal breaker, if one of us receives an attractive offer?
7. Have we brainstormed connections that might help with job leads?
8. When is the best time for us to take a run at the market?
9. Who else do we know who has participated in a dual-career job search? What was their experience, and what advice can they offer?

A different route some couples take is job sharing, in which two people work jointly in one or one-and-a-half positions. This may be an appealing solution for partners who work in the same discipline and especially in a field that is small, where the chances of finding two openings in the same department at the same time are slim. Often each member of the couple does half of the teaching and is expected to produce the same quality but half the quantity of publications that would otherwise be needed to achieve tenure. Depending on the institution, each person may get full or half benefits. Job-sharing partners are usually evaluated separately for tenure, with the ability to renegotiate the percent appointment if both people are not promoted. Although there is an obvious financial disadvantage, job sharing can work well for couples that want more time, whether for family or for other interests, such as a writer who wants to continue to write and publish her novels. Because summer salary in some fields is more likely to come from grants, and some academics have the option to earn additional money from consulting projects, it may also be possible to make up some of the lost salary.

A difficult question is when in the hiring process to bring up the dual-career issue. If a couple has decided that it will accept a position only if both people can be accommodated, and especially if one or both members of the couple are at the top of their game, bringing up a spouse's search early in the process might be wise. The sooner the department knows that this is a factor, the sooner it can begin to make arrangements for the second hire to be considered. The person doing the hiring may need to coordinate with another department and will certainly need to go to her or his dean or provost to request funds to accommodate a second hire, and all of that takes time. A delay in the process might make a search committee less willing to work on a second hire, for fear that the time delay will cause it to lose another potential candidate.

However, there is also a risk that bringing up a partner's situation could prejudice a hiring committee against a candidate, because the committee may be concerned that if a second position is not found for the spouse, the first candidate will not consider the job. Some committee members might decide to take a route that they perceive as safer and offer a position to someone who is unencumbered by a partner's job search. To avoid this risk, academics often wait until they have an offer in hand before attempting to negotiate consideration for their spouse. Regardless of when the issue of a second hire is raised, to get the best possible deal for both people, neither member of a couple should sign a contract until both situations have been negotiated. If one member of the couple signs before the details for the second person have been worked out, the couple loses any negotiating power.

If a couple makes a move that is of greater benefit for one half of the couple, it is worth strategizing ways to support the career of the less advantaged spouse. The couple will need to invest in child care, a housecleaner, or other support services to allow the spouse time for his or her work. Lakshmi, the professor profiled earlier, who had to pick up her ill daughter from day care, was able to maintain a strong publishing record because she and her husband had made a commitment to do whatever they could to support both of their careers. They made their next move to an institution that was stronger in Lakshmi's area of expertise, and both she and her husband are now full professors in the same department at one of the top programs in the country.

Continuing one's research off the tenure track is difficult and may not be possible in fields that require an expensive laboratory and institutional affiliation to be the primary investigator on grants. Because academic hiring is also biased toward recent graduates, the longer a person remains off the tenure track, the more difficult it will be to move into a tenure-ladder position. However, there are academics who have successfully made the transition onto the tenure track after a period of working independently. Jody was frustrated

when her husband got a tenure track job at a New England university that could come up with only a part-time lecturer position for her. However, she continued to carve out time for her own research and even won a prize for a journal article based on the work in her dissertation. After she won the prize, the institution came up with a visiting position that eventually turned into a permanent tenure track job.

There are advantages for dual-career academic couples. If one member of the couple achieves tenure first, that person has job security and can take on a greater weight of home and parenting responsibilities to free up time for his or her partner's work. When a woman has a spouse in the same or a similar field, her partner is often her first reader, is sometimes a coauthor, and is in the position to give instrumental support to her work. It may be easier for two academics to arrange for the entire family to spend a sabbatical abroad, and one man I coached told me, "I do decent work, but my wife is a superstar, and that has been a great benefit for my own job security, since the university does not want to lose her."

Professional networks are particularly important for couples looking to move together. Those doing the hiring are more likely to go to bat for people who were recommended by a colleague or friend and who have reputations as hard workers and amiable colleagues. Senior people in your field may have valuable advice about the prevalence of dual hiring in the field and when in the process to raise this question, and people in your network might be able to put you in touch with others who can share their own experiences with going on the market as a couple.

LEARN MORE

In response to the increasing prevalence of dual-career academic couples, several institutions have joined nonprofit higher education recruitment consortia, also known as HERCs. A HERC is a group of colleges and universities in a particular geographic location, such as Northern California, Michigan, or New England, that works together to advertise positions at their member institutions. Each HERC maintains a website with the goal to provide one location where those searching for positions in the area can find all current listings. Given the stakes involved, some people choose to also follow individual member institutions' postings, to be sure not to miss a single opening. The national HERC website, with connections to regional HERCs, is available at: www.hercjobs.org/home/index.cfm?site_id=793

Dual-Career Spousal Competition

Strong feelings sometimes arise when the members of a dual-career couple meet with different levels of success. This can be difficult for those on both sides of the equation. Upon getting an exciting offer to set up a center focused around her area of expertise, a scientist told me that her first response was "Oh no, what will this do to my marriage?" The couple's last move had been great for her but had taken her husband away from an environment that was more conducive to his research and, as her star continued to rise, her husband became more and more demoralized.

A professor of psychology was on the opposite end of the equation. As her husband received greater recognition, she felt overlooked. Her frustration was compounded by her sense that subtle sexism was at play in how her academic work was received. She was particularly irked when she received an outside offer, and in response to the possibility that the couple would leave, her husband's department put together a much stronger retention offer than she received. "It was because of *my* offer that he got all these goodies. I don't want him to feel bad about how things are going for him, but it's so frustrating," she said.

For many couples, the feelings that come up are complicated by awareness that we are all embedded in a society that still has different standards, rewards, and expectations for men and women. The professor of psychology, who suspected that her work was evaluated through a sexist lens, wanted her husband to be successful but also resented the fact that his work might be privileged because of his choice of topics or simply because of who he was.

When it is the woman who is receiving more acclaim, even a man with progressive beliefs might struggle with not meeting the traditional cultural norm of being more successful than his wife. Although partners are not responsible for each other's feelings, the spouse who is receiving a greater degree of recognition can certainly acknowledge the discomfort of receiving public acclaim while his or her partner's contributions are overlooked. Statements such as "It's nice to get kudos for my work, but you are doing great work too, and I hate it that you're not getting the kind of credit you deserve" can go a long way to keep the goodwill in the relationship. On a practical level, a couple can use its joint resources to bring more balance to the equation. If one spouse has a better travel or research budget and just got a big raise, dedicating some of that money to supporting travel or research assistance for the less-recognized partner might ease the stress for both people.

7

AUTHORITY, VOICE, AND INFLUENCE

My friend Sean was just appointed dean of our school. A self-deprecating style works for him because he is conferred all this respect just for being a tall, gray-haired, professorial man. As a five-foot, one-inch woman professor, I'm not granted the same automatic esteem just for how I look. (Wendy, department chair)

I'm not a good advocate for myself within my department. I have a hard time getting my voice and ideas heard, and I notice that I have begun to take an apologetic tone when asking for what I need. I'm outperforming my colleagues, but I don't get recognition for that. I want to have a stronger professional voice, to communicate more effectively. (Donetta, associate professor)

When I recommended a method to my research group, one of my colleagues suggested we run the decision by Joe Smith, an older White professor in the department. I replied, "I am an expert in this area, and Joe Smith is not, but if you would feel more comfortable running it by an older White man, that's fine." The colleague who had questioned my recommendation immediately apologized, but his mental image of an expert clearly didn't match someone like me—a younger woman of color. (Abigail, fourth-year assistant professor)

When I speak in faculty meetings, these two guys look at each other and roll their eyes. I'm perfectly on track with my scholarship, so these people can't screw that up, but I would like strategies to address their undermining behavior. (Elena, fifth-year assistant professor)

Gender Bias and Authority

Although the women quoted at the beginning of this chapter represent a diverse group of academics at a variety of career stages, they all share a desire for respect and influence, and they are all impacted by gender bias in how others perceive and respond to them. I was not surprised to learn that Elena, the woman with the eye-rolling colleagues, was the only tenure track woman in a mostly male department, because the fewer women there are in a workplace, the more likely they are to be devalued. This phenomenon, *tokenism*, occurs when those from a historically underrepresented group make up less than 15% of a department. When someone is the only woman and/or person of color, or one of very few, others tend to view her according to stereotypes rather than individual characteristics. If she makes a mistake, it is attributed to her membership in the group, and if she is very successful, she is considered to be an exception from her group (Heilman, 1980; Kanter, 1993). Women like Elena, in professions that are male dominated, often confront gender bias early in their careers. In academic fields where women are well represented, these issues may become salient only when they have moved up the career ladder, because women are still underrepresented at higher levels of administration (Dominici, Fried, & Zeger, 2009).

In this chapter I lay out some background on the topic of gender and authority, including a look at how the intersections of various group and individual characteristics make it impossible to generalize about the best communication techniques. First, I present a variety of communication patterns and discuss their benefits and risks, then review strategies women can use to effectively convey an image that is both strong and likable. Then, I discuss the use of voice and nonverbal communication to project authority. Finally, I offer a strategy for getting your voice heard when discussions turn to controversial topics and emotions become heated.

Although issues of gender and authority are more pronounced in a predominantly male environment, women in mixed or majority female environments are not immune to gender bias. Researchers have found that *both* females and males make unconscious judgments of women who act outside of traditional gender norms (Brescoll & Uhlmann, 2008; Moss-Racusin, Dovidio, Brescoll, Graham, & Handelsman, 2012). In a 2007 article for the *Stanford Graduate School of Business News,* Joanne Martin discussed Frank Flynn, a Stanford Business School professor who conducted an experiment in which he changed only the name and the pronouns in a Harvard Business School case. With Harvard's permission, half of the students in his course were given the case of Heidi Roizen, a Silicon Valley chief executive officer, venture capitalist, and entrepreneur, as it was originally written. The other students were given the identical case, but the name was changed to Howard.

Both groups saw Heidi/Howard as equally competent and effective, but there was a significant difference. Flynn explained, "They don't like her, they wouldn't hire her, and they wouldn't want to work with her. . . . The more assertive they thought Heidi was, the more harshly they judged her (but the same was not true for those who rated Howard)" (Martin, 2007). Because the gender norm for women is to be kind, caring, and understanding, and the norm for leaders is to be assertive, bold, and resolute (all qualities that fit the traditional gender norm for men), a woman is often judged as less likable than a man who displays the exact same characteristics (Heilman, Block, Martell, & Simon, 1989; Heilman, Wallen, Fuchs, & Tamkins, 2004).

Women Must Walk a Tightrope Between Competence and Likability

For a woman, speaking with authority is a lot like walking a tightrope. If she leans too far to one side by using speech patterns that are traditionally female, she is seen as likable but less competent. If she leans too far in the other direction and adopts speech patterns more common to men, she is seen as competent but risks being marginalized as an "ice queen" or "bitch." As compared to their male colleagues, women must work within a narrower band of acceptable behaviors when they want to convey both competence and collegiality.

For most women, the ideal is to project an image that combines both "hard" and "soft" qualities. Women academics want to be respected as leading thinkers and highly competent professionals but also viewed as supportive colleagues who are cooperative team players. To achieve both high respect and high likability, women need to differentiate between patterns of communication that signal friendliness and those that signal authority and then choose the appropriate communication for a given situation.

Race, Context, and Other Factors Influence Listeners

Communication is complicated, so it is impossible to make facile prescriptions about how to speak with authority. Listeners respond differently depending on whether the speaker is in a role that conforms to gender and ethnic expectations, the relative institutional power of the people in the situation, and the identities of the speaker and the audience. In a study by Robert Livingston, Ashleigh Shelby Rosette, and Ella Washington (2012), participants were asked to read a situation in which a boss is talking to a subordinate who is not meeting expectations. The researchers used two scripts,

one with a dominant leader who expresses disappointment, uses assertive language, and demands action on the part of the employee, and one with a communal leader who encourages the employee and shows compassion. When the researchers gave the participants these two scripts but changed the race (Black or White) and gender (male or female) of the leaders, they had an interesting result. Participants approved of Black female and White male bosses who used dominant language but disapproved of White female and Black male bosses who used the exact same dominant language (Livingston et al., 2012). A likely explanation is that an authoritative style is considered to be more culturally appropriate for Black women, whereas an authoritative style is discordant with cultural expectations of White women.

Although the range of acceptable behavior may be somewhat different for African American women than for White women, Black women also walk a tightrope to be seen as both competent and likable. A case in point is First Lady Michelle Obama, who is a model of poise and restraint but who has sometimes been depicted in the media as domineering and angry (Powell & Kantor, 2008). Unfortunately, the experience of the woman at the start of the chapter whose competence was questioned by a colleague is also all too common for women of color, including African American women, in academe (Gutiérrez y Muhs, Flores Niemann, González, & Harris et al., 2012).

Asian Americans face another kind of bias. University of Toronto researchers Jennifer Berdahl and Ji-A Min conducted a study to assess how survey respondents reacted to an East Asian employee who displayed dominant behavior in the workplace. Although the study participants did not appreciate dominant behavior in a person of any race, an East Asian with dominant behavior was more disliked than a White employee who displayed identical behavior. The study authors found that stereotypes of East Asians include the belief that they "stay in their place" and concluded that people who don't conform to that stereotype are sanctioned in the workplace (Berdahl & Min, 2012).

Whereas the East Asians in Berdahl and Min's study were reproved for dominant behavior, Latina professor Kathleen Harris Canul was criticized for being too passive. Canul (2003) wrote that her collaborative leadership style, which is influenced by her Latina/o value of collectivism, "has been viewed as passive, non-decisive, and too non-directive" (p. 170). The juxtaposition of Berhdahl and Min's findings that people reacted more negatively to a dominant East Asian colleague with Canul's experience of being criticized as too nondirective suggests that professors of color often walk an even narrower tightrope between competence and likeability than their White counterparts.

Additional evidence of the complexity of communication comes from a 2009 study by Scott Reid and colleagues. Reid and his coinvestigators

found that when attention was called to participants' shared status as college students, a woman who spoke assertively was influential with male study participants, but when attention was called to gender, a woman who spoke tentatively was more influential with male (but not female) participants (Reid, Palomares, Anderson, & Bondad-Brown, 2009). This high degree of nuance makes it impossible to offer easy answers. My goal is to expand your choice of communication strategies so that you can assess the dynamics of an interaction and respond accordingly.

I also invite you to conduct your own inquiry by listening to the women and men around you and noticing what types of speech patterns are effective for different speakers in a variety of situations, paying particular attention to how speakers manage to wield influence without coming across as overbearing. I encourage you to experiment by trying out new patterns in low-stakes situations to assess how well they work before implementing them in critical conversations.

Should Women Have to Moderate?

This is a complex issue. One view is that coaching women to soften their approach to make others comfortable is a frightening throwback to an earlier time, and it is those around powerful women who need to change and get over their discomfort with authoritarian women. A lesson we might all take is to stop judging and make an effort to appreciate tough, uncompromising women who don't conform to gender norms. A woman I'll call Nadine once mentioned to a coworker that she was uncomfortable with a female colleague who doesn't show much emotion. "Yes," Nadine's coworker replied, "she's creepy!" Later, Nadine realized that a man with the exact same affect would be considered strong and competent, not creepy. Since then, Nadine has consciously focused on this woman's competence and business acumen, and she has developed a greater appreciation of what this colleague has to offer.

Another view holds that although it may not be fair, it is reality that women are held to a different standard, and for women to succeed, we need to function in the world as it exists, not as we wish it to be. Whether to fight for a principle or compromise in one area in order to reach a larger goal is a very personal decision. It is worth noting that although an authoritarian style is more accepted in White men, men also must balance hard and soft styles of communication. I have coached several White men who were referred to me because they were seen as overly autocratic and were being asked to develop a more cooperative style.

Declarative Statements of Fact Versus "I" Statements

One choice for speakers is whether to use "I" statements or declarative statements of fact. Many of us have learned to use "I" statements in place of accusations to successfully navigate interpersonal conflicts. A spouse who becomes defensive when told, "You don't clean up after meals" (a declarative statement) is more receptive to a partner who uses an "I" statement; for example, "I feel hurt when you go upstairs to work, and I am left to clean the kitchen on my own." In the case of Elena, who was the only tenure track woman in her department, her skill with "I" statements makes for excellent relationships with her husband and friends, but in a work meeting, the guys in her department don't see feelings as relevant. They want to know the facts. Rather than saying,

> *"I'm concerned about an expertise gap in our department, and I'm hopeful that candidate A could help us to attract better students,"*

Elena found it more powerful to say,

> *"Candidate A brings skills that are essential to fill the expertise gap and attract the brightest students to our program."*

"I" statements project a nonthreatening tone, whereas declarative statements project authority. Elena keeps "I" statements as an important part of her repertoire for conflict resolution and for times when she wants to lean toward the friendlier side of the communication tightrope, but she now uses declarative statements when she wants to project power.

Questions and Hedges

Questions and hedges can be used deliberately and to good effect to invite input from others. A committee chair might indicate that she is interested in feedback and alternative perspectives by the use of a question, "*I wonder if* the course could be divided into two eight-week segments?" or a hedge, "*One possible way we might* structure the course is by splitting it into two eight-week segments." Both forms signal cooperation and openness, because they leave room for her colleagues to suggest other possibilities or to build on her preliminary ideas (Coates, 2011; Peck, 2006).

However, hedges and questions convey less authority. Here are some examples of questions and hedges compared with direct statements, with italics used to identify the hedging words. Notice the powerful shift that occurs when the sentences are rewritten as direct statements:

Question:

Would we want to consider having students listen to the lectures outside of class? *Perhaps* learning would be enhanced if instructors used class time to assist students in working through challenging problem sets.

Direct Statement:

I propose we have students listen to the lectures outside of the class. The learning will be deeper if instructors are available to assist students in working through challenging problem sets in class.

Hedging:

It seems like it might be possible to attract more minority students if we had a more diverse faculty.

Direct Statement:

A more diverse faculty would attract more minority students to our program.

Some female bosses instinctively use questions and hedges to soften orders and make them more palatable to their subordinates. A boss might phrase an order ("Type this report") as a question ("*Could you please* type this report?") or preface an order with a hedge ("*When you have the time*, please type this report."). The questions and hedges are relationship-preserving conventions meant to respect the secretary's dignity; they are not meant as information about the relative importance of the task (Tannen, 1994). If the secretary waits to type the report next week, when she has more time, the boss might be quite unhappy.

Apologies

Many women use apologies similarly to hedges and questions, as conversational smoothers to keep the power equal between two speakers and to help a person save face. Linguist Deborah Tannen explained, "Admitting fault can be experienced as taking a one-down position. When both people share the blame, they end up on an equal footing" (Tannen, 1994, p. 46). Sometimes this is achieved through a direct apology and sometimes through a subtle sharing of blame. If a professor asks her research assistant to correct a mistake in a table he or she created, and the assistant apologizes for the error, the professor might soften the correction by a direct apology, such as "I'm sorry I didn't explain it clearly," or an implied apology, such as "I might not have explained it clearly." Even if the professor thinks she *was* clear, she might

apologize to spare her assistant from feeling bad. Tannen went on to show that this works only when both people follow the ritual:

> Someone . . . who does not use apologies ritually may well take them all literally. And this can lead to resentment on the part of the ritual apologizer. If I say "I'm sorry" and you say "I accept your apology," then my attempt to achieve balance has misfired, and I think you have put me in a one-down position, though you probably think I put myself there. (Tannen, 1994, p. 47)

How apologies are interpreted depends on the context and whether those around you are following the same rituals, but there is a risk of giving up power if you issue frequent apologies as compared with your colleagues. Because men are less likely to use them, employing ritual apologies with male colleagues and male students might tip the balance too far into the "nice but not respected" side of the tightrope.

Can Speech Be Too Authoritative?

It is more common for women I work with to err by leaning too far to the side of friendly but less authoritative speech. However, some academics excel at authoritative speech but are seen as intimidating autocrats. Because most workplaces currently value a democratic leadership style, both women and men may be asked to adopt a softer tone. People rarely self-identify as being overly authoritative, but it may be brought to their attention if they risk losing valuable staff or are undermining morale because of the way they come across. In this case it may be helpful to *add* hedging language and to use questioning rather than declarative forms, to show that one is open to input. Another way to balance authority with likability is to consciously choose to let go of issues that you do not consider vital but still take a strong stand on the decisions you deem most important.

Inflection

Women are often cautioned to avoid rising inflection when they want to project authority, with the warning that "My name is Brittany? I'll be your pilot today?" does not inspire confidence. The nervous passengers might wonder, "If she isn't sure of her name or occupation, how competent can she be?" Shifting away from the rising inflection to a matter-of-fact tone creates a more self-assured impression.

Managing Interruptions

Men tend to interrupt women more than the reverse, so women need strategies to hold their ground. Pat Heim, the author of *Hardball for Women: Winning at the Game of Business*, gave the following instructions:

1. Continue to talk as if the interruption hadn't happened.
2. Don't make eye contact with the person who interrupted. Look at other members of the group.
3. Continue to talk at the same rate of speech. Don't speed up in an attempt to quickly fit in your statement before conceding the floor.
4. Maintain the same volume. Don't get louder to try to speak over the interruption (Heim, 2005, p. 175).

When women try this out in small groups in my workshops, they find that Heim's advice works remarkably well. Initially, the speaker may be thrown by the interruption and glance over at the interloper. If the speaker quickly shifts her attention back to the other members of her audience and continues speaking, she generally succeeds in holding the floor. Of course, there are people who, by force of their position, have the right to interrupt. Hold your ground with a student or colleague who has a bad habit of interrupting, but if the dean interrupts you, you might do well to graciously concede the floor.

Some women find it uncomfortable to keep speaking when someone else is talking, even if this person interrupted them. A softer method to hold your ground is by addressing the interrupter and saying, "Just a second" before finishing what you have to say, then turning back to him or her to ask, "Now what were you saying?"

Cynthia, an academic administrator at an Ivy League college, uses a different technique. She explains,

I have a gentle style and don't like to adopt the same mannerisms of those who interrupt me. Instead, I concede the floor, wait until the interrupter winds down, and then politely ask, "May I finish what I was saying?" This allows me to stay true to who I am but still speak my piece.

Cynthia concedes that there are occasions when she adopts a harder style. "If I never interrupted in the university directors' meetings," she explains, "I might never get a chance to speak." Clearly part of the balancing act for a woman who wants to be both liked and respected is to continually evaluate the circumstances in which she finds herself and respond accordingly. If holding your ground is challenging, try it out in a practice situation with

friends before you attempt it with colleagues at work. If the techniques presented here do not suit your personal style, experiment until you hit on your own best method.

Claiming Conversational Space

Jane Hyun (2005), author of *Breaking the Bamboo Ceiling*, explained that Americans from Asian and Pacific Islander backgrounds are more likely to have been taught Confucian values, including harmony, self-restraint, respect for authority, and putting the good of the group ahead of individual goals. American values include individual achievement and questioning those in authority. Hyun contrasted the American saying "the squeaky wheel gets the grease" with the Chinese saying that "the loudest duck gets shot." An example Hyun shared is the experience of a high-achieving student from Korea in an American marketing class:

> I noticed that my peers were raising their hands to make very minor, at times irrelevant, comments. . . . I only raised my hand if I had something hugely important to add or some new insight into something. I did well on my papers and tests, so I was totally shocked when I got a C+ in the class. (p. 19)

Following Korean cultural norms did not work in that class, because the instructor interpreted the student's silence not as respect and self-control but as disengagement.

To signal involvement, Hyun (2005) suggested the following:

1. Prepare ahead of time with questions and comments about the topic at hand.
2. In many Asian countries, extended eye contact is seen as disrespectful, but Americans interpret eye contact as showing warmth and connection. Increase your comfort level with more eye contact by role-playing with a friend.
3. Prepare for meetings in which controversy might erupt. Practice responses to possible objections, and have premeeting discussions with potential allies to garner support. Build your comfort level by speaking up in low-risk situations.
4. Ask colleagues how they perceive you as a coworker, and explain the cultural values that influence your interactions. Explaining such values as putting the group ahead of individual agendas, collegial decision

making, and harmony can help your peers to interpret your behavior in a favorable light.

It is not only Asians and Asian Americans who are more reserved in large groups. When it is important to have input from all group members, Hyun advised leaders to solicit opinions anonymously, in one-on-one conversations, in small groups, and in informal settings.

Challenges in Supervising Other Women

Women often complain that administrative assistants kindly accept orders from men but bristle if given an order by a woman, even if she has vast experience and an institutional role that places her at the helm. The same dynamic shows up in other hierarchical relationships, such as when female nurses respond negatively to direct orders from female physicians while cooperatively accepting orders from male physicians.

In their book *In the Company of Women*, Pat Heim, Susan Murphy, and Susan Golant (2001) connected power struggles between adult women with women's early friendships, in which girls strive to keep the power "dead even." The authors explained that when a woman takes time to ask about the secretary's family or when she phrases an order as if it were a favor, the secretary feels she is being treated as a peer and responds supportively. But if the woman boss fails to do these relationship-building tasks, the secretary feels she is "one-down" and to even things up will delay a task or use other indirect means to impede the boss's goals.

When Laura was an administrator, her male counterpart could say, "I need this by 1:00 p.m.," and the women who worked for him would gladly oblige, but Laura found it more effective to say, "I know you're really busy, and I hate to bother you, but I have a dilemma because I just got notice about this. Could you do me a huge favor?" Laura said, "It was more productive for me to pretend as if we were equal, even though I had positional authority and made three times the salary of the women who were working for me." Although it may not seem fair that other women are more deferential to men than they are to women in authority, another perspective is that everyone should make the effort to build relationships and personally connect with those who support our work.

Attending to the relationship does not mean being a doormat. The administrative assistant of a newly appointed female dean insisted that the dean would have to adopt a different computer program to match the others in her office. The dean responded kindly, saying, "I'm so sorry that my system is causing this complication. I know what a hassle this is for

you." She expressed plenty of empathy for the administrative assistant, who would have to bridge the gap between the two systems, but she did not back down. By attending to relationships with a caring style, the dean was able to maintain her authority while keeping the goodwill of those who work for her.

Relentlessly Pleasant

The dean's combination of empathizing and holding her ground is not unlike the balancing strategy that former University of Michigan president Mary Sue Coleman called "relentlessly pleasant" (Babcock & Laschever, 2009). With a relentlessly pleasant approach, a woman leans toward authority by advocating strongly for her position while leaning toward congeniality by maintaining a nonthreatening tone of voice and sending pleasant nonverbal signals. Gina, a vice provost, observed a related strategy in the provost to whom she reports: "Whenever our provost uses words that are harsh or pushy, she sends a reassuring message with her demeanor and tone. She manages to sound tough but not harsh."

Invoke Shared Identity

As mentioned earlier, an assertive pattern of speech is more influential with male listeners when they are focused on their similarities with the female speaker (e.g., as fellow scientists or professors) rather than their gender difference. Given this finding, a female professor like Elena who is working in a mostly male setting might want to consciously invoke areas of shared identity between herself and her colleagues when trying out more direct speech patterns.

Gentle Methods to Claim Authority

Dr. Linda Gillum, an associate dean at the Oakland University William Beaumont School of Medicine, told me that, on occasion, she is in a meeting where she makes a contribution that is then attributed to someone else who expresses the same point *after* she has made it. She has no way of knowing for certain if it is because she is a woman, she is African American, or the later speaker just put the point in a different way, but she says sometimes, "You can just tell that bias is at play." Gillum takes credit for her leadership by gently responding with a comment such as, "I'm so glad that Jim supports my suggestion about this."

In interviews with Asian American faculty members, Fanny P. F. Yeung (2013) found a common issue of Asian and Asian American professors being mistaken for graduate students by other faculty members, because of their height and youthful appearance. Deborah Goldberg, the chair of ecology and evolutionary biology at the University of Michigan, faced a similar dilemma related to her height. Goldberg remarked that although she is well respected as a leader by her colleagues, as a petite woman, she does not fit the cultural schema of "leader." Goldberg went on to explain that research on unconscious schemas shows that when a man is sitting at the head of the table, most people assume that he is the leader, but if a woman is at the head of a mixed-gender table, 50% of the time it is assumed that the leader must be a male who is sitting somewhere else at the table (Porter & Geis, 1981). Because Goldberg realizes that this is not deliberate, she seeks to correct it in a comfortable manner. When entering a meeting with people she does not already know, Goldberg introduces herself and explains, "I'm the program chair, so I'm the one who you'll be working with on this issue." Goldberg explained, "I don't want to appear pompous, like someone who always has to introduce herself with her title, so I try to put it in context, with information about why it is relevant for them to know that this is my role."

The dean of a professional school asserts her authority this way:

> *When I really want to hold the line on something, I tend to stay very soft spoken, and I think other people may believe they're walking over me, even in arenas where I have the authority. And so I've had people ask me, "So how come it ended up your way? You didn't do anything." Well, I didn't have to do anything. All I had to do was to continue to indicate that I wasn't in agreement, because it was my call.*

Powerful and Effective Versus Universally Beloved

No matter what your style, the reality of being a woman leader is that some people will not like you. Soo Jin, who works at a major medical center, tells me that women secretaries in her building often complain that the health system's chief executive officer is "a total bitch." "She's not," Soo Jin asserts, "but she is a strong, competent woman who is in charge, and that makes some people uncomfortable."

Developing a thick skin can be a challenge for women who have had a lifetime of acculturation to keep those around us comfortable and happy. One way to reconcile yourself to enmity incurred simply by being a woman with power is to remind yourself that you are in good company. The Pulitzer-Prize-winning Harvard historian Laurel Thatcher Ulrich coined the phrase

"Well-behaved women seldom make history" (Ulrich, 2007). If you want to have real impact within your field, your institution, or beyond, then the realization that some people do not like you may actually be a sign of what you are doing *right*. If you are universally liked, you are probably not taking bold enough action.

Establishing a Strong Vocal and Visual Image

Communication consists of more than our words. We also communicate through the quality of our voice, including tone, pitch, volume, and inflection, and through our nonverbal presentation, including eye contact, gestures, posture, and facial expression. Depending on how we combine words with vocal and visual cues, we can strengthen, soften, or unwittingly undermine our words. Academics are often so focused on their thinking and ideas that they forget that these ideas need to be conveyed through their physical body, including their voice. However, because speakers have a very short window of time before listeners begin to assess whether this is someone to whom they should pay attention, vocal and visual cues really do matter.

Voice Personalities

When I attended her presentation titled "Voice Habits of Successful People," voice image specialist Marlena Reigh asked us to think of voices that are uncomfortable to hear and to consider what makes them unpleasant. She pointed out that most of us find it difficult to listen to someone who speaks in a monotone, to a voice that is so soft that we must strain to hear, or to a voice that is high and piercing or extremely nasal. She then asked us to think of voices that we enjoy hearing and consider why those voices keep and hold our attention. Voices that are appealing convey energy by changing inflection, volume, and rate of speaking. They are neither too loud nor too soft but fall within a comfortable range.

Reigh acknowledged that some people are uneasy with the idea of changing their voice. They see their voice as a part of who they are, and it seems inauthentic to change it. However, Reigh explained that we all have a variety of "voice personalities." We use one voice to motivate a team and convey excitement and another voice to pass on the news that a friend has died or to fire an employee. We speak differently to a baby than to a teenager. One voice is not more "real" than another, and we can work within our own vocal range to choose the voice personality that most reflects who we want to be at work.

Margaret Thatcher famously used voice training to lower her pitch in order to convey greater authority. The idea that listeners attribute greater leadership capabilities to lower voices was borne out in a study by

political scientist Casey Klofstad and biologists Rindy Anderson and Susan Peters (2012) in which students listened to digitally manipulated voices of men and women saying, "I urge you to vote for me this November." Both women and men preferred the lower pitched voices 60% of the time (Klofstad et al., 2012). Slightly lowering your pitch can convey greater authority, but a pitch should not be lowered to the bottom of a person's range, because speaking in a range that is lower than your natural voice can damage your vocal cords (Boone, 1997). In addition, if you are already at the bottom of your range, it limits your ability to vary your inflection to create interest.

Voice Work is Physical and Emotional

Reigh pointed out that voice work is both physical and emotional. If a woman tends toward a monotone, she can work with physical technique by varying her inflection, rate of speaking, and volume. Someone who runs out of air can learn the mechanics of maintaining breath support. However, people often know the mechanics but are not able to implement changes without a shift in their inner state.

Years ago, an organization asked me to add an additional hour to a workshop they had contracted with me to present. I needed to ask for more money for the longer workshop, but I didn't have much experience negotiating fees, so I called a friend to practice. When I said the dollar figure for the additional hour, my friend observed that my voice trailed off at the end. "Okay, let me try again," I responded and launched into my practice. "No, your voice is still trailing off when you say the cost," my friend patiently explained. So I tried a third time, but once again my friend said, "No, you're doing the same thing." She then wisely advised that I listen and practice with a recording device.

When I listened to the recording, I heard what I was doing, but I was frustrated to discover that I couldn't fix it. I knew what to do mechanically—keep my breath support strong all the way to the end of the sentence—but even after multiple tries, I couldn't manage it. I decided to try an exaggerated, over-the-top obnoxious version and recorded myself angrily saying, "You're out of your mind if you think I would do another hour for the same price that I charge for two hours. I spend hours preparing, and I expect to be paid what I'm worth!" After the over-the-top response, I went back and tried again to speak in a way that was pleasant and professional. This time I recorded, "I'd be glad to do another hour, and I have some great content to add. The cost for the three-hour workshop is [X]." I had finally nailed it and named the cost with a matter-of-fact, confident voice. Once I did the emotional work, the mechanics took care of themselves.

Lynn had a similar experience when she invited colleagues to attend a dress rehearsal of a presentation she would be delivering at Princeton. Lynn didn't think to request that comments be saved until the end of the presentation, and a well-meaning colleague jumped in with on-the-spot feedback: "You keep saying 'um,' and ending your statements with question marks. Don't do that at Princeton!" Instead of this reducing the unwanted vocal habits, Lynn became even more self-conscious, and her "ums" and upward inflections *increased.* It was only a bit further into her presentation, when Lynn relaxed, that the "ums" and question marks disappeared altogether. Lynn couldn't change her speech by focusing on mechanics, but when she changed her inner state, the problems corrected themselves.

How does one maintain the emotional equilibrium that will be reflected in a confident speaking voice? Elena, the professor who didn't want to let hazing by her male colleagues shake her confidence, handled stressful interactions by imagining herself standing on a foundation of solid rock. The solid rock represented the research she had conducted, papers she had published, grants she had obtained, students she mentored, and relationships with other respected researchers. She even put a small stone in her pocket as a literal touchstone that she could hold on to and use to remind herself that she was competent and on solid ground—ground that would not give way in the face of hazing by some of her departmental colleagues. Elena could respond calmly after taking a deep breath, touching the stone in her pocket, and imagining herself standing on solid rock.

For other professors that place of confidence might be crossing the finish line in a road race or delivering a particularly well-received talk. Often simply imagining ourselves in a positive situation changes our emotions, and even our posture, to ones of self-assurance. In a coach training class, Ben Dean, psychologist and founder of Mentorcoach (mentorcoach.com), suggested getting centered by silently saying to oneself, "I'm glad I'm here. I'm glad you're here. I know what I know." This mantra imagines a positive connection with our audience, reminds us that we know something about our topic, and suggests to us that what we know is enough.

Speaking Accented English

Unfortunately, students are more likely to question the credibility of professors who speak English with an accent. A Latina professor teaching English and intercultural communication graded a student paper that was a "disaster," but she gave the student a "C" rather than an "F" because she wanted the student to revise the paper. The student protested, "You don't even speak English. How do you know my paper is bad?" (Moffitt, Harris, & Forbes

Berthoud, 2012, p. 89). Studies have found that group members rate a leader more highly if she has been endorsed by someone with high status, so perhaps one solution is to have the department chair or another authority provide an introduction of the professor, either by email or face-to-face, with an emphasis on her expertise in the subject at hand (Brown & Geis, 1984; Yoder, Schleicher, & McDonald, 1998).

The Process of Change

Changing our patterns of voice, speech, and gestures involves changing entrenched habits, and it's hard, especially in the thick of an interaction. Often before they work with me, clients are not even aware that their patterns are not serving them well. As they begin to become aware, my clients start to notice when they use an ineffective pattern of speech, but only *after* the fact. The next step is to catch oneself in the act and change midstream. With practice the new patterns finally become second nature.

INTO ACTION

Email is a great place to practice, because we have time to read and edit our words. In the next week, look for opportunities to edit your emails for greater power by changing hedges and questions to definitive statements of fact, where appropriate.

The following are some examples:

1. Instead of "*It might be helpful* to have the speaker arrive the night before," try "The speaker should arrive the night before."
2. Instead of "*Do you think we could* offer separate workshops for junior and senior professors?" try "It would be most effective to offer separate sessions to address the concerns of junior and senior faculty members."

It is difficult to be self-aware about one's own voice. Many people cringe when they hear a recording of their voice, because it is different from the way they perceive it to be. When Marlena Reigh asked a woman who had spoken quietly for years to increase her volume to a level that was much more comfortable for her listeners, who no longer had to strain to hear her, the woman felt like she was shouting. In one of my own workshops, when other participants

noticed that an academic kept saying her name with an upward inflection ("I'm Professor Suzanne Brown?"), she could not hear it herself. I recommend listening to a recording of your voice in order to get an outside, objective view and then practicing with a recorder until you are pleased with the result.

Nonverbal Communication

The message is stronger when a speaker stands up straight and still rather than leans on one hip or twists a ring or a lock of hair. We are much more engaged by a presenter who makes eye contact with various audience members than one whose eyes are glued to the floor. As with voice, it is much easier to assess our body language from the outside. In leadership workshops, I invite women to introduce themselves to the group and then practice one or two "do-overs," incorporating feedback to present a stronger image. Methods to add power include the following:

1. Stride purposefully to the front of the room. Do not take small, hesitant steps.
2. Come to a complete stop and face the audience before you begin to speak.
3. Use enough volume so that your audience does not have to strain to hear you.
4. Start with your arms at your sides to project authority. Once your authority is established, adding gestures will set a friendlier tone and balance your expertise with approachability.
5. End your introduction on a downward rather than an upward inflection.
6. Keep your breath support strong all the way to the end of your speech.

LEARN MORE

An academic who wants to develop her voice and presentation style can choose from a variety of resources:

1. Teaching and learning centers offer workshops and coaching on presenting classroom and online lectures, conference talks, poster sessions, departmental colloquia, and job talks.
2. Many colleges and universities provide excellent media training because professors are often called on by news sources to provide expert opinions, and institutions want to promote their faculty members' research.

3. Toastmasters International is a nonprofit organization with clubs around the world whose primary purpose is to strengthen its members' presentation and leadership skills. Members have plenty of opportunities to practice speaking and to receive feedback from their peers, and because it is a nonprofit with very affordable dues, membership is an excellent value.

4. Voice and presentation coaches work with clients on learning breath support, finding their natural voice, eliminating nasality, and much more. Marlena Reigh, the voice specialist cited in this chapter, offers both face-to-face and telephone coaching. Her website is marlenareigh.com

Stepping to Their Side

Academics are well schooled in how to critique or defend a position, and many issues can be worked out through argument and counterargument. However, when a topic is controversial and the conversation becomes heated, opponents become entrenched in their positions, and receptivity to other perspectives is greatly diminished. At this point, if we respond to a verbal argument with a counterattack, the conflict escalates. A more effective response at these times is to do what negotiation expert William Ury (1991) called "stepping to their side." Ury explained that when a topic is heated, "The negative emotions will emerge in the form of inflexible positions" (p. 53). To deescalate the emotions, we must stop planning our next argument and instead "step to their side" by listening deeply to what other people are saying, considering not just their words but the values and emotions behind their words. The next step in disarming other people is to find something to acknowledge or affirm in what they said. Even if we don't agree with their conclusions, we might be able to affirm their emotions or values, saying, "I can see that this is very important to you" or "I know you want what is best for the department." When the other person has been heard and acknowledged, there is now a chance that he or she will be receptive to a different view, so it is at this point that we can move on to explaining where it is that we disagree.

When I ask workshop participants to practice listening and affirming before responding, they invariably make the mistake of giving only a brief acknowledgment before jumping in with a rebuttal. The impression this creates is that the person was biding her time until she could counterattack. In especially tense interactions, it helps to step more fully to the opposing side

by asking them to tell us even *more* about their point of view, getting as clear an understanding as possible and fully hearing them out before we attempt to acknowledge their position. In one-on-one interactions, communicating that you have fully heard the other person opens up the possibility that he or she will be able hear and consider your perspective. In groups, a respectful hearing and acknowledgment of the opposition garners the respect of your audience, so that even if the person you disagree with never comes over to your point of view, some of the others in the group likely will.

INTO ACTION

In the next week, look for opportunities to practice understanding and validating an opponent before stating your own viewpoint. Try the following:

1. Ask questions and invite the other person to explain his or her perspective more fully.
2. Respectfully acknowledge the validity of his or her concerns or point of view before stating your opinion.

There are times when providing a full acknowledgment of an opposing point of view is not in your best interest. In a short question and answer session after a talk, you might respond to an off-the-wall comment by saying, "That's an interesting point," and moving on to the next question, rather than using up your valuable presentation time discussing the merits of another scholar's agenda.

Stepping in toward a dissenter can be as effective in responding to nonverbal signals, or even hazing, as it is with verbal disagreements. One of the vignettes at the start of this chapter described a professor who experienced eye rolling by her male colleagues when she spoke up in meetings. In some instances, eye rollers have a legitimate concern that you will learn only if you invite them to speak up. In a workshop for graduate students, I advised students who were "all but dissertation" to set up regular meetings with their chairs. Many in my audience responded with skeptical looks. I said, "I'm seeing a lot of people making faces. What's going on?" Some of the participants then poured out their frustrations with unresponsive chairs who flatly refuse to have regular meetings. Other audience members nodded emphatically. I then asked if anyone in the group had found an effective strategy to deal with an unresponsive dissertation chair. The students generated a number of

solutions, including going to their committee members for support, asking for assistance from students who were further along than they were, or asking assistance from postdocs in their labs. By "stepping over to their side," I created space for the students to share solutions about a serious challenge to completing their degrees.

Sometimes eye rolling is nothing more than an attempt to discredit the speaker. However, it may be equally effective to respond as if you believed the person was expressing a genuine concern. If you remark, "Joe, I see you rolling your eyes. Help me to understand your concerns with this proposal," Joe is on notice that he will be put on the spot to explain his nonverbal signals. Once he realizes that you are not an easy mark and will (politely) call him out on his behavior, he is more likely to back off.

Although women academics must contend with gender bias, this is a challenge to which women can respond on multiple fronts. As individuals, women can practice a variety of communication techniques and combine both hard and soft styles to keep their balance and convey both competence and collegiality. Because gender bias occurs in women and men, we can also be alert to our own biases and develop greater respect for women who do not conform to gender roles. Finally, we can educate not only ourselves but also our students and colleagues about the propensity to judge women differently from men and, in doing so, broaden the acceptance of women in authority.

8

NEGOTIATION

Don't skip this chapter, even if you are not on the job market and don't plan to leave your current position. One of the most powerful things a woman professor can do to advance her career is to identify resources that will help her succeed and ask for them on a consistent basis. As simple as that sounds, it turns out that there are significant gender differences in the propensity to negotiate, and when women do negotiate, some styles that work for men come with a social cost for women (Babcock, et al., 2006; Bowles, et al., 2007). This chapter explains why negotiation matters, examines internal and external barriers for female negotiators, and provides guidance on how to negotiate.

Think of Negotiation in Broad Terms

Negotiation opportunities are not limited to formal contract agreements; they occur all the time. In academia, the most coveted assignments and positions of responsibility can be negotiated, balancing service with rewards. A professor who is asked to be in charge of a difficult or time-consuming project might negotiate to let go of another responsibility or for training that will help her to succeed in the new role. If asked to do service for a professional society, an academic might negotiate the start date by explaining, "I'm on leave this semester but would be happy to chair the prize committee next year." Teaching duties can also be negotiated, trading a less desired assignment for something one wants later: "I'll teach the 250-student lecture in the fall if I can have two small classes in the spring, including a graduate-level course in my research area."

154

LEARN MORE

A nonexhaustive list of the kinds of work-related issues that professors regularly negotiate *outside* of job-offer situations includes the following:

- The provision of teaching assistants and graders
- Course scheduling
- Teaching of preferred courses
- Additional funds for conference travel
- How the workload is shared with coauthors
- Author order
- The number of student advisees
- A reduced teaching load for revising a course, creating a new course, or directing undergraduate or graduate studies
- Bridge funds between grants

At home, spouses negotiate the job of dropping off the kids in the morning, vacation destinations, and myriad household responsibilities. In the larger world, there are also countless opportunities to negotiate, from traditional arenas like buying a car to more novel applications, such as requesting a free upgrade to a better hotel room or a discount on a bulk purchase.

Men Are More Inclined to Negotiate

The following story was told to me by a faculty member who attended one of my seminars:

> When my friend was on the market as a relatively unknown assistant professor of law, he was offered an interview at a prestigious law school. He told the law school that he would like to come and interview but that he wanted to meet with a famous composer in the music department as part of his visit. In addition to his law degree, my friend has a PhD in music composition, and although they had never met, this composer was one of his personal heroes. Someone from the law school made the request to the composer, but he declined. However, my friend held his ground and explained that he would interview only if they arranged for him to meet with this person. So the composer was asked again, and he finally agreed. When they met, my friend and the composer hit it off, and the university ended up offering my friend a joint position in law and the school of music.

Impressed with what I just heard, I exclaimed, "Wow, that's an amazing story!" "Yes, but that's not all," the professor continued:

> When my friend got the offer, he explained that he was eager to settle down with his family and develop roots, and so he would like to be brought in with tenure. The university agreed to do this, and my friend entered the position as an associate professor with tenure.

This story is remarkable for a number of reasons. The professor had the confidence to ask for the meeting he wanted, he persisted even after being told that the composition professor had turned down his initial request to meet, and he believed it was in the realm of possibility to start the job with tenure, despite that being outside of the norm. Although possessing a marketable degree and skill set put this professor in a strong bargaining position, he would never have achieved such a positive outcome if he hadn't seen opportunities where others would have seen limits.

This mind-set, that there are more resources available than are first apparent, is more common in men than in women (Babcock & Laschever, 2007). When offered a salary, some women assume that there is a set rate that can be paid, and if the institution could offer more, it would do so. Later, they might learn that their colleagues asked for and received not only a higher salary but also other perks such as more start-up funds, additional resources for their labs, or a lower teaching load. All of these things increase the chances of success and the probability of being able to request even higher salaries down the road.

Linda Babcock, a Carnegie Mellon professor of economics, explains that she became interested in gender differences in negotiation when women graduate students came to her to complain that their male counterparts had the opportunity to teach their own courses while the female graduate students were serving as teaching assistants to professors. Babcock agreed that this didn't seem fair and investigated by talking to the person in charge of teaching assignments. It turned out that the men had come to him with ideas for classes that they wanted to teach, and he had done his best to accommodate them. He explained, "More men ask. The women just don't ask" (Babcock & Laschever, 2007, p. 1). As a researcher, this piqued Babcock's curiosity about whether this was part of an overall gender difference in who asks and who does not.

Babcock looked at starting salaries and negotiation patterns of male and female master's students who had graduated from Carnegie Mellon. The men's starting salaries were 7.6%, or $4,000, higher on average than the women's salaries, and 57% of the men, but only 7% of the women, had negotiated. The students who did negotiate increased their salaries by 7.4%, or about $4,053, very nearly the difference between the average starting salaries for men and women (Babcock & Laschever, 2007).

In her book *Why So Slow? The Advancement of Women*, Virginia Valian (1999) showed how small imbalances accumulate over time to cause enormous disparities. Likewise, in their popular book *Women Don't Ask*, Babcock and her coauthor Sara Laschever (2007) explained that with a $5,000 difference in starting salary, each raise would be based on an initial higher starting point, and this would result in several hundred thousand dollars difference over the course of a career. If the difference were invested at 3% interest, someone who negotiated her salary would make over half a million dollars more over time. Because the worker who negotiates her starting salary is much more likely to negotiate subsequent raises, as well as to ask for other resources that will contribute to her success and promotion, the impact of deciding to negotiate is likely to be much greater (Babcock & Laschever, 2007).

Babcock and Laschever are clear that despite the dramatic research findings, women's reluctance to negotiate does not explain the entire wage gap. As we saw in the discussion in chapter 7 on authority, women continue to face both conscious and unconscious bias in the workplace. This bias occurs in the arena of negotiation as well, and negotiating partners have different responses to male and female negotiators. But simply deciding to negotiate makes a powerful difference.

LEARN MORE

Sample items that might be discussed in an employment negotiation include the following:

- Salary
- Sabbatical and leave time
- Start-up funds
- Lab equipment, space, and renovation budget
- Teaching assistants
- Research assistants
- Conference and travel funds
- Teaching load
- Summer salary
- Computer hardware and software
- A position or job search assistance for one's spouse
- Moving expenses, including the cost of a second trip to search for housing

Chapter 6 provides additional information for those negotiating joint appointments or conducting a dual-career job search.

Compelling Negotiation Outcomes

Some years ago Anita, a highly competent university administrative assistant, was having difficulty making ends meet. She began to request a raise every six months and to monitor university job postings and apply for positions that offered greater levels of responsibility and better pay. Over time she became one of the highest-paid administrative assistants in the system, and she joined a department where her boss supports her goal of advancing her education.

When she went back to school, Anita negotiated with her landlord, who agreed to lower her rent. Although it took a number of rounds of dialogue between Anita and the placement director, Anita obtained permission to use projects at her job to fulfill the internship requirement, becoming the only student in her graduate program with a paid internship. Her boss agreed to free up Anita's time so that she could lead an exciting project for the internship, while still being paid her regular salary.

Anita is now two thirds of the way through a graduate program for which her department has paid a good share of the tuition. She will graduate next spring with minimal debt and excellent experience working on a project that she describes as "my dream job."

Joan, an associate professor of computer science, decided to plan a conference to offer support and mentoring for female computer science graduate students. While enthusiastically explaining the program she had planned, Joan mentioned that she needed to figure out what to cut, because her plan would cost double what her department usually spends for similar events. I suggested that she start off by asking for exactly what she wanted and cut back only if and when she was told it was too much. Joan wrote a compelling proposal that justified the extra cost as necessary to support graduate students traveling to the conference, and to her surprise and delight, the full budget was approved.

Susan, a valued and effective university administrator, told me that she asked the provost for a raise after hearing Babcock and Laschever report on their research. When the provost explained that she needed an outside offer to justify the raise, Susan went on the market and came back with an offer. The result was that Susan received a $30,000 raise to stay at her original institution.

Although Anita, Joan, and Susan are extremely hardworking and competent, they would not have achieved their goals if they had not asked.

Barriers to Negotiation

Despite compelling reasons to negotiate, women face both internal and external barriers to asking for what they want and need. One barrier is a lack of entitlement. From a young age, women are socialized to be nurturing, supportive, and communally focused, whereas men are taught to be independent and assertive. In a study in which men and women were asked what they thought they should be paid for completing a work task, the men consistently named a higher figure, even though the women felt they had performed the work task just as well as the men (Major, McFarlin, & Gagnon, 1984). As a group, women undervalue the worth of their work.

For some, cultural barriers to asking on behalf of oneself exacerbate the gender barrier. Kathleen Harris Canul (2003) explained that in Latina/o culture, "we experience a sense of discomfort both in risking shame in receiving a negative response and in placing someone in an awkward position of potentially saying 'no' to a request" (p. 170). In the chapter "Developmental Career Challenges for Latina/o Faculty in Higher Education," Edward Delgado-Romero and his coauthors offered this perspective from a Latina/o professor:

> My mother taught me never to argue with authority and to show elders *respeto*—communication was one way: they spoke and I listened. So it came as a shock to have to negotiate for salary and benefits with the Dean. I was not very good at it but I had friends who helped me a great deal. I was lucky that I had a Dean who made a fair offer to start with. . . . However in the long run I realized that this was just the first time I had to justify how much I was worth, and I had to get used to it. So even though it felt totally alien, I had to learn to stand up for myself. (Delgado-Romero, et al., 2003, pp. 269–270)

Likewise, in her book *Breaking the Bamboo Ceiling*, Jane Hyun (2005) explained that cultural values of harmony, modesty, duty, and humility make it difficult for many Asian Americans to promote their own accomplishments and value. The cultural belief is that if you are modest and work hard, your efforts will be rewarded.

Another barrier is that women more often experience negotiation as stressful, whereas men more often experience negotiation as exciting. Even when men do experience anxiety about negotiating, they overcome the stress and go ahead and ask for what they want. When women experience anxiety, they often choose to drop their goal in order to avoid the stress. Without

strategies to manage stress, women may decide that the potential gains are not worth the discomfort of negotiating (Babcock & Laschever, 2007).

Can It Hurt to Negotiate?

Although extremely unusual, a disastrous negotiation outcome ricocheted through the academic blogosphere when a new PhD had an offer withdrawn by a college after she attempted to negotiate the terms. The candidate had emailed requests that are common at research-intensive institutions, including a limit on new class preps and a research leave. However, the administrators at the teaching-focused college told the candidate that because her requests indicated she wanted to work in a research-focused program, not a teaching department, they had decided to withdraw the offer. One important lesson is to consult with people who are familiar with the kind of institution with which you are negotiating so that your requests are appropriate to the setting. Negotiating in a real-time conversation rather than by email may also be beneficial. If the candidate had asked for an earlier item on her list and been told that it was not something that could be granted at this teaching-focused program, she could have calibrated the rest of the negotiation in response to that information (Flaherty, 2014).

Gender bias also poses a challenge for female negotiators. As with women who use more assertive speech, women who negotiate risk paying a price for stepping outside of the prescribed gender role. Bowles et al. (2007) did a study in which they showed participants videos of men and women being interviewed. Some of the interviewees just answered questions, and others negotiated quite assertively. Men who saw the videos were as likely to hire the male interviewee regardless of whether he negotiated aggressively but were 50% less likely to hire a woman who negotiated aggressively. Women who viewed the videos reacted negatively to *both* men and women who displayed aggressive negotiating styles (Bowles et al., 2007). This means that men have an advantage when a man is making the decisions, and, because the proportion of men increases at higher levels of an organization, the advantage is magnified. Given gender bias, one has to wonder whether the successful outcome for the lawyer–composer mentioned earlier in the chapter, who obtained a tenured joint appointment, would have been possible had he been a woman.

How to Negotiate: Strategies for Success

Through ongoing research, Babcock and others are working to identify strategies for women who want the benefits of negotiation without the social costs

of appearing aggressive. Bowles and Babcock (2013) found that providing a relational account for the negotiation was helpful. Examples include explaining that a senior mentor instructed you to negotiate or asking that your decision to negotiate be seen positively, because your negotiation skills will help you to perform your job well. The relational accounts made no difference for how people perceived male negotiators, but they allowed women to obtain the benefits of negotiation without being perceived negatively (Bowles & Babcock, 2013).

Develop Strong Alternatives

You will achieve the best outcomes when your negotiating partners have a lot to lose if they cannot negotiate an agreement, and they believe that you have strong outside options. In their bestselling book *Getting to Yes*, Roger Fisher, Bruce Patton, and William Ury (1991) discussed the abbreviation BATNA, "Best Alternative to a Negotiated Agreement." A person with good alternatives (a strong BATNA) is not under pressure to come to an agreement, so she will push harder for what she wants. A person with poor alternatives (a weak BATNA) might rather accept inferior terms than risk the chance that the negotiation will break down completely. When the provost told Susan to go after an outside offer, he was essentially telling her to improve her BATNA. This allowed him to persuade *his* boss to agree to the raise, because there was a high likelihood of losing a valued employee if they did not match her offer. Susan's experience is quite standard in academia, where outside offers are the most common way for professors to improve their negotiating position and get a raise. Remember, though, that if you are not actually open to moving, this strategy carries risks. If your dean decides not to offer a retention package and you stay put, you've lost credibility and leverage in future negotiations.

Gather Objective Information

Women negotiate just as well as men with the right preparation. In situations when they know exactly what others are being paid, women do not show a lack of entitlement and are willing to ask for equal pay (Major et al., 1984). In employment negotiations, gather as much objective information as you can about salaries and perks. It is easy to find salary information for faculty members at state universities, where it is a matter of public record. At private universities, comparing salaries takes a bit more work, especially because in the culture of the United States, people are more inclined to discuss the details of their sex lives than the amount of money they earn.

A comfortable way to gather information without personalizing the question is to ask colleagues what kind of salary range they think is appropriate for someone at your type of institution and career stage. Similarly, it is wise to ask colleagues and mentors to suggest the kinds of resources that

should be requested when negotiating a job offer or retention package. Some professors even ask a colleague from within their new department for advice on what they should request in order to be successful. Because men tend to ask for and earn more than women, when you are gathering information about salaries and perks, be sure to include men in your conversations.

LEARN MORE

Additional sources of information that will help you prepare for a job negotiation include the following:

- "After the Offer, Before the Deal: Negotiating a First Academic Job," article in *Academe: Magazine of the AAUP* (Golde, 1999) offers an overview of the negotiation process
- Websites like Glassdoor allow employees to post salary information anonymously: www.glassdoor.com/index.htm
- *The Digest of Educational Statistics* lists average salaries by state: nces.ed.gov/programs/digest/d04/tables/dt04_240.asp
- *The Chronicle of Higher Education* lists average salaries by school: chronicle.com/stats/aaup
- Your professional association website may list academic salaries
- Web-based cost of living calculators allow you to compare housing and other costs in different cities and around the world

Ask on Behalf of Someone Else

Women negotiate as well as men when asking on behalf of someone else, so identifying how the request benefits your organization, your students, or your family can bolster your confidence (Babcock & Laschever, 2007). Framing requests as benefiting the organization may also help women navigate the tightrope of appearing assertive and competent without being seen as pushy or difficult. Most reasonable requests can be explained as good for the department or the university, if you give them some thought. For example, a professor requesting travel funds to attend a conference might frame the trip as important for recruiting graduate students or as a way to give her institution a presence on the national and international stage.

Use a Social Style

Men can get away with a very task-oriented style, but women are more successful when they employ a social style (Carli, LaFleur, & Loeber, 1995). After a full professor showed her chair that her salary was below the norm in her field

and asked for a raise, her chair came back and explained that he had been able to get part but not all of what she had requested. The savvy professor responded positively, saying, "Thanks so much. I'm really pleased with this raise and grateful that you went to bat for me. This is terrific!" But she didn't stop there. She asked, "Can we continue to look at how we can bring my salary in line with the market over the next several years?" By framing her response positively, she was able to continue to press for her goal without coming across as demanding.

Set High Targets

When compared to men, women are more likely to focus on the minimum they will accept rather than what they would be "thrilled to get" (Babcock & Laschever, 2007, p. 148). In negotiation jargon, the minimum you could live with is your reservation value, and the amount that you'd love to get is your target or aspiration value. Negotiators who focus on high targets achieve better outcomes. Once you've been offered a position, rather than ask for the minimum you need to live on, identify an amount that you'd be delighted to earn, and ask for that. Starting with a high target means that even if the other side counteroffers, you are likely to end up with more than your reservation value.

Have a Plan to Handle the Stress of Negotiation

Focusing on high target values brings improved results for women but, because it also brings improved results for men, setting high targets does not by itself level the negotiating playing field. An additional action that women can take to even things up is to prepare for negotiation by planning how they will handle the associated stress (Babcock & Laschever, 2007). One of the best ways to plan for stress is with rehearsal. Ask a friend to role-play the chair, dean, or provost, and practice responding to specific objections that might be raised. Identify your top priorities and decide ahead of time which parts of your request you wouldn't mind parting with. Expect that the negotiation might go for several rounds and stick with it, rather than give in if you receive an initial "no." If you find yourself becoming very anxious, take a deep breath, pause, and remember that you are prepared and have strategies. If necessary, take a break from the negotiation. You can thank the person, and let him or her know that you'd like to think about things and continue the conversation at another time. If you come from a background in which negotiating goes against the cultural norm, taking plenty of time to rehearse will be a particularly important step to increase your confidence.

Negotiate Interests Rather Than Positions

Many women possess a set of relational skills that make them adept at certain types of negotiations. One area in which women's social skills help them to

excel is in bargaining around interests rather than positions. A classic illustration of the difference between interests and positions has been attributed to the social worker and pioneer of management consulting, Mary Parker Follett (1868–1933). Two sisters were fighting over an orange, so their mother insisted they compromise by cutting the orange in half and each taking an equal share. But it turned out that one of them wanted a glass of juice, and the other wanted the orange peel to make orange zest for baking. Because each sister was locked into her position, they never stopped to discuss their interests or *why* they wanted the orange. If they had, each sister could have gotten all of what she wanted. Follett was an early advocate of managing conflict by identifying the interests of both parties and integrating their desires to find solutions that work for everyone (Graham, 1995). This concept of looking for "win-win" solutions was later popularized by Fisher et al. (1991) in *Getting to Yes.*

To conduct a negotiation that is based on interests, you must first clarify your own interests. If you are resisting a service assignment because it will eat up your precious research time, don't get stuck in a position of refusing the assignment. Your interest is time—and if you can trade out of another obligation and preserve your time, accepting the assignment might work out. On the other hand, if you are a junior faculty member being asked to chair a controversial committee that will decide an issue on which senior members of the department are split, your interest is to stay out of a political quagmire. You can explain to your chair that you want to do your share of service but request that he find a less perilous way for you to support the department.

To get to a win-win solution, you also need to know what other people value. Consider the constraints under which they are operating, and listen to the values they express in one-on-one conversations or in meetings. Ask others who know them well for insight into what is important to them. Finally, engage with people directly to understand what outcomes they desire, what concerns they have, and whether alternative ways of getting to their goal would work or would pose challenges for them. In thinking about what other people value, don't forget to consider intangible values such as a need to feel important or to be seen as fair.

Overcoming an Initial "No"

In keeping with the strategy of negotiating interests, you can take a "no" as an opportunity to learn more. Invite the other side to explain the kinds of problems that would be created for them if they were to agree to the request. An example might be a chair who responded negatively to a professor who asked for a daytime teaching schedule. If the professor asked what hurdles that request poses for the chair, the chair might explain that the department is working to broaden its constituency by offering evening classes for nontraditional

students, and she is concerned that if she grants special requests, she won't be able to find enough instructors to cover the evening classes. In the discussion in chapter 7 on authority, we talked about the idea of "stepping to their side." The same skill is essential at this stage in a negotiation. If the professor first expresses empathy for the chair's dilemma by saying, "I can certainly understand the importance of staffing evening classes, because nontraditional students make up a sizable percentage of our enrollment," the chair is more likely to be open to discussion. At this point, the professor might say, "I'd like to do my part to cover the night classes. My husband is teaching a night class this spring, and one of us needs to be home with the kids, but he is on leave next semester. If I could have daytime classes this semester, I will commit to covering the night class next fall." Learning the other side's interests and acknowledging her point of view doesn't guarantee that she will grant your request, but it does increase the likelihood of your arriving at a mutually satisfactory agreement.

LEARN MORE

Women and Negotiation

- *Women Don't Ask: The High Cost of Avoiding Negotiation— And Positive Strategies for Change* by Linda Babcock and Sara Laschever (2007)
- *Ask for It: How Women Can Use the Power of Negotiation to Get What They Really Want* by Linda Babcock and Sara Laschever (2009)

Popular Classics

- *Getting to Yes: Negotiating Agreement Without Giving In* by Roger Fisher, Bruce Patton, and William Ury (1991)
- *Getting Past No: Negotiating in Difficult Situations* by William Ury (1991)

Comprehensive Texts on Negotiation

- *Negotiation* by Roy J. Lewicki, David M. Saunders, and Bruce Barry (2014)
- *Negotiation: Readings, Exercises, and Cases* by Roy J. Lewicki, David M. Saunders, and Bruce Barry (2009)
- *The Mind and Heart of the Negotiator* by Leigh L. Thompson (2011)

9

LIFE AFTER TENURE

Pretenure, professors look forward to the day when they achieve promotion, and the sense of being under the guillotine is lifted. They imagine that with job security, their lives will be more relaxed. Tenured faculty members do experience relief upon making it through the hurdle of promotion, and they appreciate the associated privileges. However, with tenure comes greater responsibility. You may be asked to take a turn on the executive committee, chair your department, lead your professional organization, or edit a journal. Although these are honors that provide a greater say in the governance and direction of one's department, institution, and profession, they also require a great deal of time.

Women remain at the associate level longer than men do, and fewer women than men make it to the rank of full professor. Women also spend more time than their male counterparts on teaching, mentoring, and serving their institutions (Poor, Scullion, Woodward, & Laurence, 2009). Thus, this chapter addresses how to maintain one's own research agenda while juggling additional commitments. Other topics covered include dealing with the pressure to live up to one's own earlier work, finding mentors at midcareer, rebuilding a stalled research program, conducting posttenure job searches, and advocating for diversity.

Adjusting to New Roles

Chelsea, an associate professor at a large public research university, had gotten better at saying "no" to requests, but she was apologizing right and left

166

for delays in responding to the myriad demands of her job, including emails, reviews, letters of recommendation, and much more. When I questioned her need to apologize, she told me, "I've always prided myself in being responsive. If I can't get to things right away, I want to at least acknowledge it and apologize."

I responded, "There's a saying, 'What got you here may not be what you need to get you where you want to go.' As a graduate student and assistant professor, you said 'Yes!' to every request that came your way, and you responded quickly. But now you have more coming at you, so you can't crank it all out as quickly. Apologizing might send the wrong signals. People realize that at a certain level there are more demands on your time and would not expect apologies, because they understand how precious your time is."

"That makes sense, but it also makes me uncomfortable. You know I just gave a talk at another university, and when I was introduced with this long list of accomplishments, I just started feeling more and more uncomfortable. And then the students asked questions with this kind of awe, like, 'How did you come up with that idea?' as if it was some kind of amazing feat. In my family it is considered the worst kind of sin to have a swelled head. If someone mentions your accomplishment, you're supposed to say, 'It was nothing' or 'I just got lucky.'"

As we talked, it occurred to me that Chelsea has a double whammy: She came from a working-class family that taught her to be self-effacing, and as a woman, she was socialized to apologize. Together we considered how she could become more comfortable with her higher profile. Chelsea recalled, "I have a colleague who is an academic star, but when graduate students express admiration for his work, he asks, 'What is it about this that grabbed your interest?' He really draws them out. He makes it a conversation about the student and the topic, not about himself. I'd like to try that approach. I'm really passionate about the work I'm doing, I just don't want it to be all about me, and I don't want to be a jerk who is too self-important to be considerate of other people."

"That sounds like a great strategy. But maybe you also need to forgive all the busy people who have written terse responses to you in the past," I suggested. "They may really just not have time to write longer responses to everyone who sends them an email."

"I think that's right. I used to be able to beat my email in-box back down to zero, but lately I can't keep up. I get so many requests from people I don't even know."

"What if you just didn't respond at all to emails from people you don't know?"

"No, I really do want to respond to everyone, but I think that's right that I need to stop apologizing when I can't respond right away and that I shouldn't be spending a lot of time crafting the perfect response to someone I don't know. My research is important to me, and I'm willing to come across as less gracious if it gives me more time to do my work."

A full professor had a different realization about the shift into a more advanced career stage. She observed, "I decided to go to this conference because there will be someone there with whom I want to connect. That made sense 5 or 10 years ago, but not anymore. I have access now—if I just call him up and say I want to meet, he will meet with me." She realized that having built strong professional connections over a number of years, she could pull back on travel in order to spend time on her research and also manage a larger administrative role in her department.

Living Up to One's Own Earlier Work

An associate professor told me, "When I was younger, I didn't worry about my writing because I didn't really believe that anyone would ever read it. Now that I've had a level of success, I get paralyzed because I know that people will be eager to see what I have to say, and I feel like I have to come up with something great." Although this might sound like an enviable problem to people at an earlier career stage, it is not uncommon for senior scholars to feel burdened and sometimes paralyzed by the weight of higher expectations.

Elizabeth Gilbert (author of *Eat, Pray, Love* [2006]) addressed the pressure to live up to earlier accomplishments in her TED talk on creativity. Gilbert (2009) explained, "Everywhere I go now, people treat me like I'm doomed. . . . They come up to me now, all worried, and they say, 'Aren't you afraid you're never going to be able to top that?'" Given this awareness that her work will now be judged by what she has already done, Gilbert realized that she would need to come up with a mechanism to separate herself from those expectations. She took inspiration from the ancient Romans' understanding of a genius not as a person but as a spirit that resides within the walls of one's home and studio. If the work is going well, it is because the genius is doing her job, and when it is going poorly, it is because the genius isn't on the ball that day. Gilbert concluded that it is her job to show up to work and to keep showing up, regardless of whether her genius seems to be "in" on any given day (Gilbert, 2009). Others reduce the pressure by focusing on what they find interesting in their research or by thinking about how they can be of service through their work rather than about whether they will come up with a field-changing theory or a prize-winning discovery.

Promotion, Raises, and the Job Market Posttenure

Moving From Associate Professor to Full Professor

Both women and men can be thrown off course by the change from the clearly defined time clock leading up to tenure to the more fluid timeline and sometimes fuzzier requirements for achieving the rank of full professor. Often, assistant professors are assigned mentors and offered direct support, whereas associate professors are left to fend for themselves. Some institutions are beginning to recognize the need for continued mentoring for associate professors, but if that is not built into the fabric of your program, then you can and should start planning early for promotion. This could include having conversations with senior members of your department about expectations for full professorship; continuing to write out personal visions and goals to achieve in the next year, as well as five to 10 years down the road; and setting up regular meetings with a colleague at a similar career stage to commit to goals and report on progress.

As you rise through the ranks, connections with scholars from outside of your own institution may become indispensible. In a survey on the status of women in the profession by the Modern Language Association (described in the report "Standing Still: The Associate Professor Survey" [Poor et al., 2009]) one professor wrote, "In a smaller department such as mine, mentoring at higher ranks is impossible, because quality mentoring requires an ability to critique the research of one's colleague in the context of the specialty in which they are working. I believe that conference attendance (i.e., networking in the field of specialization) makes a lot more sense than on-campus mentoring for associates who wish to be promoted to full" (p. 10). Another professor in the study emphasized that her contacts around the nation were instrumental in supporting her "in writing, presenting, revising, and submitting my work for publication" (Poor et al., 2009, p. 10).

Associate Professors and Role Conflict

Recently, a dean at a prominent East Coast university told me that her administrative team looked at professors who had remained at the level of associate professor for an extended number of years and found that they fell into two camps: "deadwood" who shirked service, were uninspired teachers, and were unproductive researchers; and those who excelled at teaching and advising and provided the lion's share of departmental service, all at the expense of their own research productivity. The first group was almost all male, and the second was almost all female.

I sometimes hear complaints from tenured women about senior men in their departments who are productive researchers but flatly refuse a turn

at time-consuming administrative roles in the department. Several studies provide concrete data that back up these anecdotal accounts. In "Standing Still: The Associate Professor Survey," Poor and colleagues (2009) reported, "On average it takes women from 1 to 3.5 years longer than men to attain the rank of professor, depending on the type of institution in which they are employed" (p. 5). Women at Carnegie doctoral institutions took 2.5 years longer than men to achieve full professorship. The gender discrepancy was greatest at private independent institutions, where it took women 3.5 more years to be promoted to full professor. There are also more women than men who never make it to the rank of full professor. The study found discrepancies in how men and women spent their time that would account for some of the difference. Looking at all institutions in the study, the authors found that men spent two more hours a week on research and writing, and women spent 1.5 hours more a week on grading and commenting on student work and an additional 1.8 hours a week on course preparation (Poor et al., 2009).

In another study, Joya Misra and colleagues (2011) surveyed 350 professors at the University of Massachusetts Amherst and reported the results in the *Academe* article "The Ivory Ceiling of Service Work: Service Work Continues to Pull Women Associate Professors Away From Research. What Can Be Done?" The authors found that time-use differences by gender were greater at the associate rank than at any other level. Although male and female professors were putting in the same total number of work hours per week, men in their research sample spent seven and a half more hours on research each week than women. The women were putting in one additional hour teaching, two more hours mentoring, and nearly five more hours of service each week than the men. There were also differences between the types of service being done. Men and women were doing similar amounts of service to the profession, which often carries more visibility and prestige, but women were doing more service to the university. And many more female than male associate professors were doing time-intensive lower prestige service, such as serving as director of undergraduate studies (Misra, Lundquist, Holmes, & Agiomavritis, 2011).

When professors stall at the associate level while watching their peers, or even their protégées, move on to become full professors, they often feel embarrassed and demoralized. If you are stalled at midcareer, then it is time to reassess your priorities. Often women accept labor-intensive service because doing otherwise feels selfish. It can be helpful to consider, "Who else will benefit by my promotion?" Some women are not motivated by personal ambition, but they do care about providing a model to their colleagues or graduate students or earning a raise at a time when their kids are approaching college. Focusing on who else will be helped may make it easier to step down from time-intensive service roles and decline new ones until you achieve your next promotion.

Often professors feel overloaded but don't know how their workload actually compares to that of their departmental colleagues. When a newly promoted associate professor wondered how many students she should be advising and funding and what percentage of her salary she should be covering through grants, she went to her department and student services administrators and asked for the numbers. She learned that prior to her promotion, she was the only assistant professor who was funding any students and that she was funding more people than one of the full professors in her department. She also learned that the percentage of salaries covered by grant funding ranged from 25%, or just enough to cover summer salary, to 100% of salary. This information made it easier for her to say "no" to additional advising. If the numbers do not support your cutting back on service, you can implement other strategies such as doing group advising, having shorter or less frequent student meetings, or judiciously choosing to skip some departmental or committee meetings.

Negotiating a Raise

Although promotion to full professor comes with an increase in pay, professors' salaries often increase very slowly after that point. Although some chairs and deans will approve a raise after being shown data that others with comparable experience are earning more, conventional wisdom is that you need to go on the market to get a substantial boost, as well as to negotiate funding for research assistance or other desirable support. Chapter 8 provides more information on negotiations and requests for raises and other resources.

Going on the Market Posttenure

Although open searches do still occur at higher ranks, at the most selective institutions these searches often follow different rules of engagement. A department first contacts potential candidates informally to ask if they might be interested in the position. If the response is affirmative, the department continues the courting process with an invitation to give a talk for the department. This allows both the department and the unofficial candidate to get to know each other and begin to consider if there is a good mutual fit. Likewise, professors at advanced levels who are looking for outside offers often start the process by letting former advisors, mentors, friends, and acquaintances know that they are movable and inquiring as to whether departments at desirable institutions are in the market for someone with their profile.

Although this informal process is common, there are good reasons to apply for posted positions, regardless of whether you suspect the department may have one or more preferred candidates. The favored candidate may receive a counteroffer that convinces her to stay put at her current institution,

or her spouse may decide to veto a move. Likewise, there may be people who assumed that you would not be interested in the position but who are pleased with your candidacy. Because market conditions and hiring conventions differ between fields, if you have questions about how to proceed with a job search, seek the advice of trusted mentors or peers.

Continuing Scholarship From an Administrative Role

Many administrative positions specify a percentage of time that will still be devoted to research or teaching. A vice provost may be assigned 60% to the provost's office and 40% to her department, or an assistant dean may have 20% of her time designated for research. In reality, people often find it difficult to advance their research agenda while juggling the demands of an administrative job. One administrator's boss told her that she should absolutely take time for her research, but then the boss continually interrupted the administrator's work with questions and issues that needed immediate attention. If your assistant is willing to guard your door, and your boss can be trained not to barge in, then block out research hours in your schedule, close your door, turn off your email, and keep your head down during that time. Some people find that the only viable solution is to have regularly scheduled hours to work from home or from a library or café, away from the distractions of the office.

Chapter 1, "How to Have More Time," discussed the importance of differentiating between someone else's sense of urgency and your own priorities. In a larger administrative role, you will find it becomes even more essential to set your own agenda rather than respond to pressure. Rhoda, an assistant dean, has an administrative assistant who becomes anxious when programs are not planned well in advance. However, Rhoda is adept at pulling programs together very quickly, and when she tried to please her assistant, her research suffered. After struggling for months to complete a paper, Rhoda decided that she was no longer willing to abandon her research time to assuage her assistant's anxiety.

Liz, a program director in the humanities, experienced a similar challenge with getting sidetracked by someone else's sense of urgency. When she informed student fellows that they would not be able to move into their offices until a renovation was complete, one student insisted that he had to be accommodated immediately. Liz thought through various solutions before concluding that there was no way to accommodate this student without addressing the needs of the rest of his cohort, so everyone would have to wait. However, she felt so badly about having to disappoint the young

scholar that she spent mental energy and a significant amount of time worrying about the decision and checking in with colleagues to be sure that she was being fair. "This one was really tough," she confessed, "because I want people to be happy with my decisions and to like me." For women who found success earlier in their careers by working hard to please people, it can be tough to adjust to roles that require them to make quick decisions and move on, despite people being unhappy. But that tough decision-making "muscle" is one that can be strengthened and developed over time. In the big picture, accommodating an impatient student was a much lower priority for Liz than completing the paper that would forward her research goals and help her coauthor to achieve tenure.

Jump-Starting a Stalled Research Program

Diana is a scientist who came to coaching because she wanted to build her research enterprise back up to a more robust state, but she wasn't sure how to proceed. In our first meeting she told me,

> I'm a full professor, but a large research collaboration I was involved with fell apart, and since that was a major source of my funding, I can no longer support postdocs and graduate students. When my kids were younger, I pulled way back on travel to be home with them, so I'm pretty disconnected from peers in my field. I never had good mentoring. When I asked my departmental colleagues to read a manuscript or grant, they either refused or gave me very superficial feedback. I don't need to be the best known in my field or to have the largest lab—I find the work innately interesting—but I need funding and collaborators to move forward, and I don't know how to get them. It seems late in my career to deal with not having been mentored, but I'm only 48, and I don't feel ready to be put out to pasture.

Diana had a promising project she wanted to pursue, but she had a dilemma about collaboration. She explained, "I discussed working on this project with a woman from Wisconsin a few years ago, but we both had other things going on and never got going on this. There's a fellow I know at Connecticut who would be a stronger collaborator but, unfortunately, I already committed to the woman at Wisconsin."

"Tell me more about the fellow at Connecticut," I suggested.

"Well, he has a set of skills that is a perfect complement to what I bring, so I think we'd make a super team. He is also very prolific, so I know we'd

get something out quickly. I like the woman at Wisconsin, but she's not as senior and not as strong a scientist, and I don't think she works very fast. But I already talked to her about the project, so I guess I'll have to go with her."

"Wait a second, you said you discussed doing this project with her; you didn't say that you made a definite commitment," I observed.

"Well, no, but I'd feel bad going back on it after we discussed doing the project together."

"Is discussing a project the same as promising that you will do it together? Is it like taking a marriage vow, that you won't work with anyone else?"

"I don't know; it just doesn't seem like it would be right to go back on that."

"Could you describe the situation to someone else and ask how they see it?"

"Sure, I could ask my husband."

The next week, Diana reported on the conversation with her husband:

He said that just because we had a conversation didn't mean that it was a commitment. He said people bat around ideas like that all the time, and that doesn't create a promise or obligation. I guess I can tell the woman at Wisconsin that I'm going to go ahead on that project with someone else but that I hope we can collaborate on something else in the future. I wouldn't mind working with her on something, but this particular project is just a much better fit with the fellow in Connecticut.

When Diana spoke to the woman at Wisconsin, she was relieved by her response: "She said that was great because she had so much on her plate right now, she couldn't take on anything else anyway. She did say that we should keep talking and hoped we can collaborate on something else down the road." Diana moved ahead with the Connecticut professor and is excited about how well the project is proceeding with their complementary areas of expertise.

Diana took a number of other positive actions that gave her research program the boost she was seeking. She invited colleagues to participate in a writing group to read and comment on journal articles and grant proposals. When all of the other group members turned out to be pretenure faculty members, Diana noticed a number of benefits. She was able to give her junior colleagues advice based on her years of experience, but they frequently shared information and resources that she was not aware of, filling in some of the gaps that had been left by her poor early mentoring. Her department decided to count the writing group as service, because Diana was supporting the newer faculty members.

Diana also identified individuals in key funding roles with whom she wanted to connect, and she began to reach out to request meetings with those people. When she had questions about how to structure those conversations, she asked other successful colleagues to explain how they handled them and emulated the best practices she heard.

Asking for assistance is often difficult for associate and full professors because of their sense that they should already know how to do a given task. Another concern is that if they suggest meeting for writing dates or starting a writing group, it will call attention to the dearth of recent publications in their CV. But Diana was successful in jump-starting her research program precisely because of her willingness to reach out to others and ask for support.

The Opportunity to Advocate

A diverse faculty is often championed as a way to right historical wrongs, create a fairer society, provide students with role models, or prepare young people to work in a global world, but researchers are also finding that workforce diversity results in higher performing teams and organizations. In his book *The Difference*, Scott Page (2007) used mathematical models to show that groups with greater diversity perform better than groups with more high-performing individuals but less diverse ways of thinking and solving problems. Although the kind of diversity Page looked at was not based on differences in identity per se, he pointed out that people with diverse identities also tend to think differently.

Page gave an example of the benefits of diversity in his own field of economics. Before many women were in the field, unpaid labor that was done in the home was left out of calculations of gross domestic product. When women entered the field and pointed out this oversight, economic estimates became more accurate (Dreifus, 2008; Page, 2007). Researcher Anita Woolley and her colleagues found that one of the characteristics of higher performing teams is having more women, in part because women have a high degree of social sensitivity, and this characteristic contributes to team success (Woolley, Chabris, Pentland, Hashmi, & Malone, 2010). Given academia's increasing focus on collaborative projects and interdisciplinary work, smart leaders should care about diversity not just because it is the right thing to do but also because it leads to better results.

One of the benefits of achieving tenure is that it puts you in a position to support other women and members of historically underrepresented groups. Because mentoring efforts are heavily focused on junior faculty

members, department chairs can fill in the gap by meeting with midlevel people to discuss their goals and help them map out their path to promotion. The criteria for promotion to full professor are often less explicit than those for tenure, so associate professors benefit from as much clear guidance as possible.

Another important step is to educate yourself and others about implicit bias. The University of Michigan's Committee on Strategies and Tactics for Recruiting to Improve Diversity and Excellence (STRIDE) offers training for program chairs and administrators to promote diversity within the university. This section of the chapter draws on key points from the STRIDE program.

We all use schemas, or unconscious hypotheses, about gender, race, sexual identity, and disability as a way to make judgments. Even members of historically underrepresented groups carry schemas about their own groups. The schemas allow us to make quick assessments—for example, a man is likely to be taller than a woman—but those assessments are not always accurate. There is a great deal of evidence that reliance on these schemas negatively impacts evaluations (Valian, 1999).

One commonly cited study found that when members of orchestras auditioned from behind a screen, it dramatically increased the number of women hired by symphony orchestras (Golden & Rouse, 2000). Another study sent identical résumés with either a typically White name or a name more common among African Americans. The résumés with the White-sounding names resulted in many more interview invitations than those with African-American-sounding names (Bertrand & Mullainathan, 2004). A similar study found that when students are given a cue that a lecturer is gay, he receives lower evaluations and much more criticism than when the students are given a cue that he is straight (even though the same person gives the same lecture in both instances) (Russ, Simonds, & Hunt, 2002). The results of this research confirms what members of disadvantaged groups know from personal experience—that interviewing while Black or teaching while gay can be a liability.

The good news is that there are ways to reduce a college's or department's reliance on skewed schemas in hiring. One step is to broaden the pool of applicants from historically underrepresented groups. When the pool includes only one member of an underrepresented group, others tend to rely more on their biased schemas. When there are several people from the same group, each person is much more likely to be judged on individual characteristics and merits (Heilman, 1980). A dean from a professional school that

prides itself on diversity described how her program turned around a reduction that had occurred in the hiring of faculty members from historically underrepresented groups:

> *Over the last few years, we felt we needed more focus on maintaining a diverse faculty. Last year and this year, we made a concerted effort to diversify where we advertised and how we recruited our candidate pool and engaged all faculty members to talk with other people about our particular interests in supporting postdocs and junior faculty who would be interested in coming here. We ended up with a quite large pool, and it was a more diverse pool than usual.*

STRIDE recommends educating committee members about implicit bias so that they can design a search process to minimize its effects. Bias is greater in situations that are ambiguous, and an interview, by its nature, is a complicated process. A committee can take steps such as writing down clear standards by which each candidate will be assessed in order to reduce the ambiguity as much as possible. For example, men may be unconsciously evaluated more according to their potential, whereas women are evaluated on the basis of what they have already accomplished (Carter & Silva, 2011). Explicitly evaluating each candidate in both domains leads to a more equitable process.

Sometimes committees post a position with a very specific focus and then lament the fact that no one from a historically underrepresented group applies. A department that truly supports diversity will conduct a more open search and look at scholars who specialize in areas that may not have originally been considered. Another way to create a more diverse applicant pool is to look for high-performing minority scholars working in less prestigious colleges and universities. Dual hires can also be a way to increase diversity. Because women in academia are more likely than men to have a partner who is also an academic and to value her partner's career equally to her own, women will be especially attracted to programs that support dual hires (Schiebinger, et al., 2008). Often people on hiring committees need to be reminded that diversity does not mean that the department will look and operate in the same way that it did in the past but will need to change to reflect our changing world. People with diverse backgrounds will also bring diverse interests and ways of operating, which can be both exciting and challenging for those who are used to the status quo.

LEARN MORE

1. The STRIDE website includes a number of resources for individuals and departments interested in diversity. It is available at this link: sitemaker.umich.edu/advance/stride_committee

2. Virginia Valian, the author of *Why So Slow? The Advancement of Women* (1999), offers online tutorials on gender schemas and science careers that provide both background information and remedies for change. Although the material is geared toward undergraduates, graduate students, and postdocs pursuing science careers, the information and solutions offered are equally useful for professors and administrators and for those in nonscience fields. The tutorials are available at this link: www.hunter.cuny.edu/gendertutorial

3. In *Presumed Incompetent: The Intersections of Race and Class for Women in Academia* (Gutiérrez y Muhs, et al., 2012), the final chapter "Lessons From the Experiences of Women of Color Working in Academia" includes recommendations for administrators and for women of color and allies on topics including campus climate, faculty-student relations, social class, tokenism and the search process, tenure and promotion, and building networks of allies and mentors.

10

LEADERSHIP

Professors are leaders. Even outside of administrative positions, professors are called on to envision a desired future, plan the strategy to achieve it, and motivate individuals and groups to work cooperatively toward shared objectives, all of which require leadership skills. Higher education leadership consultant Diana Kardia pointed out to me, "On the California Psychological Inventory 260, the testing pattern of faculty members generally matches that of leaders in business, whether or not the faculty member is in a formal leadership role."

In this chapter, I focus first on leadership skills relevant to all academics, including emotional intelligence, meeting facilitation, consensus building, and staff supervision. Then, I look at positional leadership, including the decision to enter academic administration and the skills necessary to succeed in administrative positions. Topics include strategic planning, working with multiple constituencies, giving bad news, managing a budget, fund-raising, and speaking with the media. In the final section, I offer a profile of the career of a successful woman in academic leadership. Because there is overlap between the skills needed by all professors and those needed by administrators, the entire chapter will be useful even for those who never plan to take on a formal administrative role.

Leadership Versus Management

Stephen Covey (1989) credited both Peter Drucker and Warren Bennis with the quote "Management is doing things right; leadership is doing the right things." Covey gave the example of managers who keep a crew of

machete-wielding producers on schedule clearing a path through the jungle. The work is being done efficiently and well, until the leader climbs a tall tree and yells down to everyone, "Wrong jungle!" (Covey, 1989, p. 101). Leaders set the plan, whereas managers implement the plan and make sure that procedures are followed and the work goes smoothly. As most administrative positions involve a combination of big picture inspiration and day-to-day management, and often the distinction blurs in real life, this chapter will cover aspects of both.

Emotional Intelligence

Whether overseeing a committee, a department, or a university, successful leaders require skills that are collectively referred to as *emotional intelligence*. Emotionally intelligent leaders listen to others' perspectives and at the same time maintain awareness of their own thoughts, feelings, and values. They show caring, but they are also able to make difficult decisions and accept that they cannot please everyone.

Psychologist Daniel Goleman (2004) made the point that unlike analytical and technical skills, which are governed by the neocortex, emotional intelligence is connected to the limbic system, the part of the brain "which governs feelings, impulses, and drives" (p. 4). For those who don't come by these traits naturally, emotional intelligence skills can be acquired, but Goleman explained that these skills are best learned through direct practice and feedback rather than by reading a book or sitting in a classroom. This kind of practice can occur in a coaching relationship, but I have also known talented leaders who developed their emotional intelligence through journaling, mentorship, therapy, meditation, and other practices.

A *New York Times* interview with WNBA president Laurel J. Richie (Bryant, 2012) illustrated how Richie developed her emotional intelligence to become a more effective leader. As a vice president at Ogilvy & Mather, Richie ran an incredibly successful account, but while she was on vacation, her entire team went to the human resources department and asked to be moved to projects in which they would be treated as equal partners and have more of a say. Like many very bright leaders, Richie could quickly identify solutions for problems, so rather than giving her staff time to work out issues for themselves, she had been telling them what to do. But because her staff members' ideas were not heard and valued, their morale plummeted.

Although it took serious effort, Richie was able to keep her talented team by changing her style. Richie explained how she managed to hold back in meetings:

I also bought some Silly Putty. And I remember I would sit in meetings and just open up that pink little egg and literally just stretch the Silly Putty to give people time to think and create and develop, even though I was sitting there thinking: "I know how to do this. I know exactly what we should be doing." Instead, I let them present a point of view or share work that may have been not exactly the way I would have done it, but I learned that there are many different ways to get to the end point. (Bryant, 2012, p. 2)

If she had focused only on content, Richie would have had plenty of great ideas but no team with which to implement them. When she attended to the group process, it generated tremendous loyalty. Richie said, "One of the greatest things is at the end of the year, somebody on the team came to me and said, 'I'd walk through fire for you'" (Bryant, 2012, p. 2).

If you are a fast thinker and a highly verbal leader but Silly Putty is not your style, try writing down your thoughts before blurting them out. Having something to do makes it easier to remain quiet, and you will have captured your important ideas. You can add pertinent thoughts *after* all of your team members have given their input.

Ann had to employ every ounce of her self-control when she led a decision-making process with representatives from various university departments. The group was working on an issue about which Ann was passionate and knowledgeable and to which she had devoted years of her life. Given the institutional culture, Ann realized that her agenda would move forward only if she had the support of people across a range of interests. However, one committee member, Peggy, opposed the program that Ann wanted to implement. Ann had both research evidence and personal experience to back up her position, but she understood that to succeed, she had to come across as being open to all viewpoints.

When Peggy made false statements about the efficacy of this type of program, Ann refrained from citing the research or reactively telling Peggy that she was dead wrong. Instead she listened respectfully, smiled, and thanked Peggy for her input. Some days Ann went home and ranted to her husband about the crazy woman on her committee who was driving her nuts, but at work she always maintained a professional demeanor. When Ann wrote a report for the committee, she sought ways to recognize the issues that her adversary had raised, and she explained to the group how she had attempted to address each of their concerns. In the end, Ann's final report went forward with the wholehearted endorsement of the entire committee, including Peggy.

Masterful Meetings

When meetings are well run, crucial business is accomplished and at the same time group cohesion is built. Unfortunately, professors often endure meetings in which a few people dominate, someone goes on at length about a pet concern, old issues are rehashed, and time runs out before important topics are fully addressed. Those meetings waste valuable time and damage morale. One senior professor who felt worn down by the culture of meetings at his institution said,

> *I'm so frustrated by the abundance of meetings. They take me away from the projects that I'm doing. It's a Potemkin Village of democracy. We don't actually have any power over the things that we are meeting about, and they are wasting our time. When someone says they're having a meeting to get "buy in," it really means that there's no reason to meet!*

You can avoid a lot of anger if you make clear from the start whether the group's recommendations will be the final word or whether the group is working in an advisory capacity, with the chair, dean, provost, or president making the final decision.

This kind of frustration can also be avoided by thinking carefully before calling a meeting. If you only need to convey information rather than invite input or facilitate a discussion, you may be able to handle the issue by email or an informal conversation with a few people. If you do need to meet, consider who actually needs to be in attendance. There may be some people who will need to be informed of the outcome but don't have to attend.

However, eschewing meetings altogether can be risky. Norma described an experience on a conference planning committee:

> *It was so aggravating, because we almost never met. The chair felt that each member knew what needed to be done, and so we could carry out our duties independently. But sometimes I needed input, and I had to find that from sources outside of the committee, which didn't make sense. And it was a lot less enjoyable than the planning experiences I've had where the committee members worked as a team. But the worst part was that there were details that I put a lot of time into planning, and then it turned out that someone else had planned the same thing, so my work was completely wasted. The actual conference came off well, but I will never work with that group again.*

Part of the difficulty Norma recounted was due to a lack of communication, but she also missed the camaraderie she experienced in other work groups. Regular meetings provide a sense of belonging, which is important in today's academic culture where there is less faculty cohesion within departments and institutions. Some professors work with partners across the globe but have limited contact with members of their own departments, and higher expectations for publishing leaves less time for casual get-togethers. The sense of community that develops with regular meetings also fosters connections between faculty members that may lead to research collaborations. Protecting people's time by not calling unnecessary meetings must be balanced with judicious use of meetings to support the social fabric of your department or institution.

Strong facilitation is crucial to meeting success. I recommend that facilitators require that agenda topics be submitted in advance and that before the meeting, they post the agenda where everyone can see it. People who go off on tangents are reminded of the agenda and can be invited to add their issue to the agenda for the next meeting. Another strategy for managing digressions is to include some time in each agenda for "other issues." When someone brings up a concern unrelated to the matter at hand, you can politely ask him or her to raise the question in the "other issues" part of the meeting. Research on collective intelligence shows that team performance is stronger when members equally share the conversational space, rather than when one or two people do most of the speaking (Woolley, et al., 2010). The facilitator can play a crucial role in ensuring equal participation by seeking the opinions of quieter participants or, in some situations, asking that everyone be given a chance to comment before anyone takes a second turn.

Because people who try to both facilitate and take notes do neither job very well, a recording secretary should be appointed to document the gist of the discussion, decisions reached, and follow-up that needs to be done after the meeting, along with the person responsible for the follow-up and the due date. The secretary should also note any items that need to go on the agenda for the next meeting.

Morale will be higher if you end meetings by highlighting what was accomplished. In most cases, there should be actionable outcomes, and someone should summarize what those actions are and who is responsible for carrying them out. Even when a meeting airs various points of view, but a decision is postponed, it can be helpful to invite people to identify what they will take away from the meeting. Hearing that a colleague now has clarity about the issues involved in making a decision will give others the sense that their time was put to good use.

LEARN MORE

Meeting Planning Checklist

1. *Purpose:* What is the outcome that I want from the meeting? Do I want the group to share information, generate ideas, or make a decision? How will the meeting support group cohesion or morale? What will be different after the meeting takes place?
2. *Members:* Who needs to attend? Are there people who don't need to be at the meeting but do need to be informed of any decisions that are made?
3. *Complexity:* What is the size of the group? If there are more than five people attending and you want everyone to contribute, you will need to watch time closely, and you might consider splitting up into smaller groups, at least for part of the time.
4. *Agenda*: How can I most effectively assign time and members to address our issue(s)? Assign each agenda item the number of minutes it will need, the person responsible for introducing the item, and the method by which the topic will be handled. Some possible methods include general discussion, a round-robin in which everyone is invited to comment, a brainstorm, and small breakout groups that are followed by reports back to the whole group.

Handling Conflict in Meetings

If a conflict breaks out between group members, you can broaden the focus by asking for input from those who have not yet spoken. The facilitator should prevent people from speaking over one another by regularly announcing who is in queue to speak. Keeping a queue and insisting on turn taking can break up the tendency of dyads to get into repetitive arguing back and forth, and people are much more willing to wait their turn when they know that they have a place in the queue.

When things become heated and the group seems to be split, it can be helpful to acknowledge that there is a lot of passion around the topic and to suggest taking a break before returning to the discussion. This could be a 10-minute recess or a tabling of the issue until a future date. A time delay gives participants the chance to cool down; even one minute of silence can significantly shift the mood in the room.

Building Consensus

A simple majority vote is an efficient process for decision making and works well for noncontroversial issues, but majority rule also poses disadvantages. If you win a vote for a new initiative, but 49% of the department's members are dead set against it, you will not have the support necessary for implementation. You may never have perfect agreement, but getting as close as possible to consensus will help to get your plans off the ground.

One strategy for moving a group toward consensus is an informal survey of support called a "five-finger vote." The leader asks each member of the group to hold up anywhere from one to five fingers to express the level of support for a proposal as it currently stands. One finger means that the person is absolutely opposed, five fingers means the person is 100% behind it, and two, three, and four fingers represent points in between those poles. If support is lukewarm, the group members are asked what it would take for them to get to five fingers, a proposal they could endorse wholeheartedly. This question allows members' concerns to be aired and addressed. The leader can periodically check back on the level of support and put off a final vote until most of the serious reservations have been resolved.

Supervising Staff

Although they receive limited instruction as supervisors, faculty members are called on to oversee the work of research assistants and teaching fellows and often other staff members. Unfortunately, some of these people will not perform to expectations. The complaint I most often hear is "I gave my assistant clear instructions, but when he showed me his new work, he hadn't completed the most basic steps I asked for." Professor Kim Cameron (2008) developed and researched a process for supervision called the "Personal Management Interview," or PMI. PMI begins with an initial one-on-one meeting in which the supervisor explains that she will be meeting with the supervisee at regular intervals for the purpose of the supervisee's professional development, and she lays out the format of the meetings as follows:

1. Both parties will bring an agenda to each meeting.
2. In every meeting, notes will be written up reviewing topics of discussion and any action items (having action items is essential; if nothing will happen as a result of the discussion, there is no reason to meet).
3. Subsequent meetings will begin with a review of action items from the last time, followed by items on the supervisee's agenda, and finally the boss's agenda.

These meetings can take place weekly, but they should not be any less frequent than once a month. Because supervising a secretary is different from supervising faculty members or professional or technical staff, and all are very different from advising graduate students, the frequency of the meetings will be dictated by the situation. Often supervisors worry that they won't have time for all these meetings, but Cameron's research showed that they actually save time for the supervisor, because employees begin to function at a higher level.

Delegation also keeps the time commitment reasonable. Assign the supervisee to document notes and action items from the meeting and to email you a copy. If you manage many people, for example, in a large lab, schedule regular meetings with the lab manager and some of your senior staff, but train the more qualified people to supervise less experienced members of the team using the same process.

Whether to Enter Academic Administration

If you have a vision for positive organizational change but need a platform and the time to carry that vision forward, then you will be drawn to academic administration. However, before you step into an administrative role, assess what kind of support you will have from your dean, provost, or president. Can you make a case for how your vision fits with his or her strategic plan? Will he or she agree that it is a good use of your time and energy? Without a reasonable amount of support from and rapport with the person to whom you report, moving into an administrative role might just be an exercise in frustration. You will not only need positive connections with those higher in the administrative hierarchy, but also the support of the faculty members beneath you on the organizational chart. Lateral connections (with other chairs or deans) are important as well.

Next, consider your personality and skill set. Can you relate to a variety of people and see things from many points of view? Do you take a measured stance and think through what you have to say before committing it to words? Are you comfortable making a number of decisions in a short time frame? Do you thrive on a busy schedule constantly, shifting gears from one project to another? Will you be satisfied spending much of your time in meetings?

You will also want to weigh your attachment to continuing your research career. Even when appointments are officially split between administration and research, it is the rare person who is able to stay as involved in her research as she was before taking on a leadership position. After being away from the field, people may find it difficult or impossible to return to an earlier level of productivity. Although administrative positions usually come with a substantial increase in pay, most administrators say that given the kind of schedule they must keep and the stress of the position, they would encourage faculty

members to think long and hard before taking on a leadership role, despite the financial benefits.

For those who thrive in the fast-paced role of academic leader, there can be significant satisfactions. As provost of the University of Michigan, Nancy Cantor played a major role in supporting diversity in both the faculty and the student body. In her next role, as chancellor of Syracuse University, Cantor oversaw a visioning process that led to an initiative called "Scholarship in Action." This program supports activities by both faculty and students that engage with real-world communities and problems, including forging strong ties to the university's home city of Syracuse. Her position at the helm of the university allowed her to implement programs on a much larger scale and with a greater impact than would likely be possible in the role of professor.

Some of the women I coach forgo opportunities to move into administration because they still have children at home, and they perceive the lifestyle costs to be too great. Even when children are grown, many women hesitate because they don't have a stay-at-home spouse to manage all the things that male leaders traditionally had done for them by their wives. Before you turn down a position, consider whether there are resources available that would make the job more manageable. In her book *On Being Presidential: A Guide for College and University Leaders*, Susan Resneck Pierce (2012) described her negotiation for the presidency of the University of Puget Sound:

> When the presidential search committee at Puget Sound asked me what I would need in order to say yes to an offer to become president, I unhesitatingly (and almost unthinkingly) said, "A surrogate wife." . . . After the laughter subsided, I explained my reasoning: I would not be able to be an effective president and also arrange for all the entertaining I anticipated doing, not to mention managing an eighty-five-hundred-square-foot house. The board wound up hiring a live-in house manager who was terrific and freed me to focus on being president.

Colleges and universities don't provide live-in house managers for their deans and provosts, but you can negotiate for additional salary to pay for household support or funding to employ a research fellow who can play a significant role in moving your research agenda forward.

Strategic Planning

Some professors roll their eyes when they hear the phrase "strategic planning," lamenting the time and effort they gave to earlier plans that then gathered dust on a shelf. However, without a plan, all decisions are made

on a case-by-case basis, and no one understands why some ideas are supported and others are not. The point of a strategic plan is to determine where it is that your department, division, school, or university hopes to go and how you will get there, with a timeline for reaching your goals. When program leaders need to make decisions about how to assign or cut resources, the strategic plan gives them guidance by laying out the agreed-on priorities.

Even in difficult times, a program can move toward a goal by making decisions in keeping with its strategic plan. Syracuse University chancellor Nancy Cantor explained to me how, in spite of having to do her share of budget cutting, she could still move her institution in a positive direction:

> *I think it's a real problem when people say, "If I'm cutting people, I can't then hire people." I think if you let the institution stop moving, then everybody suffers. And so even though it's hard to do that, it's still absolutely critical, and the leader has to be willing to take the brunt of that but also provide the motivation for supporting new things.*
>
> *When, after 2008 and 2009 we took something like $12 million in recurring dollars out of the budgets on the administrative side of Syracuse and we hired something like 160 or 200 new faculty over a three-or-so-year period, and increased financial aid for students, that may have seemed counterintuitive to people, but it was still important to move the institution forward.*

If Cantor had not had a clear vision, the cuts could instead have preserved the administrative infrastructure but inhibited growth in the faculty and diminished the vitality of the student body by pricing out students whose ability to pay for college had been hurt by the recession.

On a unit level, in times of tight budgets, an engineering department whose strategic plan includes a focus on sustainability might not be able to replace all departing faculty members, but when the department is able to make a hire, the hiring committee would look for someone with expertise in sustainability. The department might also pool reduced funds with programs such as environmental studies, architecture, and organizational studies to offer a joint lecture series on sustainability. Although the size and budget of the engineering department may be smaller, it can still add an area of interest to students. When you are leading a strategic planning process, it is critical to follow up the plan with action and to communicate what has changed as a result of the process, so those who contributed can see that their time and energy were put to good use.

How to Give Bad News

A downside of having real decision-making power is that you will need to make decisions that some people are unhappy about. You will say "no" to budget requests, turn down tenure and promotion cases, and fire employees. In recent years, with most university budgets remaining flat or declining, many administrators spend more time than they would prefer identifying ways to cut costs. Freezing new hires, laying off staff, and reducing travel costs are all stressful and don't help to win popularity contests, but administrators can temper the reaction to difficult situations by showing that the decisions are being made in ways that are evenhanded and fair.

After being appointed dean of the College of Arts and Sciences, Madelyn grappled with how to convey bad news. She explained,

> *I needed a way to express bad news without provoking anger and hatred. When I was a midlevel administrator, it was easier, because I wasn't the one making the decisions. I could say, "I can't change the decision, but I can help us figure out the least disruptive way to carry on in light of these constraints, so let's focus on that." But now I am often the one making the decisions.*

After some thought, Madelyn realized that she could externalize the decision by focusing on the objective facts. For example, she might explain,

> *I need to cut 2% from the Arts and Sciences budget, and I don't see a way to do that if departments are permitted to search on positions that are not yet vacant. So your search is going to have to wait until after the next retirement. I can't change the facts of this, but I can help you to think through how to do this in the way that causes the least harm to the department, so let's focus on that.*

Another strategy Madelyn employs is to invite the people who disagree with her to suggest alternative solutions. She gives this example:

> *Even if all four departments had arguments of exactly the same merit, I would have to disappoint three of them. This seems, in my limited view, to be a zero-sum situation. Is there anything I'm missing about the situation? Is there any way that we can leverage this to turn it into something where everyone can get some of what they want?*

Yet another approach she uses is to move people a level up on self-understanding. She explains,

In some cases, people don't conceive of themselves as being part of a team. Often, people in a department like Classics don't know or care about what is happening in Economics or in Physics—or even in intellectually proximate departments like Philosophy or History— and vice versa of course. But I have to think about balancing the resources given to the humanities, the social sciences, the sciences. In times of scarcity, all of the divisions feel beleaguered. If this person is thinking about what is best for herself, I want to get her to move from thinking at the level of the individual to considering what is best for the department, and then from the department to the division, and from the division to the good of the College of Arts and Sciences and then the university as a whole.

It's Not Personal

Even when administrators are consummate diplomats, they must handle the frustration that is expressed at them about any number of issues. Whether it is students contesting grades, faculty unhappy with policy decisions, staff members who don't get along, or an angry parent on the phone, the frustration is not about you personally. A professional school dean explains that she tends not to take offense at what some people might consider challenges to her authority, because responding to those challenges is something she considers to be a natural part of her job as the face of the administration. She says,

I occasionally am surprised when somebody says, "Did you hear the question they asked you!? That was disrespectful!" I don't actually frame conversations in those terms to myself. I feel my faculty and students can basically ask me almost anything they want. I don't have to answer, and I don't have to agree with them, but as long as they're prepared to deal with that, I'm fine being asked.

She further explained,

If the premise is that I'm supposed to do something and I don't think I should do it, it doesn't make any difference how people are behaving, because I can stick with my decisions. It's a very different dynamic if I'm trying to persuade other people to do something I want them to do. If the idea is pressure on me, then that's part of my job to absorb that pressure and make the decisions. I don't have to be aggravated about it. I mean I get irritable like everybody does, because I don't like the pressure sometimes. But I never think it's not part of my job and that it shouldn't be happening.

Listening

Those who report to you will be more forgiving when they feel as if they have been heard, so even if you know what your answer will be, take time to listen. Ask questions to get as full an understanding as possible, and even take notes. Then summarize what you have heard. If a professor made a case as to why he needs a grading assistant despite not having the enrollment to justify it, you might say, "I understand that you are requesting a grading assistant because your course fulfills the college writing requirement, and the grading is more time intensive than for courses with larger enrollments."

Once you have shown that you have a clear understanding, don't succumb to pressure to make an immediate decision that you may later regret. One exception may set a precedent for others. Maybe you can fund one additional grading assistant, but can you afford to provide assistants for all the other courses that fulfill the writing requirement? Let the person know that you will look into the issue, including what other classes might be affected, and get back to him or her.

If there will be major changes that will affect many people, the process will take much longer. Evan Caminker, who served as dean of the University of Michigan Law School from 2003 to 2013, described an extended listening process related to his law school's major building project. When Caminker began his tenure as dean, his predecessor had the project underway, having chosen one of the top architects in the world, who had drawn up a schematic design that had been widely publicized. When Caminker reviewed the project, he had questions about how the plan would fulfill the space needs of the school, as well as concerns with the high cost. Over time, he began to discuss his concerns with the various constituencies and to move the project in a different direction. In the end a different architect was brought on who worked out a less expensive and more land-protective solution.

"How," I wanted to know, "were you able to turn such a massive effort in a different direction?" Clearly, this could have been a political nightmare. Caminker explained that as a new administrator, he decided that his first response would be to see if he could make the original plan work. Maybe there would be a way to pull it off, and if it didn't work out, then at least he would have credibility when he brought up concerns. For 18 months he did his utmost to raise funds and address areas of concern. Over time, his original misgivings were borne out, and the costs for the first plan had only escalated, so he began to discuss the dilemma with the various constituencies and to move the project in a different direction.

On a small issue with an individual, listening is something that can occur in a short conversation. When it came to a multimillion-dollar project that would impact many people and change the physical footprint of the campus

in a very visible central location, listening was accomplished over a period of many months in which Caminker worked with key players to shape a project that would be optimal for all involved and would serve the needs of the school well into the future.

At the end of the day, everyone may not be happy with the decisions made, but people will be more accepting if the process was transparent, and they had the opportunity to voice their opinions. The greatest challenge to transparency and listening is time pressure, and there will be some situations in which it is just impossible to involve people or do active listening in the time available. However, forgoing a listening process in the name of "efficiency" can backfire, because people who have not bought into a change may block its implementation.

Working With Multiple Constituencies

Administrators at higher levels must think broadly, taking into account the needs and concerns of students, faculty, staff, and alumni, as well as media relations, the university, and other constituencies. Caminker explained how these various groups have to be considered in decisions as large as a major building project and as small as deciding where the door hinges would be placed on the doors to alcoves off the beautiful law school reading room.

Why would the dean care about door hinge placement? Caminker explained that if they placed the plaques honoring large donors on alcove walls next to doors, they would want the honorees and their families to be able to see the plaques when they opened the doors. At the same time, when prospective students were shown the majestic room, the plaques needed to be placed in a way that they would not mar the view, which was a great selling point for prospective students.

Caminker also pointed out that even on decisions that appear to be minor, it is worth taking the time to consider who else could be impacted. For example, if an alumnus asked to come to the law school to speak on a case he had recently litigated, and the presentation was scheduled at a time that conflicted with a student event on a similar topic, it would cause resentment among the student organizers. Leaders need to reflect on everyone who might be affected by their actions.

Budgets

The higher a person moves up the administrative ladder, the more time she will spend on financial issues. The advice I heard over and over from

faculty-turned-administrators is to keep asking questions until you gain a thorough understanding of the budget. One chair told me that when she first became director of a campus center,

> *We didn't know whether we had a huge surplus or if we were completely over our budget. I just kept asking and asking until I got answers. I couldn't make sound decisions for the program until I knew where we stood with the budget.*

Often, a good place to start is with an administrative assistant who has worked with the budget, but you may have to go to other sources such as the business office or your dean to get all the information you need.

Ideally, the process of budgeting is guided by the strategic plan, but where no strategic plan exists, the budget is where priorities will be set. The amount of control administrators have over dividing up the budget varies depending on their position and the type of institution. If a budget is largely handed to you already made, then you will want to find out how much discretion you have to move money from one category to another. If you spend less on supplies, are you able to move some money over to support additional conference attendance and travel? Involving faculty members as much as possible in discussions of any shifts in discretionary spending will foster greater morale and less opposition, because their involvement makes it "our" plan, not the chair's plan.

In *Budgets and Financial Management in Higher Education*, Margaret Barr and George McClellan (2011) encourage budget managers to be aware of environmental conditions both within and outside of their programs to determine how those conditions are likely to affect their units. If a business that previously made strong use of your continuing education programs recently declared bankruptcy, then you might want to adjust revenue predictions from that program downward. If a general education curriculum was recently approved with a new requirement that students can fulfill through courses in your department, then you might need to plan for additional sections. Likewise, be aware of how changes to your budget might affect other units. If the statistics department stops offering a course that sociology majors are required to have to graduate, then it may solve a problem for statistics but create one for sociology.

Barr and McClellan also explain that although there are specific tasks to accomplish at different points in a budget cycle, financial management requires continual monitoring to catch errors and to adjust spending as necessary if money is being spent at a different rate than anticipated. Reviewing historical budget information might also uncover issues that will become problems if left unaddressed. If, for the past three years, money has been

transferred from the equipment category to cover the travel budget, but the department is planning to purchase sorely needed but expensive equipment, the budget may need to be reworked so that travel won't be frozen toward the end of the fiscal year.

If you run into problems, explain the issue to those at your institution who handle accounting or who have more experience with budgets and ask them to help identify solutions. There may be options of which you are not aware. In addition, don't forget to talk to the people in lateral positions. If your department needs new copiers, ask around to learn what arrangements other departments have made. Have they bought copiers new, or did they lease? What kinds of service contracts did they purchase? Are they happy with their specific vendors? There's a wealth of information around you, so you don't have to reinvent the wheel. When making financial arrangements, be sure to put all agreements in writing to avoid misunderstandings.

The most challenging time to be in charge of budgets is when resources are scarce. Words I hear over and over again from high-level administrators are *transparency* and *integrity*. Be honest with people about what you do and do not know and don't make any promises that you can't keep. If the staff wants to know if there will be layoffs, and you don't yet know the answer, explain that you will do everything in your power to avoid that outcome but that you honestly don't know.

In difficult times, invite your people to work together to suggest solutions, and take seriously ideas that will bring about even minor cost savings. Your faculty and staff may have excellent ideas, and their morale will be higher if they are given the chance to address the problem. Another potential

LEARN MORE

Budget Questions

My colleague Tony Tsai, an organizational consultant at the University of Michigan, suggests that you ask those familiar with your program and its finances the following questions:

1. Compared with last year's budget, what are the line items with the biggest changes that I should be aware of?

2. What are the chances that we will meet this budget? Is this a stretch budget, 50/50, or a conservative budget?

3. *Risks:* What are the most likely things that could happen that would cause us to miss making this budget?

4. *Opportunities:* What are the things we can do in case we have to make up a shortfall?

5. What are discretionary cost items that need to be reviewed or approved?

6. If we had to reduce the budget by a certain percentage, how would you distribute the reductions?

Some other questions for discussion or self-reflection include the following:

7. How will our budgeting decisions affect other units?

8. What environmental conditions, either within our institution or the larger world, are likely to impact our budget?

9. Does our budget correctly reflect our unit's strategic plan and priorities?

Additional Reading

Budgets and Financial Management in Higher Education by Margaret J. Barr and George S. McClellan (2011) is a clearly written introduction for those new to the topic, and it's a source I found to be invaluable in my research.

cost-savings method is considering what expenses could be shared with other programs. This might include cosponsoring events or sharing equipment or staff among departments in close physical proximity. If you do need to lay off staff or faculty members, consult with human resources and your legal department to make sure that all union agreements, laws, and regulations are followed. You are part of a large ecosystem of positions, salaries, and funding, and you need to be in touch with anyone affected, anyone you report to, and the people responsible for budgets, employment, and legal issues.

Fund-raising

As people rise to higher levels, raising money, like budgeting, becomes a larger part of the job. Fund-raising is not a place where administrators should go it alone. A chair might be thrilled to have solicited a gift for a department initiative, only to learn that the dean had been working with

the development office to prepare a request for a much larger, multimillion-dollar gift from that donor, which will now be a much harder sell. Even when a donor approaches you, involve development experts and the person to whom you report before proceeding. There may be political consequences of which you are unaware, or the gift could be structured in a way that will cause more problems than it solves. Administrators with the interest and skills in soliciting donations can do tremendous service for their institutions, as long as their efforts are coordinated with others on campus.

Responding to the Media

It is not unusual for academic administrators to find themselves fielding calls from reporters. When the topic is controversial, get the reporter's contact information and ask to return the call rather than respond on the spot. This gives you time to consult your media office and your dean to alert them to the situation and prepare a response. Most often, the goal of the media is not to present a balanced picture but to sell their news products, so take care to stay on message. Identify a few talking points, and practice them before the interview. If you are asked something that you prefer not to answer, give the response to the questions that you would like to answer. Sidestep unwanted questions by replying, "What I can say is this . . ." and then give your prepared statement. If your institution offers media training, take advantage of that opportunity.

Lessons From an Academic Administrator

In *Composing a Life*, Mary Catherine Bateson (1989) talked about her own life and the lives of four women friends as an improvisational art form. Dr. Linda Gillum first introduced me to this book, and when she and I sat down for a conversation about her path in academic leadership, I was struck by how well the term *improvisational art* fit for Gillum's own life. Gillum began her career researching, teaching, and providing clinical support to patients with head injuries at the Detroit Medical Center. She then taught medical students and faculty members at the University of Michigan before joining the dean's office in the medical school. When the provost's office noticed her knack for leadership, Gillum was invited to apply to the American Council on Education (ACE) Fellows program, informally known as "Provost and President's School." Having always worked with graduate and medical students, she took the opportunity of the fellowship to delve into the world of undergraduate education.

LEARN MORE

The Fellows program combines multiday sessions, campus visits, and placement at another institution of higher learning to provide intensive professional development over the course of a year. More information is at this link: www.acenet.edu/leadership/programs/Pages/ACE-Fellows-Program.aspx

Gillum said, "Why would someone who had always worked with graduate and professional school students choose to work in undergraduate education? Because that was the area that I didn't know, and if and when the opportunity presented itself, I wanted to be ready." Gillum spent six months of her fellowship in the provost's office at Princeton, where, in addition to developing a major project on undergraduate education, she seized the opportunity to learn about as many aspects of university administration as possible. "I sat with the deans, the athletic department, the librarians," she said.

When Gillum returned to the University of Michigan and was invited to work in the provost's office, she brought together her newfound interest in undergraduate education and her experience at the medical school to begin an undergraduate research initiative that tied the university's research mission to its commitment to strong undergraduate education in ways that benefited both students and researchers. Gillum was particularly effective in using her broad network within the medical school to set up undergraduate research opportunities in the health sciences. Later, when Gillum made a move to be part of building a new medical school in southeastern Michigan, she combined her experience in medical education with the passion she had found for teaching and learning to create a strong faculty development program.

When I asked Gillum how she managed to do all this while raising two children, she credited a strong support system. After she completed her PhD on the East Coast, Gillum and her husband chose to return to southeast Michigan where they had close friends and family.

There are several useful themes in Gillum's story. One is that women interested in academic leadership should seek out opportunities to expand their base of knowledge. If you don't have much experience with budgets, ask to serve on a committee that works with finances. If you are clueless about sports, and there is a need for a liaison between your academic area and the athletic department, seize that chance to learn more about the needs of student athletes.

Another point relates to the challenge that many professors face in choosing between an administrative career and a research career. As Gillum moved into administration and became excited about the topic of learning, her research area changed from speech and learning disorders to research on teaching and learning. If you are deeply committed to your particular sub-field, then an administrative track that takes you outside of that area for any length of time may make it difficult or impossible to return to your former level of expertise. However, if you have a talent for leadership and follow that passion, new areas of study will present themselves. For many, those areas provide satisfying ways to engage in new research.

Finally, the value of a strong support system is noteworthy. Gillum had close friends who would pick up her kids in a pinch when she was running late, and both her mother-in-law and mother were around to fill in when she had to travel for work. Although not everyone finds meaningful work in close proximity to their extended family, building strong personal and professional networks of reciprocal support makes a powerful difference in the lives and careers of academic women.

CONCLUSION

The vast majority of the academics I coach experience their work as not simply a job or a career but a calling. They chose this path not for financial reward or to advance up a ladder of achievement but because they find the work itself to be enjoyable and fulfilling (Wrzesniewski, McCauley, Rozin, & Schwartz, 1997). At its best, a life in academia is one in which a person wakes up each morning wondering, "How did I get so lucky? I get to choose what I want to work on, control my schedule, and make a difference for other people through my scholarship and my teaching and mentoring. And I get to work with other smart people who inspire me and push me to do my best work." Having a PhD signals a level of expertise and dedication that is widely respected, and achieving the status of professor provides a platform from which to disseminate your research and your point of view.

Along with the rewards, professors face a unique set of challenges. With the many different pulls on an academic's time, professors risk being overwhelmed by competing demands. Although they are smart and interesting, your colleagues are also all-too-human people with whom you have to work out any number of issues. New problems will arise for even the most seasoned academics, and old challenges will periodically rear their ugly heads. If you feel too busy, overwhelmed, unproductive, or undervalued, I hope this book has given you hope in the knowledge that you are not alone and that this is not just "the way it is" or the way that it has to be. The challenges faced by women professors (and all academics) can be successfully addressed.

Often the first time through a book, readers will go straight from start to finish, skipping over the practice exercises. At this point, I invite you to return again to the chapters that address your own current challenges and work your way through the action items. Even better, recruit a friend or colleague to partner up with you to commit to goals and regularly check in on each person's progress or start a reading and discussion group that works through this book a chapter at a time. Although higher education will never be free from any number of stressors, there is much that you can do to reconnect with the joy you first found in your work and to build a satisfying personal and professional life. I wish you well in putting these ideas into action.

REFERENCES

Alford, K. L., & Griffin, T. J. (2013, November 4). Teaching unprepared students: The importance of increasing relevance. *Faculty Focus: Higher Ed Teaching Strategies From Magna Publications.* Retrieved from http://www.facultyfocus.com/articles/effective-teaching-strategies/teaching-unprepared-students-the-importance-of-increasing-relevance/

Allen, D. (2001). *Getting things done: The art of stress-free productivity.* New York, NY: Penguin Books.

Ambrose, S. A., Bridges, M. W., DiPietro, M., Lovett, M. C., & Norman, M. K. (2010). *How learning works: Seven research-based principles for smart teaching.* San Francisco, CA: Jossey-Bass.

Anderson, L. W., & Krathwohl, D. R., (Eds.), *A taxonomy for learning, teaching, and assessing: A revision of Bloom's Taxonomy of educational objectives.* White Plains, NY: Longman

Angelo, T. A., & Cross, K. P. (1993). *Classroom assessment techniques: A handbook for college teachers.* San Francisco, CA: Jossey-Bass.

Anthony, C. G. (2012). The Port Hueneme of my mind: The geography of working-class consciousness in one academic career. In G. Gutiérrez y Muhs, Y. Flores Niemann, C. G. González, & A. P. Harris (Eds.), *Presumed incompetent: The intersections of race and class for women in academia* (pp. 300–312). Boulder, CO: University Press of Colorado.

Arredondo, P., & Castellanos, J. (2003). Latinas and the professoriate: An interview with Patricia Arredondo. In J. Castellanos & L. Jones (Eds.), *The majority in the minority: Expanding the representation of Latina/o faculty, administrators and students in higher education* (pp. 220–239). Sterling, VA: Stylus.

Aycock, A. (2012). Teaching a survey course in anthropology. In F. S. Glazer (Ed.), *Blended learning: Across the disciplines, across the academy* (pp. 59–85). Sterling, VA: Stylus.

Babcock, L., Gelfand, M., Small, D., & Stayn, H. (2006). Gender differences in the propensity to initiate negotiations. In D. De Cremer, M. Zeelenberg, & J. K. Murnighan (Eds.), *Social psychology and economics* (pp. 239–259). Mahwah, NJ: Lawrence Erlbaum.

Babcock, L., & Laschever, S. (2007). *Women don't ask: The high cost of avoiding negotiation—and positive strategies for change.* New York, NY: Bantam.

Any quotes unattributed are from direct conversations with the author.

Babcock, L., & Laschever, S. (2009). *Ask for it: How women can use the power of negotiation to get what they really want.* New York, NY: Bantam.

Baez, B. (2000). Race-related service and faculty of color: Conceptualizing critical agency in academe. *Higher Education, 39*(3), 363–391.

Bain, K. (2004). *What the best college teachers do.* Cambridge, MA: Harvard University Press.

Baker, W. E. (2000). *Achieving success through social capital: Tapping hidden resources in your personal and business networks.* San Francisco, CA: Jossey-Bass.

Banta, T. W., Jones, E. A., & Black, K. E. (2009). *Designing effective assessment: Principles and profiles of good practice.* San Francisco, CA: Jossey-Bass.

Barr, M. J., & McClellan, G. S. (2011). *Budgets and financial management in higher education.* San Francisco, CA: Jossey-Bass.

Barr, R. B., & Tagg, J. (1995). From teaching to learning: A new paradigm for undergraduate education. *Change, 27*(6), 12–25.

Bateson, M. C. (1989). *Composing a life.* New York, NY: Grove Press.

Belcher, W. L. (2009). *Writing your journal article in twelve weeks: A guide to academic publishing success.* Thousand Oaks, CA: Sage.

Berdahl, J. L., & Min, J. (2012). Prescriptive stereotypes and workplace consequences for East Asians in North America. *Cultural Diversity and Ethnic Minority Psychology, 18*(2), 141–152.

Bertrand, M., & Mullainathan, S. (2004). Are Emily and Greg more employable than Lakisha and Jamal? A field experiment on labor market discrimination. *The American Economic Review, 94*(4), 991–1013.

Bloom, B. S., Engelhart, M. D., Furst, E. J., Hill, W. H., & Krathwohl, D. R. (Eds.). (1956). *Taxonomy of educational objectives: The classification of educational goals. Handbook I: Cognitive domain.* New York, NY: David McKay.

Boice, R. (2000). *Advice for new faculty members.* Needham Heights, MA: Allyn & Bacon.

Bolker, J. (1998). *Writing your dissertation in fifteen minutes a day: A guide to starting, revising, and finishing your doctoral thesis.* New York, NY: Owl Books.

Bookman, A., & Kimbrel, D. (2011). Families and elder care in the twenty-first century. *The Future of Children, 21*(2), 117–140.

Boone, D. R. (1997). *Is your voice telling on you? How to find and use your natural voice.* San Diego, CA: Singular Publishing Group.

Bowles, H. R., & Babcock, L. (2013). How can women escape the compensation negotiation dilemma? Relational accounts are one answer. *Psychology of Women Quarterly, 37*(1), 80–96.

Bowles, H. R., Babcock, L., & Lai, L. (2007). Social incentives for gender differences in the propensity to initiate negotiations: Sometimes it does hurt to ask. *Organizational Behavior and Human Decision Processes, 103*(1), 84–103.

Boyd, B. (2012). Sharing our gifts. In G. Gutiérrez y Muhs, Y. Flores Niemann, C. G. González, & A. P. Harris (Eds.), *Presumed incompetent: The intersections of race and class for women in academia* (pp. 277–282). Boulder, CO: University of Colorado Press.

Brame, C. (2013). Flipping the classroom. Retrieved March 14, 2015, from Vanderbilt University Center for Teaching website: http://cft.vanderbilt.edu/guides-sub-pages/flipping-the-classroom/

Brescoll, V., & Uhlmann, E. L. (2008). Can an angry woman get ahead? Status conferral, gender, and expression of emotion in the workplace. *Psychological Science*, *19*(3), 268.

Brown, V., & Geis, F. L. (1984). Turning lead into gold: Evaluations of men and women leaders and the alchemy of social consensus. *Journal of Personality, 46*(4), 811–824.

Bryant, A. (2012, August 5). Corner office: Laurel J. Richie: Tell me your idea (and don't mind the Silly Putty). *New York Times*, p. 2.

Burkeman, O. (2010, April 2). This column will change your life: Is self-discipline the key to success? *The Guardian, U.S. Edition*. Retrieved January 30, 2015, from www.theguardian.com/lifeandstyle/2010/apr/03/change-your-life-self-discipline

Byrd, A., & Tharps, L. L. (2014, April 30). When black hair is against the rules. *New York Times*. Retrieved March 31, 2015, from www.nytimes.com/2014/05/01/opinion/when-black-hair-is-against-the-rules.html

Caldwell, P. M. (1991, April). A hair piece: Perspectives on the intersection of race and gender. *Duke Law Journal, 2*, 365–396.

Calleson, D., Kauper-Brown, J., & Seifer, S. D. (2005). Community-Engaged Scholarship Toolkit. Seattle, WA: Community-Campus Partnerships for Health. Retrieved from www.communityengagedscholarship.info

Cameron, K. (2008). *Positive leadership: Strategies for extraordinary performance*. San Francisco, CA: Berrett-Koehler.

Canul, K. H. (2003). Latina/o cultural values and the academy: Latinas navigating through the administrative role. In J. Castellanos & L. Jones (Eds.), *The majority in the minority: Expanding the representation of Latina/o faculty, administrators and students in higher education* (pp. 167–175). Sterling, VA: Stylus.

Carli, L. L., LaFleur, S. J., & Loeber, C. C. (1995). Nonverbal behavior, gender, and influence. *Journal of Personality and Social Psychology, 68*(6), 1030–1041.

Carter, N. M., & Silva, C. (2011). *The myth of the ideal worker: Does doing all the right things really get women ahead?* New York, NY: Catalyst.

Castellanos, J., & Jones, L. (Eds.). (2003). *The majority in the minority: Expanding the representation of Latina/o faculty, administrators and students in higher education*. Sterling, VA: Stylus.

Cirillo, F. (n.d.). The Pomodoro Technique. Retrieved January 20, 2015, from http://pomodorotechnique.com/

Coates, J. (2011). Gossip revisited: Language in all-female groups. In J. Coates & P. Pichler (Eds.), *Language and gender: A reader* (2nd ed., pp. 199–223). Malden, MA: Blackwell.

Covey, S. R. (1989). *The 7 habits of highly effective people: Powerful lessons in personal change*. New York, NY: Free Press.

Covey, S. R., Merrill, A. R., & Merrill, R. R. (2003). *First things first*. New York, NY: Free Press.

Crone, W. C. (2010). *Survive and thrive: A guide for untenured faculty.* San Rafael, CA: Morgan & Claypool.

Culp, J. M. (1991). Autobiography and legal scholarship and teaching: Finding the me in the legal academy. *Virginia Law Review, 77,* 539–551.

Deci, E. L., Koestner, R., & Ryan, R. M. (1999). A meta-analytic review of experiments examining the effects of extrinsic rewards on intrinsic motivation. *Psychological Bulletin, 125*(6), 627–668.

Delgado-Romero, E. A., Flores, L. Y., Gloria, A. M., Arredondo, P., & Castellanos, J. (2003). Developmental career challenges for Latina/o faculty in higher education. In J. Castellanos & L. Jones (Eds.), *The majority in the minority: Expanding the representation of Latino/a faculty, administrators and students in higher education* (pp. 257–283). Sterling, VA: Stylus.

Dilworth-Anderson, P., Brummett, B. H., Goodwin, P., Williams, S. W., Williams, R. B., & Siegler, I. C. (2005). Effects of race on cultural justifications for caregiving. *Journal of Gerontology: Social Sciences, 60B*(5), S257–S262.

Dilworth-Anderson, P., Williams, I. C., & Gibson, B. E. (2002). Issues of race, ethnicity, and culture in caregiving research: A 20-year review (1980–2000). *The Gerontologist, 42*(2), 237–272.

Dominici, F., Fried, L. P., & Zeger, S. L. (2009, July–August). So few women leaders: It's no longer a pipeline problem, so what are the root causes? *Academe: Magazine of the AAUP.* Retrieved December 22, 2013, from www.aaup.org/article/so-few-women-leaders#.VRtOabDF-n2

Douglas, A. (2008). Three sides of the balance. In E. Monosson (Ed.), *Motherhood, the elephant in the laboratory: Women scientists speak out* (pp. 63–66). Ithaca, NY: Cornell University Press.

Dreifus, C. (2008, January 8). In professor's model, diversity = productivity: A conversation with Scott E. Page. *New York Times.* Retrieved March 31, 2015, from www.nytimes.com/2008/01/08/science/08conv.html

Duhigg, C. (2012). *The power of habit: Why we do what we do in life and business.* New York, NY: Random House.

Easton, S. (2012). On being special. In G. Gutiérrez y Muhs, Y. Flores Niemann, C. G. González, & A. P. Harris (Eds.), *Presumed incompetent: The intersections of race and class for women in academia* (pp. 152–163). Boulder, CO: University Press of Colorado.

Ehrenberg, R. G. (2012). American higher education in transition. *Journal of Economic Perspectives, 26*(1), 193–216.

Ennis, S. R., Ríos-Vargas, M., & Albert, N. G. (2011, May). The Hispanic population: 2010 census briefs. Retrieved from www.census.gov/prod/cen2010/briefs/c2010br-04.pdf

Fisher, R., Patton, B., & Ury, W. (1991). *Getting to yes: Negotiating agreement without giving in* (2nd ed.). New York, NY: Penguin.

Flaherty, C. (2014, March 13). Negotiated out of a job. *Inside Higher Education.* Retrieved December 5, 2014, from www.insidehighered.com/news/2014/03/13/lost-faculty-job-offer-raises-questions-about-negotiation-strategy

Flavell, J. H. (1979). Metacognition and cognitive monitoring: A new area of cognitive-developmental inquiry. *American Psychologist, 34*(10), 906–911.

Flores Niemann, Y. (2012a). Lessons from the experiences of women of color working in academia. In G. Gutiérrez y Muhs, Y. Flores Niemann, C. G. González, & A. P. Harris (Eds.), *Presumed incompetent: The intersections of race and class for women in academia* (pp. 446–499). Boulder, CO: University Press of Colorado.

Flores Niemann, Y. (2012b). The making of a token: A case study of stereotype threat, stigma, racism, and tokenism in academe. In G. Gutiérrez y Muhs, Y. Flores Niemann, C. G. González, & A. P. Harris (Eds.), *Presumed incompetent: The intersections of race and class for women in academia* (pp. 336–355). Boulder, CO: University Press of Colorado.

Franke, A. H., Bérubé, M. F., O'Neil, R. M., & Kurland, J. E. (2012, January). *Accommodating faculty members who have disabilities.* A report of the American Association of University Professors. Retrieved from www.aaup.org/file/Accomodating-faculty-with-Disabilities.pdf

Fredrickson, B. (2009). *Positivity: Top-notch research reveals the 3 to 1 ratio that will change your life.* New York, NY: Three Rivers Press.

Freeman, S., Eddy, S. L., McDonough, M., Smith, M. K., Okoroafor, N., Jordt, H., & Wenderoth, M. P. (2014). Active learning increases student performance in science, engineering, and mathematics. *Proceedings of the National Academy of Sciences of the United States, 111*(23), 8410–8415.

Fritz, C., Lam, C. F., & Spreitzer, G. M. (2011, August). It's the little things that matter: An examination of knowledge worker's energy management. *Academy of Management Perspectives, 25*(3), 28–39.

Galinsky, E. (1999). *Ask the children: What America's children really think about working parents.* New York, NY: William Morrow.

Galinsky, E. (2003). *Dual-centric: A new concept of work-life.* Families and Work Institute, Catalyst, and the Boston College Center for Work and Family. Retrieved from http://familiesandwork.org/site/research/reports/dual-centric.pdf

Garrett, R. (2013, February). *Online higher education in the United States: Explaining market success and diagnosing market friction* (Education and Innovation Theme Report of Alliance 21, pp. 1–21). Retrieved March 31, 2015, from www.alliance21.org.au/site/assets/media/Garrett_Alliance-21-Education-Innovation.pdf

Gilbert, E. (2006). *Eat, pray, love: One woman's search for everything across Italy, India, and Indonesia.* New York, NY: Viking.

Gilbert, E. (2009). TED talk: Your elusive creative genius. Retrieved from www.ted.com/talks/elizabeth_gilbert_on_genius.html#47469

Glazer, F. S. (Ed.). (2012). *Blended learning: Across the disciplines, across the academy.* Sterling, VA: Stylus.

Golde, C. M. (1999). After the offer, before the deal: Negotiating a first academic job. *Academe: Magazine of the AAUP, 85*(1), 44–49.

Golden, C., & Rouse, C. (2000). Orchestrating impartiality: The impact of "blind" auditions on female musicians. *The American Economic Review, 90*(4), 715–741.

Goleman, D. (2004, January). What makes a leader? *Harvard Business Review: Best of HBR 1998* (pp. 1–10). Retrieved from http://paarco.com/Articles/040507%20 What%20makes%20a%20Leader.pdf

Gordon, R. (2012). On community in the midst of hierarchy (and hierarchy in the midst of community). In G. Gutiérrez y Muhs, Y. Flores Niemann, C. G. González, & A. P. Harris (Eds.), *Presumed incompetent: The intersections of race and class for women in academia* (pp. 313–329). Boulder, CO: University Press of Colorado.

Government Accountability Office. (2014). *Higher education: State funding trends and policies on affordability* (GAO Publication No. 15-151). Washington, DC: Author.

Graham, P. (Ed.). (1995). *Mary Parker Follett: Prophet of management.* Boston, MA: Harvard Business School Press.

Granovetter, M. S. (1973). The strength of weak ties. *American Journal of Sociology, 78*(6), 1360–1380.

Gutiérrez y Muhs, G., Flores Niemann, Y., González, C. G., & Harris, A. P. (Eds.). (2012). *Presumed incompetent: The intersections of race and class for women in academia.* Boulder, CO: University Press of Colorado.

Handelsman, J. B. (2005, June 6). I think I'm having pre-traumatic stress disorder. *The New Yorker.*

Harris, D. (2008). Extraordinary commitments of time and energy. In E. Monosson (Ed.), *Motherhood, the elephant in the laboratory: Women scientists speak out* (pp. 121–124). Ithaca, NY: Cornell University.

Hartman, A. (1995). Diagrammatic assessment of family relationships. *Families in Society, 76*(2), 111.

Heilman, M. (1980). The impact of situational factors on personnel decisions concerning women: Varying the sex composition of the applicant pool. *Organizational Behavior and Human Performance, 26*(3), 386–395.

Heilman, M. E., Block, C. J., Martell, R. F., & Simon, M. C. (1989). Has anything changed? Current characterizations of men, women, and managers. *Journal of Applied Psychology, 74*(6), 935–942.

Heilman, M. E., Wallen, A. S., Fuchs, D., & Tamkins, M. M. (2004). Penalites for success: Reactions to women who succeed at male gender-typed tasks. *Journal of Applied Psychology, 89*(3), 416–427.

Heim, P. (with Golant, K.) (2005). *Hardball for women: Winning at the game of business.* New York, NY: Plume.

Heim, P., Murphy, S. A., & Golant, S. K. (2001). *In the company of women: Indirect aggression among women: Why we hurt each other and how to stop.* New York, NY: Putnam.

Henry, A. (2014, July 2). Productivity 101: A primer to the Pomodoro Technique. *Lifehacker.* Retrieved March 31, 2015, from http://lifehacker.com/productivity-101-a-primer-to-the-pomodoro-technique-1598992730

Hiltz, S. R., Coppola, N., Rotter, N., Toroff, M., & Benbunan-Fich, R. (2000). Measuring the importance of collaborative learning for the effectiveness of ALN:

A multi-measure,multi-method approach. *Online Education: Learning Effectiveness and Faculty Satisfaction, 1*, 101–119.

Hotchkiss, L. (September 2004). Lessons learned in leadership.

Howard Hughes Medical Institute. (2006). *Making the right moves: A practical guide to scientific management for postdocs and new faculty.* Retrieved March 30, 2015, from www.hhmi.org/programs/resources-early-career-scientist-development

Hyun, J. (2005). *Breaking the bamboo ceiling: Career strategies for Asians.* New York, NY: HarperCollins.

Ibarra, H., Carter, N. M., & Silva, C. (2010, September). Why men still get more promotions than women. *Harvard Business Review.* Retrieved November 27, 2012, from http://hbr.org/2010/09/why-men-still-get-more-promotions-than-women/ar/1

Isen, A. M., Rosenzweig, A. S., & Young, M. J. (1991). The influence of positive affect on clinical problem solving. *Medical Decision Making, 11*(3), 221–227.

Kanter, R. M. (1993). *Men and women of the corporation.* New York, NY: Basic Books.

Kaplan, M. (1998). The teaching portfolio: University of Michigan CRLT (Occasional Paper No. 11). Retrieved from www.crlt.umich.edu/sites/default/files/resource_files/CRLT_no11.pdf

Kaplan, M., Mets, L. A., & Cook, C. E. (2011). The University of Michigan Center for Research on Learning and Teaching. Questions frequently asked about student ratings: Summary of research findings. Retrieved from www.crlt.umich.edu/publinks/crlt_faq.php

Kardia, D., & Wright, M. (2004). Instructor identity: The impact of gender and race on faculty experiences with teaching. University of Michigan Center for Research on Learning and Teaching (Occasional Paper No. 19). Retrieved from www.crlt.umich.edu/sites/default/files/resource_files/CRLT_no19.pdf

Kelly, R. (2007, January). 5 ways to build community in an online course. *Online Classroom,* pp. 1, 3.

Kezar, A. J., & Sam, C. (2010). *Understanding the new majority of non-tenure-track faculty in higher education: Demographics, experiences, and plans of action. ASHE Higher Education Report* (Vol. 36, No. 4). San Francisco, CA: Wiley Periodicals.

Kierstead, D., D'Agostino, P., & Dill, H. (1988). Sex role stereotyping of college professors: Bias in students' ratings of instructors. *Journal of Educational Psychology, 80*(3), 342–344.

Kiley, K. (2013, July 23). Holding the line. *Inside Higher Education.* Retrieved March 31, 2015, from www.insidehighered.com/news/2013/07/23/salle-mae-survey-finds-families-unwilling-pay-more-higher-education

Klofstad, C. A., Anderson, R. C., & Peters, S. (2012, March 14). Sounds like a winner: Voice pitch influences perception of leadership capacity in both men and women. *Proceedings of the Royal Society B.* doi:10.1098/rspb.2012.0311

Kosslyn, S. M. (2002). Criteria for authorship. Retrieved March 14, 2015, from http://isites.harvard.edu/fs/docs/icb.topic562342.files/authorship_criteria_Nov02.pdf

Lamott, A. (1995). *Bird by bird: Some instructions on writing and life.* New York, NY: Anchor Books.

Lang, J. M. (2011, April 7). How do you teach networking? *The Chronicle of Higher Education.* Retrieved September 14, 2012, from http://chronicle.com/article/How-Do-You-Teach-Networking-/127008/

Laurence, D. (2005–2006, Fall–Spring). Report on the MLA's 2004 survey of hiring departments. *ADE Bulletin, 138–139,* 95–102.

Lavariega Monforti, J. (2012). La lucha: Latinas surviving political science. In G. Gutiérrez y Muhs, Y. Flores Niemann, C. G. González, & A. P. Harris (Eds.), *Presumed incompetent: The intersections of race and class for women in academia* (pp. 393–407). Boulder, CO: University Press of Colorado.

Lavariega Monforti, J., & Michelson, M. R. (2008). Diagnosing the leaky pipeline: Continuing barriers to the retention of Latinas and Latinos in political science. *PS: Political Science and Politics, 41*(1), 161–166.

Lerum, K. (2012). What's love got to do with it? Life teachings from multiracial feminism. In G. Gutiérrez y Muhs, Y. Flores Niemann, C. G. González, & A. P. Harris (Eds.), *Presumed incompetent: The intersections of race and class for women in academia* (pp. 266–276). Boulder, CO: University Press of Colorado.

Lewicki, R. J., Saunders, D. M., & Barry, B. (2009). *Negotiation: Readings, exercises, and cases* (6th ed.). New York, NY: McGraw Hill/Irwin.

Lewicki, R. J., Saunders, D. M., & Barry, B. (2014). *Negotiation* (7th ed.). New York, NY: McGraw-Hill/Irwin.

Livingston, R. W., Rosette, A. S., & Washington, E. F. (2012). Can an agentic Black woman get ahead? The impact of race and interpersonal dominance on perceptions of female leaders. *Psychological Science, 23*(4), 354–358.

Lyman, F. T. (1981). The responsive classroom discussion: The inclusion of all students. In A. S. Anderson, J. M. Dodge, & M. M. Thomas (Eds.), *Mainstreaming digest: A collection of faculty and student papers* (pp. 109–113). College Park, MD: University of Maryland.

Major, B., McFarlin, D. B., & Gagnon, D. (1984). Overworked and underpaid: On the nature of gender differences in personal entitlement. *Journal of Personality and Social Psychology, 47*(6), 1399–1412.

Mankoff, R. (1993, May 3). "No, Thursday's out. How about never—Is never good for you?" [cartoon]. *The New Yorker.*

Martin, J. (2007). Gender-related material in the new core curriculum. *Stanford Graduate School of Business News.* Retrieved May 5, 2012, from www.gsb.stanford.edu/news/headlines/wim_martin07.shtml

McCarthy, J. P., & Anderson, L. (2000). Active learning techniques versus traditional teaching styles: Two experiments from history and political science. *Innovative Higher Education, 24*(4), 279–294.

Metacognition. (n.d.) *In Merriam-Webster's online dictionary* (11th ed.). Retrieved March 25, 2015, from http://www.merriam-webster.com/dictionary/metacognition

Milkie, M. A., Raley, S. B., & Bianchi, S. M. (2009). Taking on the second shift: Time allocations and time pressures of U.S. parents with preschoolers. *Social Forces, 88*(2), 487–515.

Misra, J., Lundquist, J. H., Holmes, E., & Agiomavritis, S. (2011, January–February). The ivory ceiling of service work: Service work continues to pull women associate professors away from research. What can be done? *Academe Online.* Retrieved November 10, 2012, from www.aaup.org/article/ivory-ceiling-service-work#.VRtRC7DF-n0

Moffitt, K. R., Harris, H. E., & Forbes Berthoud, D. A. (2012). Present and unequal: A third-wave approach to voice parallel experiences in managing oppression and bias in the academy. In G. Gutiérrez y Muhs, Y. Flores Niemann, C. G. González, & A. P. Harris (Eds.), *Presumed incompetent: The intersections of race and class for women in academia* (pp. 78–92). Boulder, CO: University Press of Colorado.

Moss-Racusin, C. A., Dovidio, J. F., Brescoll, V. L., Graham, M. J., & Handelsman, J. (2012). Science faculty's subtle gender biases favor male students. *Proceedings of the National Academy of Sciences of the United States, 109*(41), 16474–16479.

Museus, S. D., Maramba, D. C., & Teranishi, R. T. (Eds.). (2013). *The misrepresented minority: New insights on Asian Americans and Pacific Islanders, and the implications for higher education.* Sterling, VA: Stylus.

Ophir, E., Nass, C., & Wagner, A. D. (2009). Cognitive control in media multitaskers. *Proceedings of the National Academy of Sciences of the United States, 106*(37), 11583–11587.

Page, S. E. (2007). *The difference: How the power of diversity creates better groups, firms, schools, and societies.* Princeton, NJ: Princeton University Press.

Palmer, P. J. (2007). *The courage to teach: Exploring the inner landscape of a teacher's life* (10th anniversary ed.). San Francisco, CA: Jossey-Bass.

Peck, J. J. (2006). Women and promotion: The influence of communication style. In M. Barrett & M. J. Davidson (Eds.), *Gender and communication at work* (pp. 50–66). Burlington, VT: Ashgate.

Pierce, S. R. (2012). *On being presidential: A guide for college and university leaders.* San Francisco, CA: Jossey-Bass.

Poor, S. S., Scullion, R., Woodward, K., & Laurence, D. (2009, April). Standing still: The associate professor survey. Report of the Committee on the Status of Women in the Profession. Retrieved from www.mla.org/pdf/cswp_final042909.pdf

Porter, N., & Geis, F. (1981). Women and nonverbal leadership cues: When seeing is not believing. In C. Mayo & N. M. Henley (Eds.), *Gender and nonverbal behavior* (pp. 39–61). New York, NY: Springer-Verlag.

Porter, S. R., Toutkoushian, R. K., & Moore, J. V. I. (2008). Pay inequities for recently hired faculty, 1988–2004. *Review of Higher Education, 31*(4), 465–487.

Powell, M., & Kantor, J. (2008, June 18). After attacks, Michelle Obama looks for a new introduction. *New York Times.* Retrieved March 31, 2015, from www.nytimes.com/2008/06/18/us/politics/18michelle.html?pagewanted=all&_r=0

Prince, M. (2004). Does active learning work? A review of the research. *Journal of Engineering Education, 93*(3), 223–231.

Rankin, E. (2001). *The work of writing: Insights and strategies for academics and professionals.* San Francisco, CA: Jossey-Bass.

Reid, S. A., Palomares, N. A., Anderson, G. L., & Bondad-Brown, B. (2009). Gender, language, and social influence: A test of expectation states, role congruity, and self-categorization theories. *Human Communication Research, 35*, 465–490.

Rockquemore, K. A., & Laszloffy, T. (2008). *The Black academic's guide to winning tenure—Without losing your soul.* Boulder, CO: Lynne Rienner.

Roediger, H. L., III. (2014, July 18). How tests make us smarter. *New York Times.* Retrieved July 25, 2014, from www.nytimes.com/2014/07/20/opinion/sunday/how-tests-make-us-smarter.html

Rostagi, S., Johnson, T. D., Hoeffel, E. M., & Drewery, M. P., Jr. (2011, September). The Black population: 2010 census briefs. Retrieved from www.census.gov/prod/cen2010/briefs/c2010br-06.pdf

Ruhl, K. L., Hughes, C. A., & Schloss, P. J. (1987). Using the pause procedure to enhance lecture recall. *Teacher Education and Special Education, 10*(1), 14–18.

Russ, T. L., Simonds, C. J., & Hunt, S. K. (2002). Coming out in the classroom . . . an occupational hazard: The influence of sexual orientation on teacher credibility and perceived student learning. *Communication Education, 51*(3), 311–324.

Sahgal, N., & Smith, G. (2009). *A religious portrait of African-Americans* (Pew Research Religion & Public Life Project). Washington, DC: Pew Research Center.

Sandberg, S. (2013). *Lean in: Women, work, and the will to lead.* New York. NY: Alfred A. Knopf.

Schiebinger, L., Davies Henderson, A., & Gilmartin, S. K. (2008). *Dual-career academic couples: What universities need to know.* Report by the Michelle R. Clayman Institute for Gender Research at Stanford University. Retrieved March 31, 2015, from http://gender.stanford.edu/sites/default/files/DualCareerFinal_0.pdf

Seligman, M. E. P. (2002). *Authentic happiness: Using the new positive psychology to realize your potential for lasting fulfillment.* New York, NY: Free Press.

Silvia, P. (2007). *How to write a lot: A practical guide to productive academic writing.* Washington, DC: American Psychological Association.

Stevens, D. D., & Levi, A. (2005). *Introduction to rubrics: An assessment tool to save grading time, convey effective feedback, and promote student learning.* Sterling, VA: Stylus.

Striver, J. (2006, September 19). The immobility of the associate professor. *The Chronicle of Higher Education.* Retrieved November 11, 2012, from http://chronicle.com/article/The-Immobility-of-the/46881

Suskie, L. (2009). *Assessing student learning: A common sense guide* (2nd ed.). San Francisco, CA: Jossey-Bass.

Sutherland, J. (2008). Ideal mama, ideal worker: Negotiating guilt and shame in academe. In E. Evans & C. Grant (Eds.), *Mama, PhD: Women write about motherhood and academic life* (pp. 213–221). New Brunswick, NJ: Rutgers University Press.

Tannen, D. (1994). *Talking from 9 to 5: How women's and men's conversational styles affect who gets heard, who gets credit, and what gets done at work.* New York, NY: William Morrow.

Thompson, L. (2011). *The mind and heart of the negotiator* (6th ed.). Upper Saddle River, NJ: Prentice Hall.

Thoreau, H. D. (1854). *Walden; Or, life in the woods.* Ticknor and Fields: Boston.

Tierney, W. G., & Bensimon, E. M. (1996). *Community and socialization in academe.* Albany, NY: State University of New York Press.

Toor, R. (2008, February 5). The writing date. *The Chronicle of Higher Education.* Retrieved March 31, 2015, from http://chronicle.com/article/The-Writing-Date/45947

Torres, S. (1999). Barriers to mental-health-care access faced by Hispanic elderly. In M. L. Wykle & A. B. Ford (Eds.), *Serving minority elders in the 21st century* (pp. 200–218). New York, NY: Springer.

Ulrich, L. T. (2007). *Well-behaved women seldom make history.* New York, NY: Alfred A. Knopf.

University of Michigan ADVANCE Program Committee on Strategies and Tactics for Recruiting to Improve Diversity and Excellence (STRIDE) website. Retrieved from http://sitemaker.umich.edu/advance/stride_committee

Ury, W. (1991). *Getting past no: Negotiating in difficult situations.* New York, NY: Bantom.

U.S. Census Bureau. (2010, April 1). *Census.* Retrieved January 27, 2015, from www.census.gov/popest/data/

U.S. Department of Education. (2013). *Digest of education statistics* (Tables 315.20 and 314.40). Washington, DC: Institute of Education Sciences, National Center for Education Statistics, U.S. Department of Education.

Valian, V. (n.d.). Tutorials for change: Gender schemas and science careers. Retrieved March 31, 2015, from www.hunter.cuny.edu/gendertutorial/index.html

Valian, V. (1999). *Why so slow? The advancement of women.* Cambridge, MA: MIT Press.

Vargas, L. (Ed.). (2002). *Women faculty of color in the White classroom.* New York, NY: Peter Lang.

Võ, L. T. (2012). Navigating the academic terrain: The racial and gender politics of elusive belonging. In G. Gutiérrez y Muhs, Y. Flores Niemann, C. G. González, & A. P. Harris (Eds.), *Presumed incompetent: The intersections of race and class for women in academia* (pp. 93–109). Boulder, CO: University Press of Colorado.

Walvoord, B. E. (2010). *Assessment clear and simple: A practical guide for institutions, departments, and general education* (2nd ed.). San Francisco, CA: Jossey-Bass.

Walvoord, B. E., & Anderson, V. J. (2009). *Effective grading: A tool for learning and assessment in college* (2nd ed.). San Francisco, CA: Jossey-Bass.

Weiss, C. O., González, H. M., Kabeto, M. U., & Langa, K. M. (2005). Differences in amount of informal care received by non-Hispanic Whites and Latinos in a nationally representative sample of older Americans. *Journal of the American Geriatrics Society, 53*(1), 146–151.

Woolley, A. W., Chabris, C. F., Pentland, A., Hashmi, N., & Malone, T. W. (2010). Evidence for a collective intelligence factor in the performance of human groups. *Science, 330,* 686–688.

Wrzesniewski, A., McCauley, C. R., Rozin, P., & Schwartz, B. (1997). Jobs, careers, and callings: People's relations to their work. *Journal of Research in Personality, 31,* 21–33.

Yeung, F. P. F. (2013). Struggles for professional and intellectual legitimacy: Experiences of Asian and Asian American female faculty members. In S. D. Museau, D. C. Maramba, & R. T. Teranishi (Eds.), *The misrepresented minority: New insights on Asian Americans and Pacific Islanders, and implications for higher education* (pp. 281–293). Sterling, VA: Stylus.

Yoder, J. D., Schleicher, T. L., & McDonald, T. W. (1998). Empowering token women leaders: The importance of organizationally legitimized credibility. *Psychology of Women Quarterly, 22*(2), 209–222.

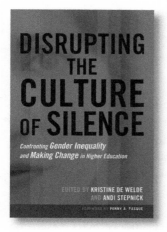

Disrupting the Culture of Silence

Confronting Gender Inequality and Making Change in Higher Education

Edited by Kristine De Welde and Andi Stepnick

Foreword by Penny A. Pasque

"What distinguishes this book are the engaging narratives and compelling contemporary research woven throughout the volume that will resonate with many readers, but the editors and authors do not stop with this important knowledge. Through real-life narratives, case studies, resources, tools, and action steps that build off of each other in an intentional manner, readers may transform this knowledge into action where they can work to make change on their own campuses and in their professional and personal lives."

— **Penny A. Pasque**, *Associate Professor ,Educational Leadership and Policy Studies, Women's and Gender Studies, Center for Social Justice, University of Oklahoma*

Despite tremendous progress toward gender equality and equity in institutions of higher education, deep patterns of discrimination against women in the academy persist. From the "chilly climate" to the "old boys' club," women academics must navigate structures and cultures that continue to marginalize, penalize, and undermine their success.

The editors provide case studies of women who have encountered antagonistic workplaces, and offer action steps, best practices, and more than 100 online resources for individuals navigating similar situations

22883 Quicksilver Drive
Sterling, VA 20166-2102

Subscribe to our e-mail alerts: www.Styluspub.com

ABOUT THE AUTHOR

Rena Seltzer coaches professors, physicians, and academic leaders to reach their professional and organizational goals. She also leads lively interactive workshops and keynotes that are popular draws at colleges and universities, professional association meetings, and health care organizations. Rena offers presentations on writing productivity, time management, networking, negotiation, work-life balance, and women's leadership, and regularly partners with organizations to design new programs to meet their objectives. Working in person, by telephone, and by video conferencing, she supports individuals and teams across North America, Europe, and Asia.

During Rena's earlier career as a psychotherapist, she completed coach training through the MentorCoach program. Living in the college town of Ann Arbor, Michigan, Rena quickly discovered the power of coaching to transform academics' work lives, and shortly thereafter she founded the coaching and training business Leader Academic. Rena lives with her physician partner and their two sons. She enjoys biking, long walks, hiking, and holds a black belt in Shorin-Ryu Karate.

Rena's website leaderacademic.com includes recommended resources, links to other useful sites, and a full list of workshop offerings.